IMAGES
of America

# HOOD CANAL

ON THE COVER: In 1890, John McReavy built his mansion on the Union City hill. The home featured a grand view from each bay window of Hood Canal and the Olympic Mountains, as well as of Union City's hotel, store, and Masonic lodge, all of which he built. "The Father of Union City," McReavy promoted Union City as "The Venice of the Pacific." Olympic Mountain explorer and judge James Wickersham observed that McReavy "runs the hotel and saloon, democratic politics and other small matters." By 1893, the Port Townsend Southern, the Grays Harbor and Puget Sound and the Union City and Naval Station Railroads planned right-of-ways. The 1893 depression quashed McReavy's Hood Canal dreams. He is identified as the man in the center with the hat and beard. (Courtesy of the Mason County Historical Society.)

IMAGES
*of America*

# HOOD CANAL

Michael Fredson

ARCADIA
PUBLISHING

Published by Arcadia Publishing
Charleston, South Carolina

Library of Congress Catalog Card Number: 2007923840

For all general information contact Arcadia Publishing at:
Telephone 843-853-2070
Fax 843-853-0044
E-mail sales@arcadiapublishing.com
For customer service and orders:
Toll-Free 1-888-313-2665

Visit us on the Internet at www.arcadiapublishing.com

*To my grandson, Oskar Vap Fredson,*
*and to everyone's grandchild:*
*May the future of Hood Canal be clean and abundant and joyful.*

# CONTENTS

# ACKNOWLEDGMENTS

Mason County Historical Society has a growing file of photographs documenting our 150 years of county history. Director Billie Howard has attracted stories and photographs from citizens of all ages from throughout the county. Billie charms both a grandfather and a second-grader touring the museum. The community has supported our mission of history, and they have brought the files, the photographs, the stories, and the artifacts to the Mason County Historical Society. This book is composed from those donated photographs.

The following staff offered enthusiastic and professional support: Stan Graham, Shirley Erhart, Justin Cowling, and Charles Fisher.

A special thanks to Jan Parker, a great partner in this project—selecting photographs, duplicating photographs, researching files, editing, and even phone calling and layout.

And to all who love Hood Canal.

## PHOTOGRAPHS:

Mason County Historical Society
Barb Robinson
Shirley Erhart
Jean Bearden
Linda Sund
Greg Stairs
Mya Keyzers
Jim Middleton
Jean Moore
Carol Schneider
Jane Seaman
National Archives and Records Administration—
    Pacific Alaska Region (Seattle)
Guy Garfield
PUD No. 1
*Simpson Lookout*
Barb Stroud
Candy Kuhr
Don McKay
Steve Whitehouse
Dave Robbins

*Hood Canal: Splendor at Risk*, Publisher *Kitsap Sun*, photographer Larry Steagull
Francis Moak
Dean Johnson
The collection of J. D. Hack
Ann Scroggs
Mike Fredson
Lindy Fredson
Jan Parker
Charles Fisher
Billie Howard
Pete Replinger

# INTRODUCTION

The Hood Canal waters journey from China, from San Francisco, and from Alaska, past Victoria and down the Strait of Juan de Fuca. Leaving Puget Sound with a hard right, as if the water had a mind of its own, it channels below the snow-capped Olympic Mountains for 45 miles until it eddies into Annas Bay, a reflecting pond for Mount Washington's eternal gaze. When Hood Canal elbows east, it seems to hook into a separate ecosystem, not only of geography, but also of mind; it becomes a source for dreamers, drifters, and vagabonds. It creates a vacationland of warm days and inspiring scenery, and its shores attracted four of America's great fortunes: California gold, Alaska gold, Washington timber, and Seattle's Microsoft. However, the canal's history has been best defined by modes of travel: 18th-century canoes and ships, 19th-century ghost railroads, and 20th-century highways.

The native Twana claimed the inlet as *tuwa'duxql si'dakw*, or "Twana's saltwater." Meadows of eelgrass riffled with the tides and herring. Salmon runs stuffed up Hood Canal rivers, such as the Skokomish, the Tahuya, the Dewatto, the Dosewallips, and the Hama Hama. Native American families canoed between several winter and summer villages on Hood Canal's river drainages, harvesting not only the salmon, but also clams, oysters, geoducks, and herring roe. Summerhouses were like tents of woven mats; the winter longhouses were crafted from cedar planks, with roof peaks vented to exhaust the smoke from fires of the families living in the longhouse.

On May 12, 1792, Capt. George Vancouver with Lt. Peter Puget led three boats into the unexplored arm of water. At what Vancouver called the "mouth of the loveliest river," the Skokomish, he traded for clams and salmon. His exploration of Hood Canal and Puget Sound penetrated beyond the Spanish at Port Angeles and contributed to the British claim. Vancouver named it Hood's Channel, after the Right Honorable Lord Samuel Hood, member of the British Board of Admiralty, but on maps it was mislabeled as Hood's Canal.

The first building was a blockhouse at Union, named Skokomish then, and it was on a winter village site that the Twana called *Do-hlo-kewa-ted*, or "have excrement on one's foot." Some say it was built by Hudson Bay trappers; some say for war. Nonetheless, years later, settler children gouged arrowheads out of the log building with a shadowy past.

In 1851, loggers arrived. Mainers Andrew Pope and William Talbot sailed from San Francisco to Port Gamble to build a mill for the booming California goldfields. By 1854, San Francisco mill owner Marshall Blinn followed with the Washington Mill at Seabeck. Soon loggers, including Ewell Brinnon and James Fulton, drifted down the canal.

Because of the sudden trickle of settlers throughout Hood Canal, Gov. Isaac Stevens negotiated the Point No Point treaty of 1855. The Twana, the Chemakums, and the S'Klallams were assigned to the Skokomish Reservation. By 1860, the Native American families scattered along Hood Canal were relocated to the reservation. Soon the tribe received a boarding school and Indian agent to assist in the government's re-educational process.

In 1858, Franklin Purdy founded Mason County's first federal post office at Skokomish, which served the new federal reservation on the west side of the Skokomish River flats to the blockhouse on the east—a distance made far shorter by canoe.

By the 1860s, the tugboat captains who hauled the log booms up the canal to Port Gamble began filing land claims in the canal's coves and river valleys. These included Capt. John Sund, Capt. Vincent Finch at Hoodsport, and Captain McNair at Lilliwaup Bay, all early captains of Puget Sound's legendary mosquito fleet.

In 1861, Mainer John McReavy walked Hood Canal from Port Gamble to Union River at the toe to buy a bankrupt logging camp. For over 50 years, McReavy loved Hood Canal. As the leading lumberman, legislator, and dreamer, he was its most important citizen. He entered territorial politics in 1869, serving 20 years—his work culminating with his signing the declaration of statehood.

In 1889, McReavy platted a new town, Union City, eight miles west of his Union River Railroad. It was a new name with a new idea. He sold the Port Townsend Southern, the Grays Harbor and Puget Sound and the Union City and Naval Station Railroads planned right-of-ways. "The Father of Union City" built the Masonic lodge, the Occidental Hotel, the Congregational church, a sawmill, and a cemetery. From his newly built mansion on the hill, in 1890, McReavy surveyed his "Venice of the Pacific"—after all, the budding metropolis was on a canal.

In 1890, his brother James, convinced that minerals lay locked in the still-unexplored Olympic Mountains, together with Jack Dow and Vincent Finch, filed a plat for Hoodsport, complete with a Port Townsend and Southern railroad easement and a mining company, the Mason County Mining and Development Company, which was owned by James and John McReavy. Soon other new plats were filed along the Port Townsend and Southern right-of-way on Hood Canal's western shore.

Hood Canal fed those 19th-century dreams of wealth. However, in 1893, the railroads failed and left McReavy's Union City bankrupt. Hoodsport almost receded into the heavy forested mountains that hulked up behind the tiny town.

But already a new dream—this time of recreation—had sprouted in Lake Cushman. Miners had ignored Cushman in their prospecting, but by 1888, young Eastern heirs discovered the unrivaled hunting for deer, elk, bear, and cougar, as well as the extraordinary lake fishing. These "remittance men," so named for the allowances received from their families to continue adventuring out West, constructed the Cushman House and the Antlers Hotel. These hunting lodges, a 19th-century luxury vacation destination for the Eastern and Seattle elite, presaged Hood Canal's development as a resort playground for fishermen and families in the pre–World War II years.

In 1890, Lt. Joseph O'Neil led the Olympic Exploring Expedition into the Olympic Mountains from Lilliwaup. The six volunteers stayed at the Antlers Hotel and the Cushman House before entering the Olympics at "Devil's Staircase." In his report to Congress, O'Neil called for an Elk National Park, as much to protect the mountains' estimated 300 elk from slaughter as to preserve the extraordinary meadow and mountainous terrain.

Although the canal's undisturbed mountains attracted tourists, the magnificent forests also had their 19th-century admirers. In 1900, Sol Simpson and Alfred Anderson founded the Phoenix Logging Company at Potlatch. In 40 years, Phoenix Logging dumped one-and-a-half-billion board feet into Hood Canal. Anderson was one of the earliest members of the upper class to build a summer home on Hood Canal. He built at Potlatch to take in the salt air.

After the 1893 depression, it took the 1906 San Francisco earthquake and an expatriate land developer to introduce tourism. Frank Pixley, the nephew of a San Francisco politician and newspaper publisher, brought California gold rush money up the coast into Hood Canal with notions of building a new San Francisco founded in art and wealth.

"Pix," as Pixley became known, purchased much of John McReavy's Union City plat. Eventually his holdings extended from Dewatto to Tahuya and from Union City to Alderbrook. He named his empire Yachthaven, and in 1916, he shipped his wife, two children, a printing press, a piano, and all the books he could stuff aboard home to Hood Canal.

Soon Pix met Tahuya teacher and artist Orre Nobles. Pix spun tales of California and the exotic

Orient. In 1922, Nobles enrolled in Pratt Art Institute in New York City. He indulged his passion for theater and music and charmed the socialites with his Danish good looks, wit, and artistic temperament. In 1928, he toured the Far East with Upton Close, a political commentator, and illustrated Close's *Six Eminent Asians*.

Nobles designed Olympus Manor, a Chinese-themed resort of tiny "cottagettes," a lodge, and a welcoming Torii gate in the water. In the summer, Nobles staged chamber music and hosted soirees for society women in his music room. His travels to the Orient, his wide range of friends, and his artistic taste and energy attracted students and resort patrons. It was as if Nobles burst with the spirit of the canal—his Olympus Manor almost a cultural outpost at the rim of a youthful continent.

Around Olympus Manor gathered an artists' colony of weavers, painters, musicians, and a tall pacifist, printmaking, teepee-living philosopher named Waldo Chase. The artists, through their work and philosophy, illuminated Hood Canal's unique mystery and attracted vacationers excited by the music and the art deco style.

With Hood Canal's extraordinary scenery and great fishing, twined together by new roads, Hood Canal was assured a prosperous future once again; this time, however, the promise was based on the automobile instead of the tree, the train, or the stern-wheeler.

The Olympic Highway slid beneath the Olympic Mountains on Hood Canal's west shore. The Navy Yard Highway snaked from Union City to Belfair, connecting to the great cities of Puget Sound tourists. At Belfair, when the Navy Yard Highway moved, Sam Theler moved his grocery and thus founded New Belfair. Resorts became popular. Rose Point offered fishing and a dance pavilion. Clara Eastwood and Eloise Flagg built Alderbrook into a destination for motorists. Guests at Camp Madrona, Stetson's, and Rest-A-While enjoyed the world-class salmon fishing on flat water. Hollywood arrived in 1934, when Don Beckman, a movie-poster designer, set designer, and dialog writer, built a chateau-like Robin Hood Tavern and Nottingham Village to look like a movie set. He, too, was peering ahead to more prosperous times.

Soon wealthier families built summer homes. Near Alderbrook, Alaska gold rush returnees and shoe-store partners John Nordstrom and Carl Wallin built in "the Swedish Colony," as did Dr. Nils Johanson, the founder of Seattle's Swedish Hospital. Nearby, Grays Harbor lumbermen, including the Schafer family and the Bishops, also constructed summer compounds. National movie stars, including Clark Gable, Gene Tunney, and Don Blanding, visited the magical canal land of movies, art, music, and scenery.

In 1935, state laws changed to aid Hood Canal tourism. State fisheries outlawed fish traps in the Strait of Juan de Fuca, which funnels water and fish into the Hood Canal. Prohibition was lifted. As a result, several "bottle clubs" and restaurants opened, including Kuett's Tavern at Union City, as well as Mel Bearden's ClarMel Inn and Dick Shively's bootleg Blue Ox near Hoodsport. Resorts circled the arm of Hood Canal like a bracelet. Fishing derbies were held by clubs from Bremerton, Olympia, and Shelton, with new automobiles as prizes. One summer tourist claimed to have spied a 20-foot-long sea serpent with a head like a bull, and the highways were soon full of serpent-seekers.

But Hood Canal was not limitless. Commercial boats dragnetted the canal, and by 1938, the state fisheries outlawed netting for shrimp because of the precipitous drop in the catch.

While most of the new resorts were located on the Navy Yard Highway, the west shore of the canal bustled with private, public, and federal development. Logging, of course, continued, from Potlatch to Hama Hama. In addition, in 1926, after much litigation, the Cushman Dam flooded the old lake to provide lights for Tacoma and Hood Canal residents. Eventually two dams were constructed, providing employment until 1935.

In the late 1930s, federal employees of the Civilian Conservation Corps (CCC) and Works Progress Administration (WPA) constructed many improvements around the canal, including Twanoh State Park and the Hama Hama Ranger Station. The young men were welcomed with basketball games and dinners, and many attended dances at the Blue Ox.

In 1947, with most private logging cutover on the canal's west side, the federal government continued exploiting Hood Canal watersheds through the Sustained Yield Cooperative with

Simpson Logging Company. The proceeds not only repaid war debts, but also employed Hoodsport residents as loggers or forest rangers. To contain the logging runoff from reaching Hood Canal, a dam was proposed but it was cancelled because it was located on an earthquake fault. Another federal project, the Bangor Submarine Base, was sited in 1962 in one of Hood Canal's sheltered bays.

The state continued to invest in the tourism and trade of Hood Canal. In 1951, dragnetting resumed briefly for herring roe for the Japanese market. In 1952, the Belfair State Park opened on Little Mission Creek. In 1961, the Hood Canal Bridge spanned the inlet near Port Gamble. Though it blew down in 1979, it was soon rebuilt. And in 1963, after 20 years of community effort led by Nell Anderson, the Potlatch State Park opened.

During the war, resorts had boarded naval officers, who drove the Navy Yard highway. Afterward veterans returned with families to the new state parks and the Olympic National Park. Fishing cabins were converted to private residences. Outboard motorboats sliced through the canal, carrying as many water-skiers as fishermen.

By the 1960s, resorts, including Colony Surf and Alderbrook, developed uplands for second homes. Hood Canal's scenery and recreation, fed by a good road system, fueled a change from small beach resorts to large developments of single residences. In the 1990s, water quality again emerged as an issue, with a zone of low dissolved oxygen despoiling the west side of the canal. Fish kills were documented at least in 1926, 1936, and 1963, and many locals associate the low oxygen with weather and tidal flush. Nonetheless, the decline of Hood Canal's abundant and diverse marine life has prompted political action.

With local, state, and federal funding, many water-quality studies measured the deteriorating condition of the canal. While blame falls mostly on septic systems and fertilizer and storm runoff, one University of Washington study determined that much of the canal's nitrogen load is untreated sewage transported in by the tidewater.

The Hood Canal is a jewel of mountain scenery and beautiful water, and it has been loved—first by the Twana, then by the loggers, then the artists and the wealthy, and now by all the rest of us.

But the canal has been loved almost to death. Though Twana names still claim the landscape, the canoes have vanished; even Nobles's Torii gate is gone. Now summer homes have turned into homes for the retired. Hoodsport is a popular diving center; Belfair is a growing bedroom community, still on the old Navy Yard Highway; and Union City—now known simply as Union—rouses, usually, for shrimping and summer.

Now more people want to enjoy Hood Canal's marine diversity and the warm summer sunsets, just as did John McReavy in his mansion above Union City, listening to his daughter Nellies play on the piano the eternal music of Hood Canal.

# One

# UNION CITY

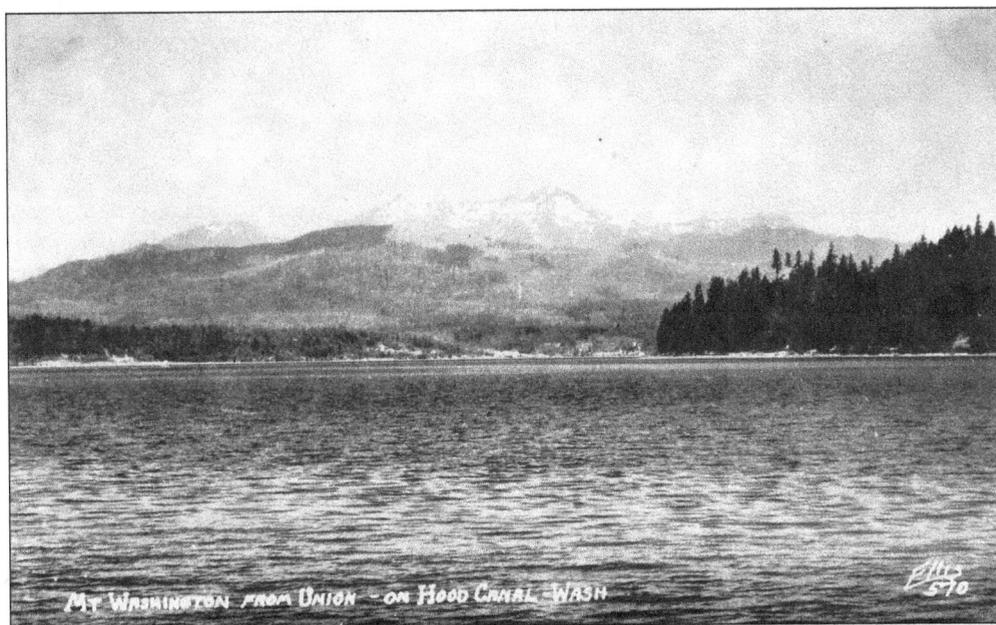

This view of Mount Washington, named after the profiled likeness of the president, shimmers with sunlight and scenery. It was originally named Mount Ellinor in 1857 by surveyor George Davidson, from the decks of the U.S. coast and geodetic survey ship the *R. H. Fauntleroy*, after Ellinor Fauntleroy, the youngest daughter of Lt. Robert H. Fauntleroy, whom Davidson later married. He also named the highest peak Mount Constance and the double-peaked the Brothers after his fiancé's brothers Edward and Arthur. However, because of the peak's resemblance to the president, the name Ellinor was moved down to the peak to the left of Mount Washington. Because of its panoramic view of Puget Sound and Lake Cushman, Mount Ellinor has remained a popular day climb.

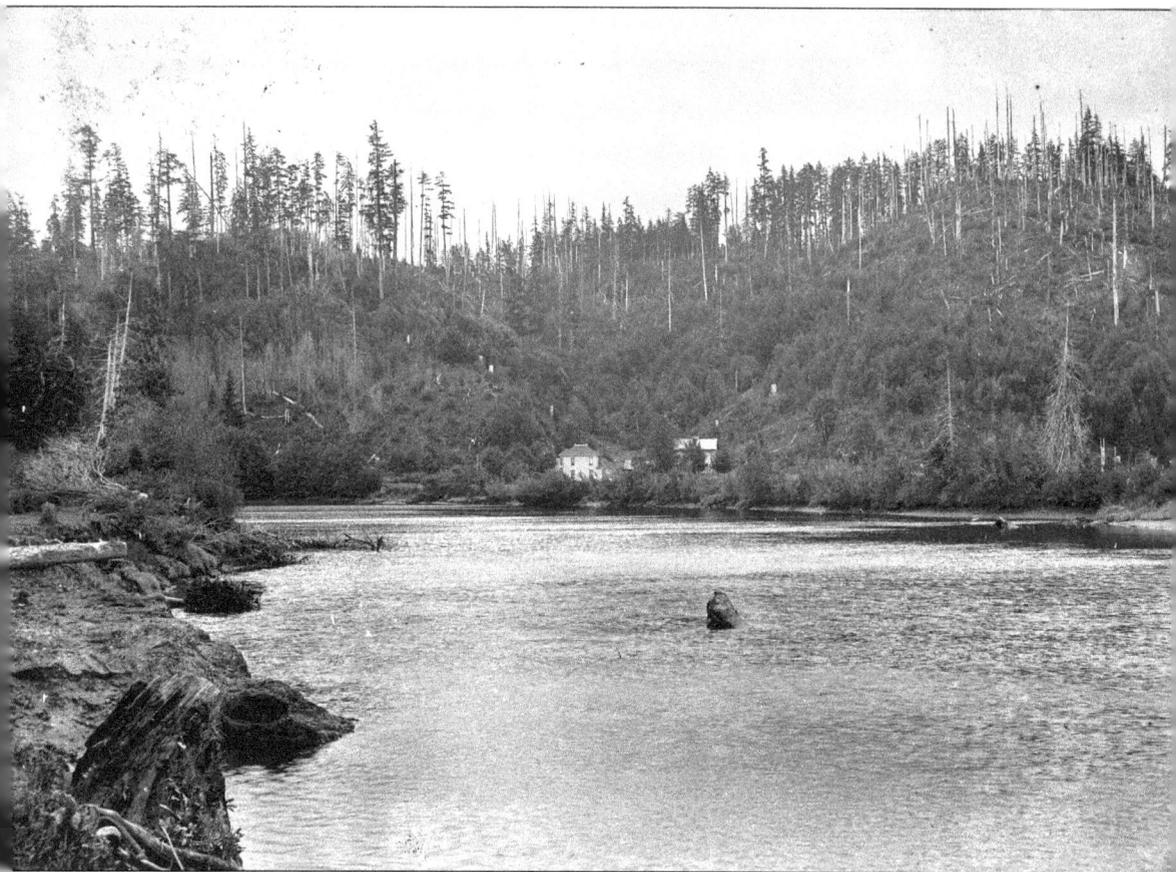

This 1900 photograph, reproduced from a glass plate, shows the Thomas Webb ranch at the mouth of the Skokomish River. Webb arrived on Hood Canal in 1854 with Franklin Purdy. The material for the house was carried up the Skokomish River by the steamer *Clara Brown*. His first year's crop was reported stolen by the Native Americans. Even after the reservation boundaries established in 1860 included his ranch, Webb declined to move his 700-acre home, called Riverside Place. The first road that reached Hood Canal switchbacked down Webb Hill to the Webb ranch. The house was eventually condemned by the state for the Olympic Highway.

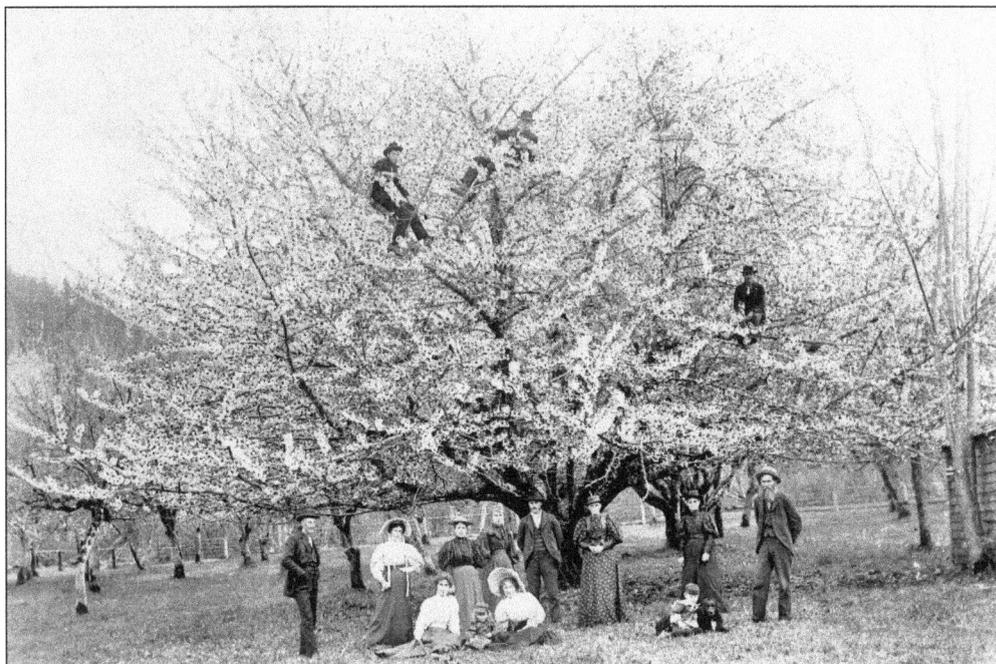

The Webb family spread underneath and even in the branches of the proudly declared "largest cherry tree in the state" in 1900. It spanned 90 feet from tip to tip and was said to have had 25 grown men climbing in it at one time. His farmland, Webb claimed, produced astounding quantities of hay ("three tons to the acre"), potatoes ("825 bushels an acre"), and a 500-tree orchard with fruit rotting on the ground. Hood Canal produces stories of superlatives, as if it is a magic land.

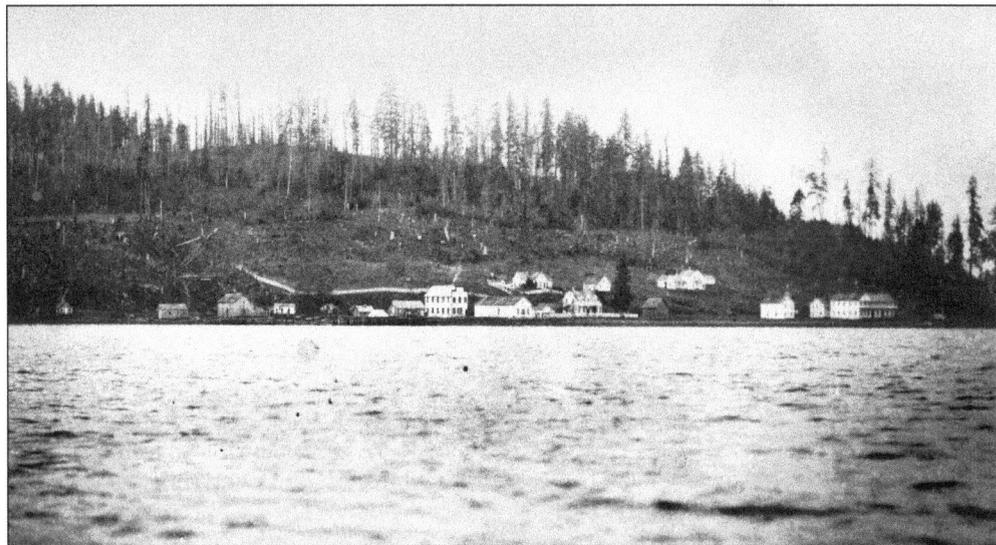

In this c. 1883 photograph of Union City, the village spreads across the waterfront. The post office remained named Skokomish until McReavy's 1889 plat. On the extreme right is the Occidental Hotel, then the Masonic lodge. The Cape Cod–style house at right center was the home Capt. Warren Gove built for his daughter Fanny and her new husband, John McReavy. Commercial buildings, including the Rush house and the store, line the waterfront, though no railroad has yet arrived and no dock has yet been built.

13

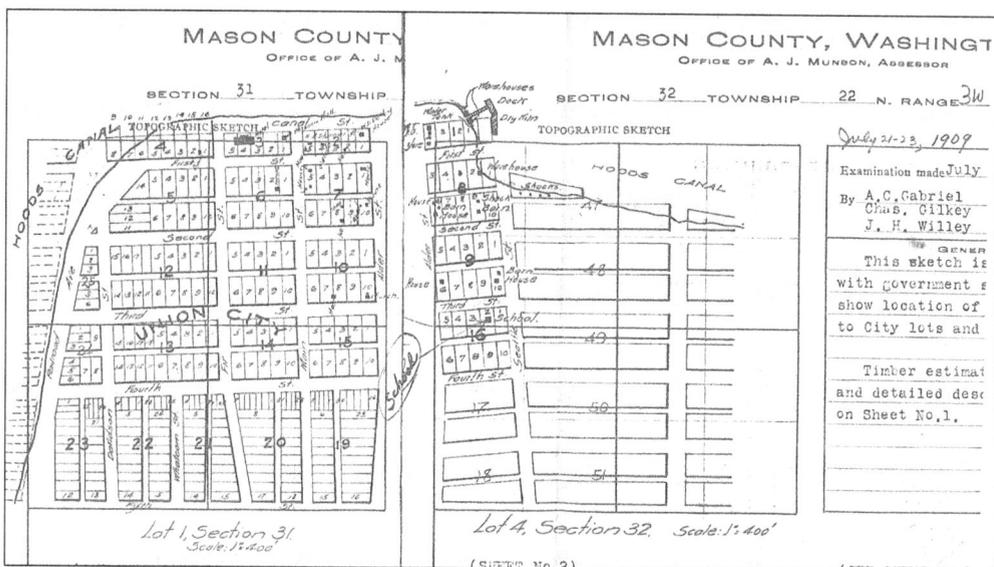

MASON COUNTY, WASHINGT

In 1909, the Mason County assessor mapped Union City. The little burg still maintained improvements for stern-wheelers and the railroads with the water tank, the warehouse, and dry kiln. The Stumer Hotel is in block three, and the McReavy House is on Alder Street just above Union City's downtown, which consisted of a post office and store.

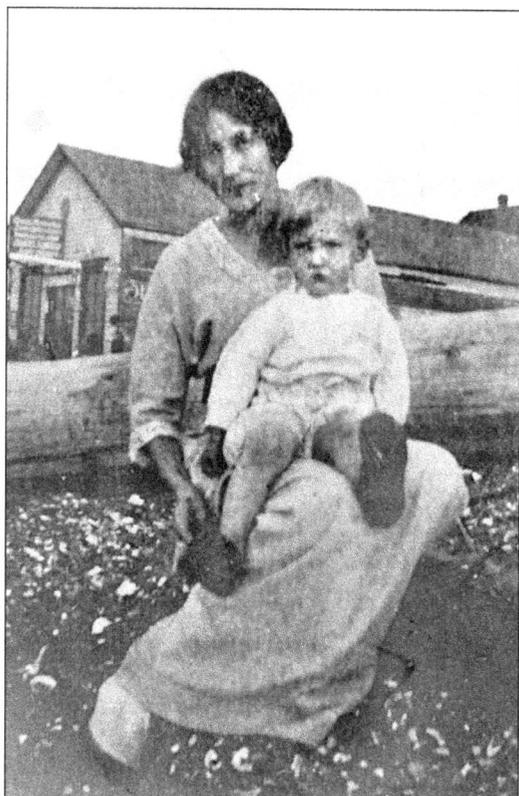

Ethel Dalby and her husband, Ed, lived with her in-laws in the Cape Cod–style home on the Union waterfront, where the McReavys previously lived. Here Ethel holds her son Fritz with the store in the background. The Dalbys arrived on Hood Canal to work on the railroads, and the family has remained on Hood Canal for four generations. Ed Dalby wrote the "Captain Barnacle" column for the *Seattle Post-Intelligencer* during the years the mosquito fleet worked throughout Hood Canal and Puget Sound.

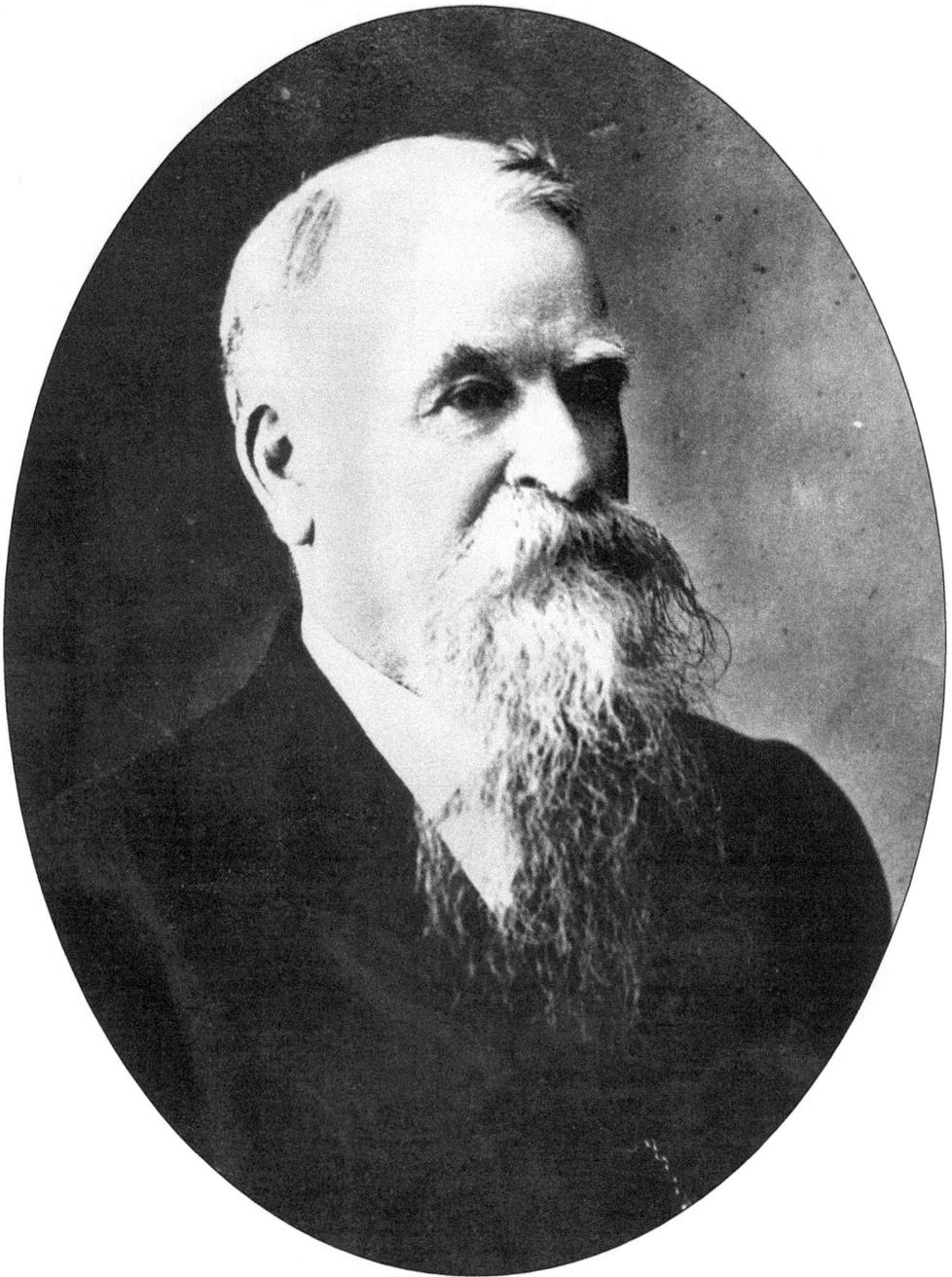

John McReavy (1840–1918), a minister's son, arrived in the Hood Canal logging district by 1861 and promised to pay fellow Mainer and Puget Mill owner Cyrus Walker $7,000 for a bankrupt logging camp near the Union River. By 1870, he controlled much of the southern part of the canal's logging. That same year, he married Fannie Gove, daughter of a Steilacoom tugboat captain, and they had two sons, Ed and Herb, and a daughter, Helen, who wrote *How When and Where On Hood Canal* (1960). The red-bearded Irishman McReavy was also a lifetime Mason. He served in the territorial legislature from 1869 to 1889 and signed the document declaring statehood for Washington. His legislative agenda included education and woman suffrage.

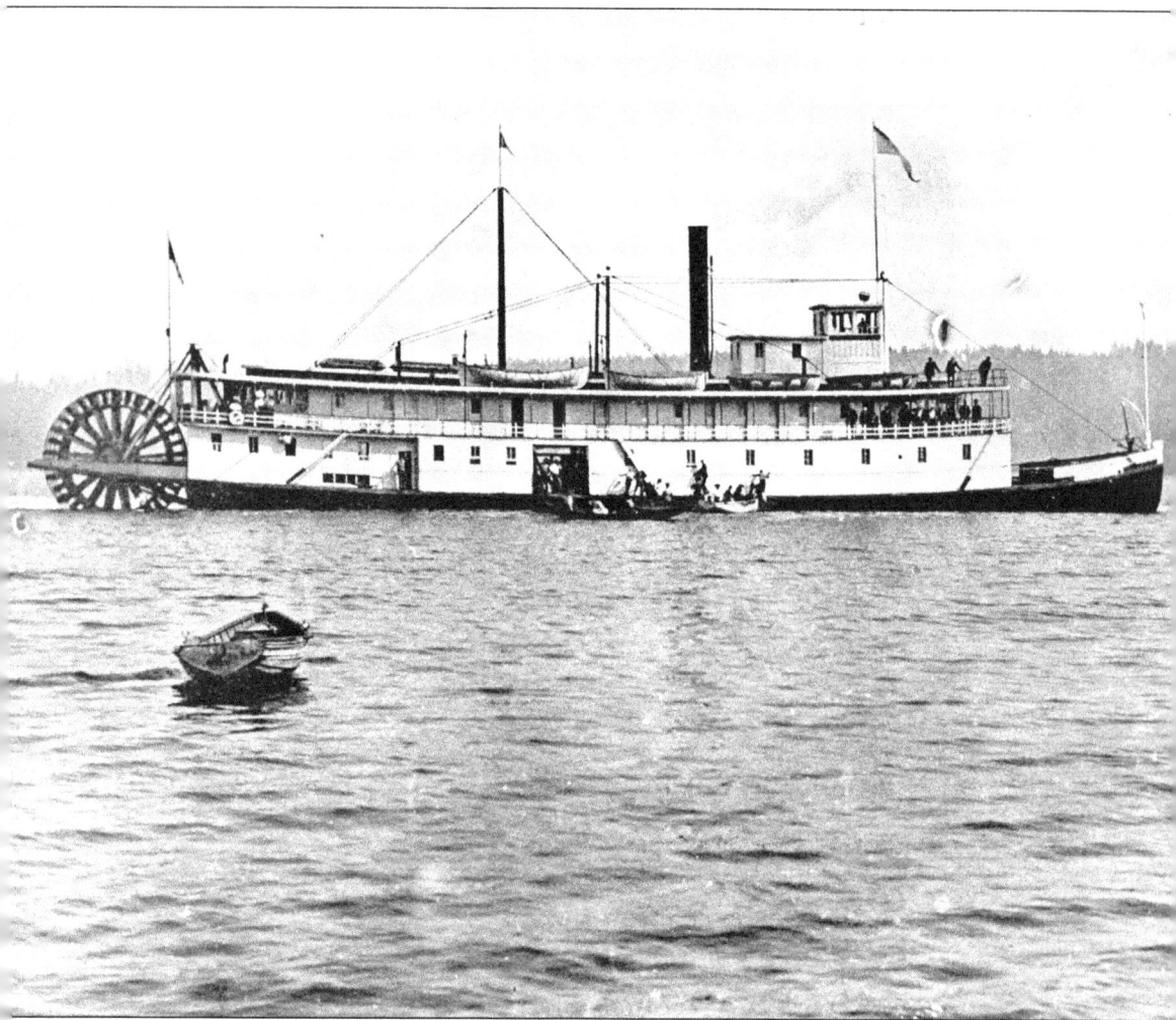

From the 1870s, steamships like the *State of Washington* churned into Hood Canal, connecting its residents with Tacoma and Seattle, part of the mosquito fleet that joined Puget Sound settlements before land transportation. Passage from Tacoma took 13 hours round-trip. Before the dock was built, passengers disembarked into lighter boats, including rowboats, dinghies, and anything else that could float, to reach solid ground.

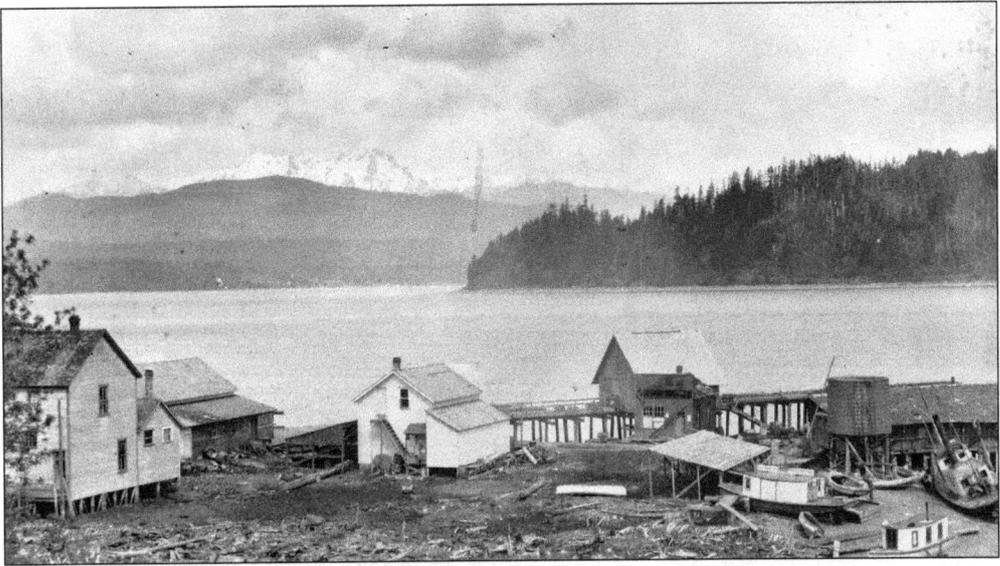

The view from Union City was unparalleled even in 1905. To the right, the Dalby boat works are aground in low tide. In the foreground, the mill debris is scattered on the beach. By 1905, the dream of Union City's being the "Venice of the Pacific" had washed away. In 1890, Olympic Mountains explorer Judge Wickersham and his party had stayed at Union City's hotel and had "found the little burg . . . filled with teams, grader's outfits, tent saloons and all the other paraphernalia of railroad building. . . . Corner lots are for sale, talk of business houses, mills, trade" as the Port Townsend and Southern industriously developed railroad yards.

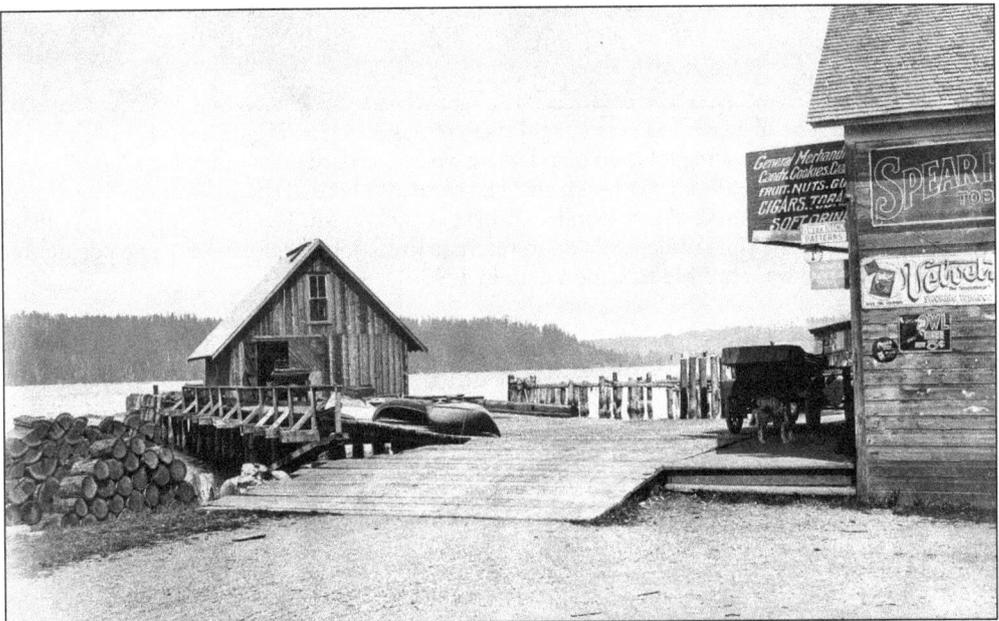

In 1905, the city dock was Union City's only economic development after the collapse of the idea of the railroad hub. Supplies and passengers arrived by steamer, safely stepping onto a solid walkway. The boardwalk and ramp offered dry footing even in high tide and heavy winter rain. The cordwood at the left is boat fuel, and John McReavy's general merchandise store met each boat's passengers. The canoes at center are for rent.

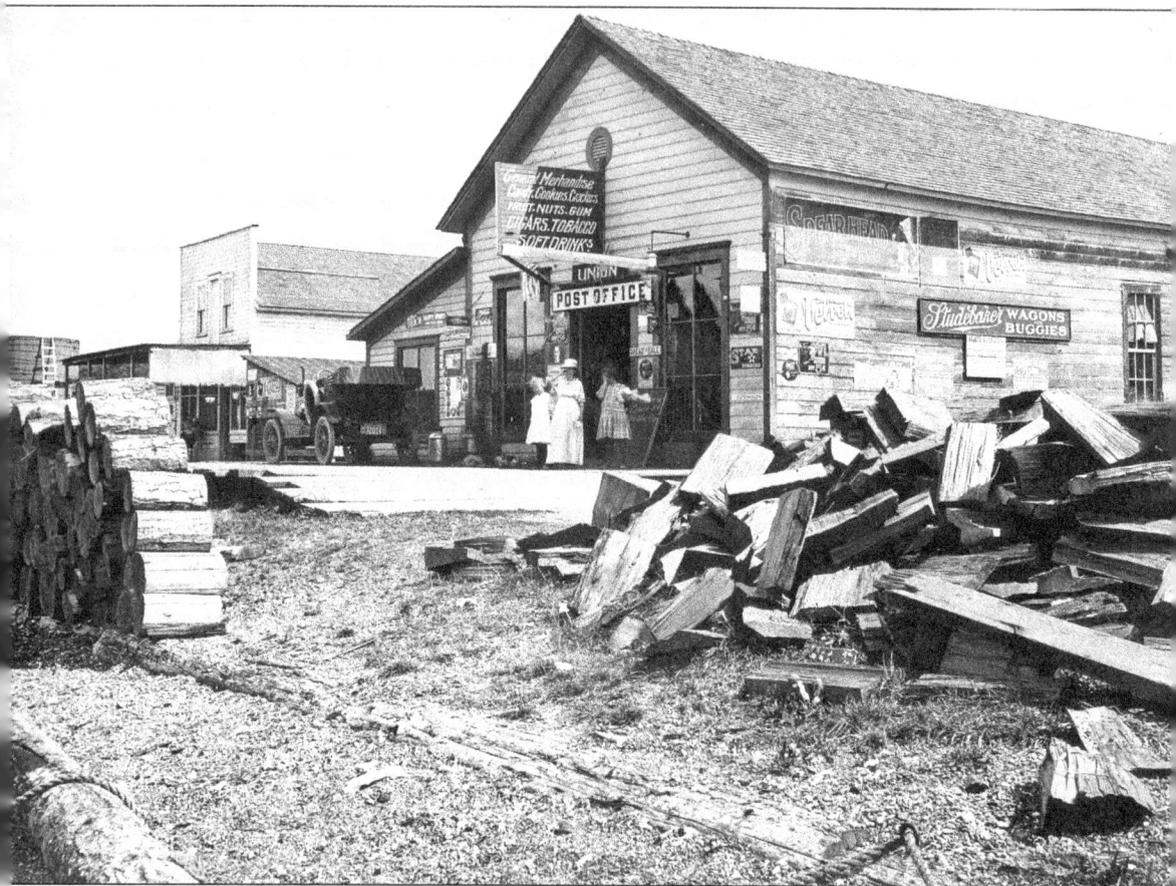

John McReavy's general merchandise store sold every provision a Hood Canal logger could possibly require. Chewing and smoking tobacco brands were well advertised, including Star, Copenhagen, Spear Head, and Velvet, as well as Owl cigars. The store also housed the post office. The Union City post office is the county's oldest, founded in 1858 as Skokomish. The first postmaster, William Purdy, was dead by the time his federal appointment arrived. John McReavy became postmaster in 1873. The name was changed to Union City in 1890.

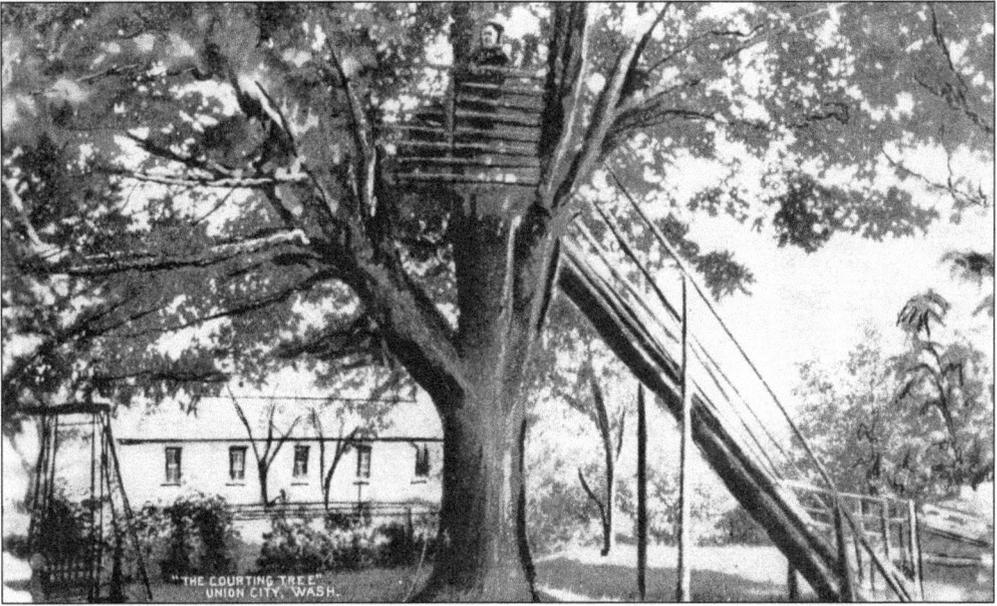

The "Courting Tree" was one of Union City's earliest tourist attractions. The round platform could seat eight or nine people, and many steamship passengers were photographed in the maple tree. It was planted by Emily Purdy in front of the McReavy mansion. A heavy snow broke it down in the 1950s. A walnut tree was planted to replace the Courting Tree.

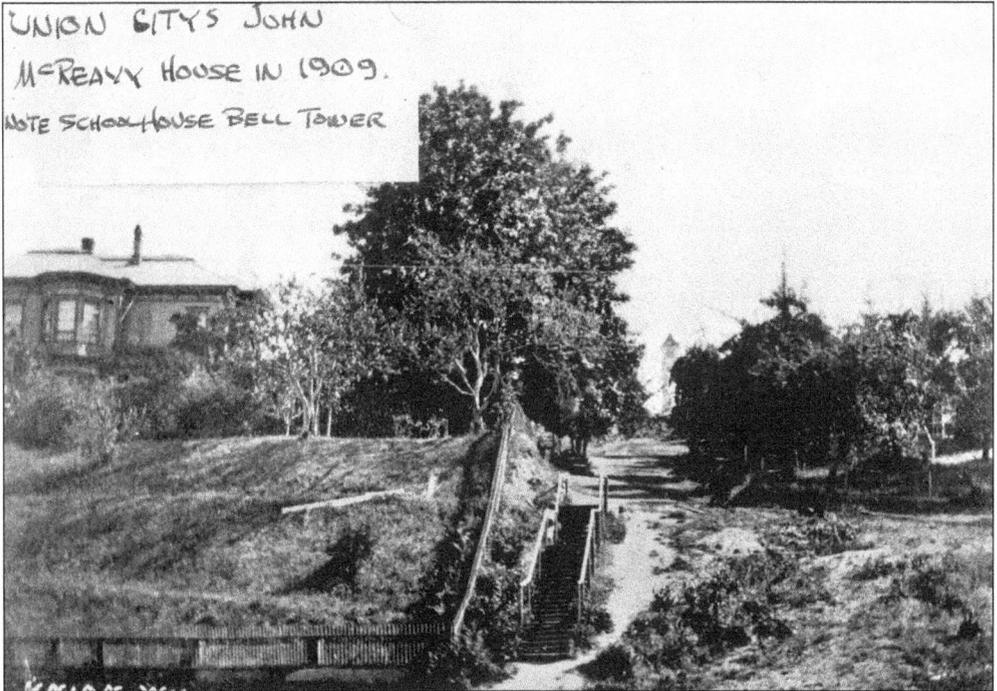

In this 1909 photograph, Union City seems suspended in time after the railroad bust. The McReavy mansion still commands the little village with its long hillside of lawn, though likely only the view remained of those earlier boom days. The schoolhouse bell tower rises above the street, though the school's second floor was used only as storage, for the railroads never arrived.

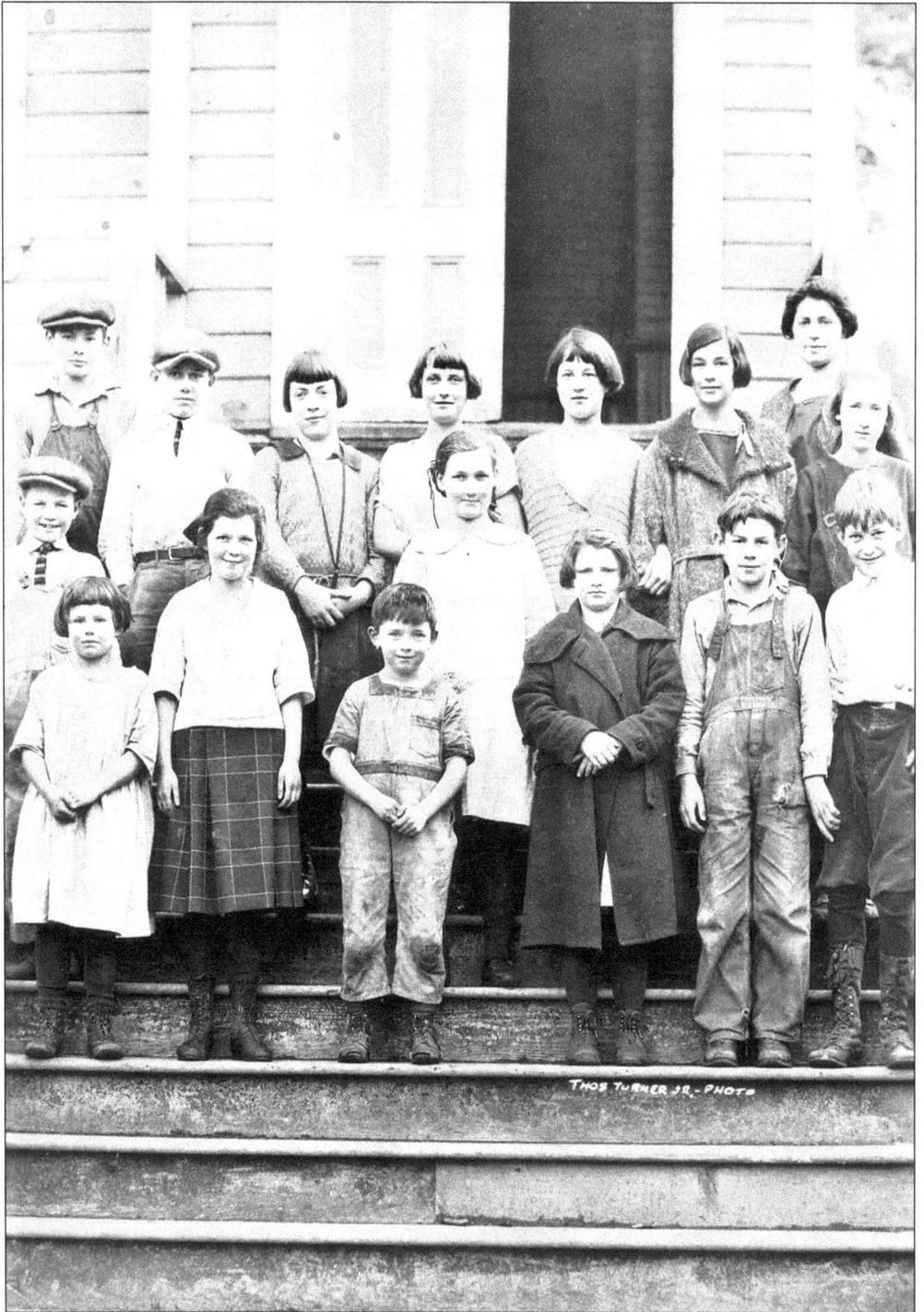

In the 1930s, a class of students poses in front of the Union School just after recess, as apparent from the dirty jeans. Fritz Dalby, on the far right, was the son of Ed Dalby and later emerged as a talented local landscape painter.

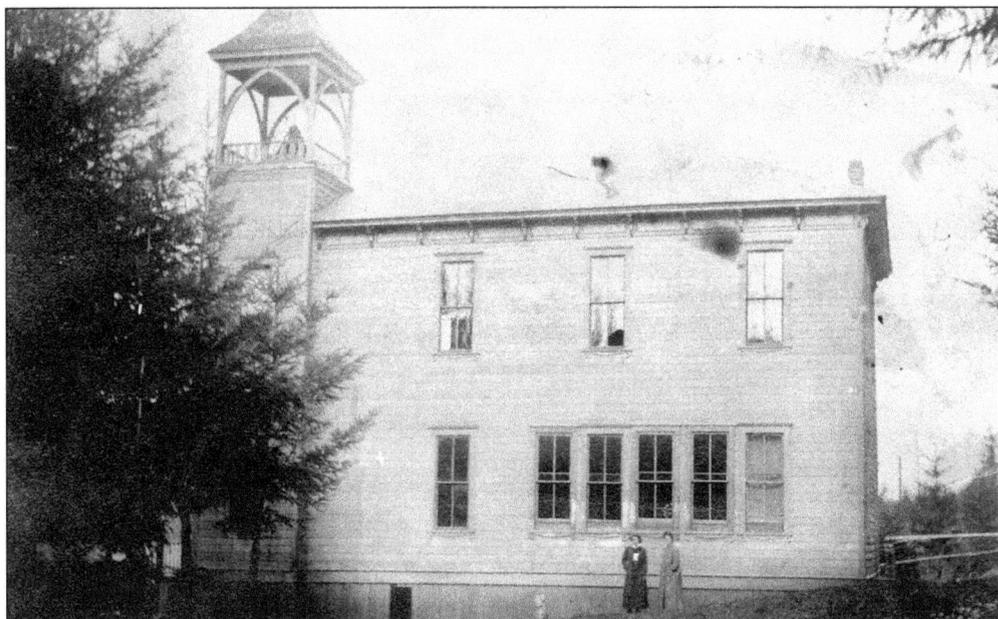

The Union City school was built in 1891 when John McReavy, anticipating a railroad boom, convinced the school board to build a school for 150 students with a $2,039 bond. Unfortunately only one floor was ever used, and in 1899, the school district entered bankruptcy, the only one in the state to do so. It operated intermittently until 1910, when McReavy secured state funding. Teachers included Nellie Dalby, Jean Todd Fredson, and Mildred Stumer. The top floor was eventually removed by Ed Dalby to build his home near Alderbrook.

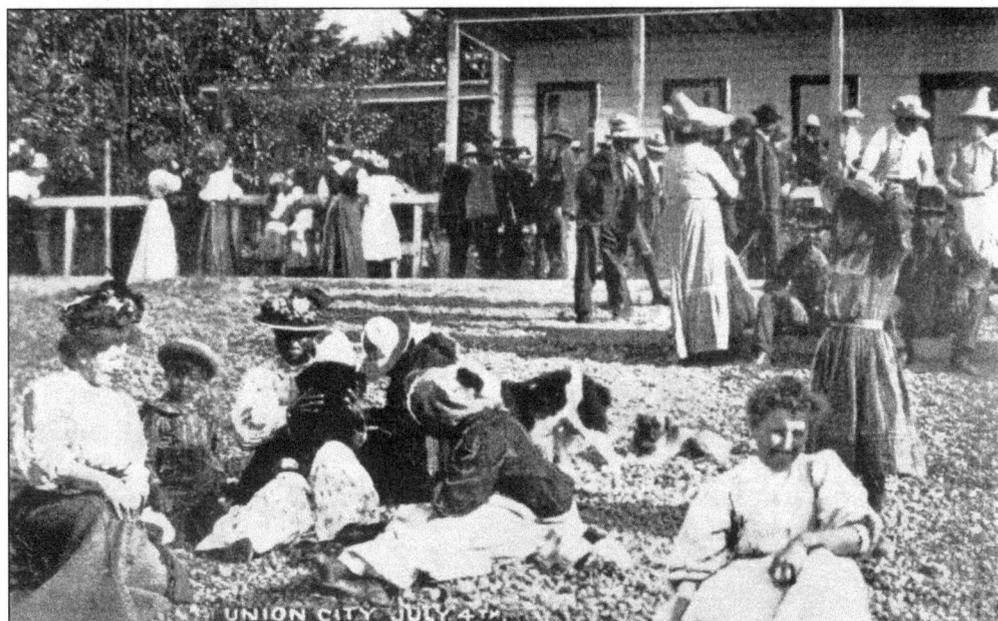

This 1910 Fourth of July celebration on the porch of the Occidental Hotel included whites, blacks, and Native Americans, though during that time "Celestials" (Chinese) seemed less welcome. Both white and black women are dressed in bonnets and are admiring the baby. Several black families lived on the Tahuya peninsula and were part of early Hood Canal society.

21

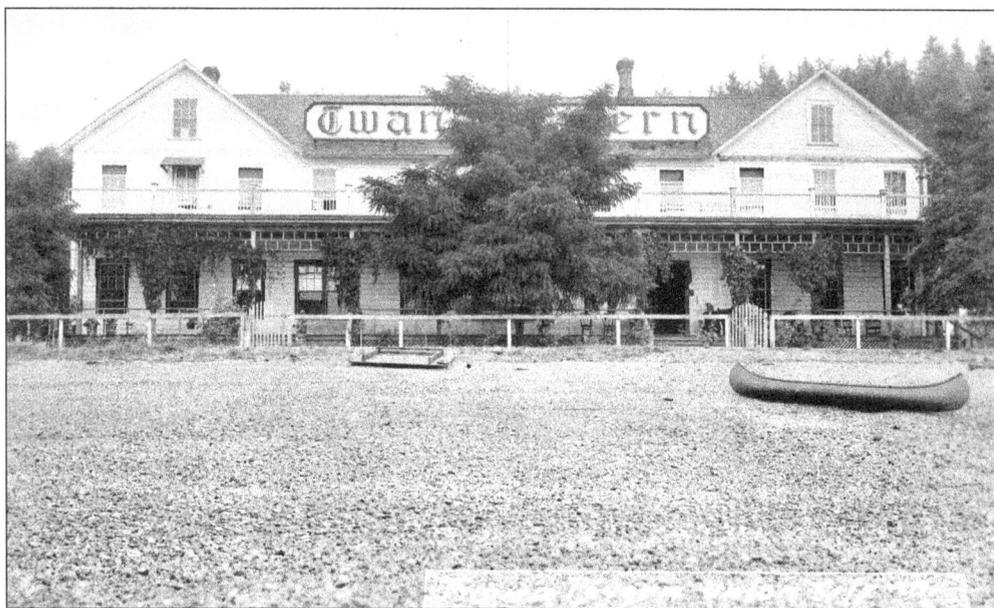

The Twana Tavern was the name in 1912 for the waterfront hotel in Union City. Finished in 1883, it was originally named the Occidental Hotel by owner John McReavy. In 1889, Olympic Mountains explorer Judge James Wickersham declared that "the view of the Olympic Mts. is grand across the waters of the 'Heel' of Hoods Canal" when he provisioned for his explorations. In 1905, new owner Henry Stumer, a Seattle and Alaska laundryman, branded it the Hotel Stumer and advertised it as "the finest summer resort in the State of Washington," with rates at $2 a day.

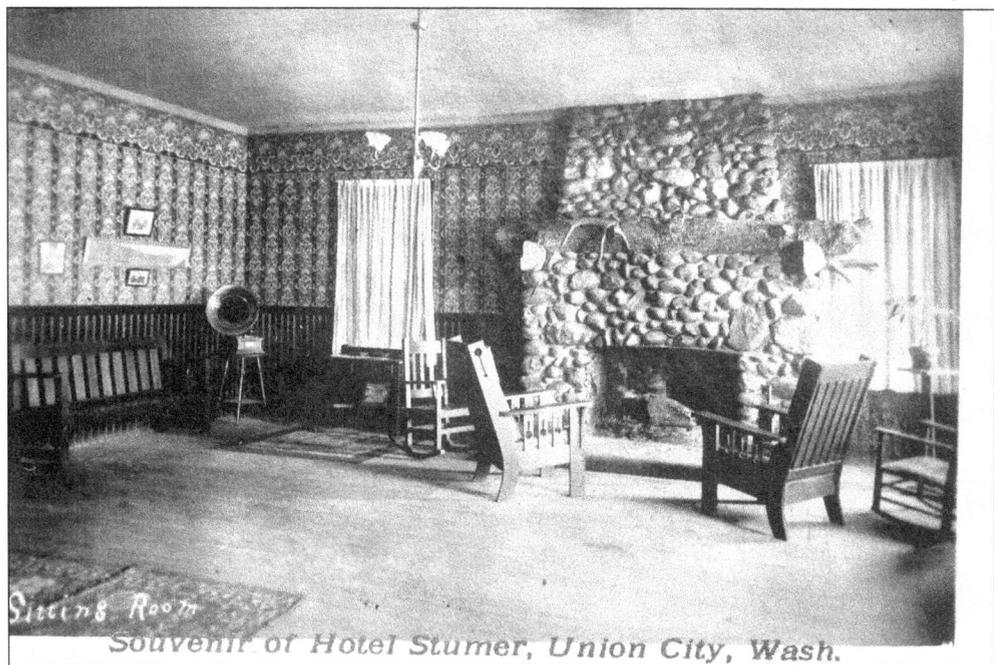

Sitting Room

Souvenir of Hotel Stumer, Union City, Wash.

In 1907, the Hotel Stumer was as nicely appointed as the Antlers at Lake Cushman. Many visitors would boat to Union City, take overnight accommodations, and refresh themselves at one of hotel's two dining rooms—likely in the one for guests and not the one for loggers.

Canoe racing was one event of this patriotic celebration. Native Americans took great pride in their canoes and frequently transported white travelers, such as missionary Myron Eells and Judge Wickersham, around the canal. One time, Native Americans Henry Allen, Pat Slade, and Wesley Whitner paddled their canoe against the steamship *State of Washington* from Potlatch to Union City and won the race.

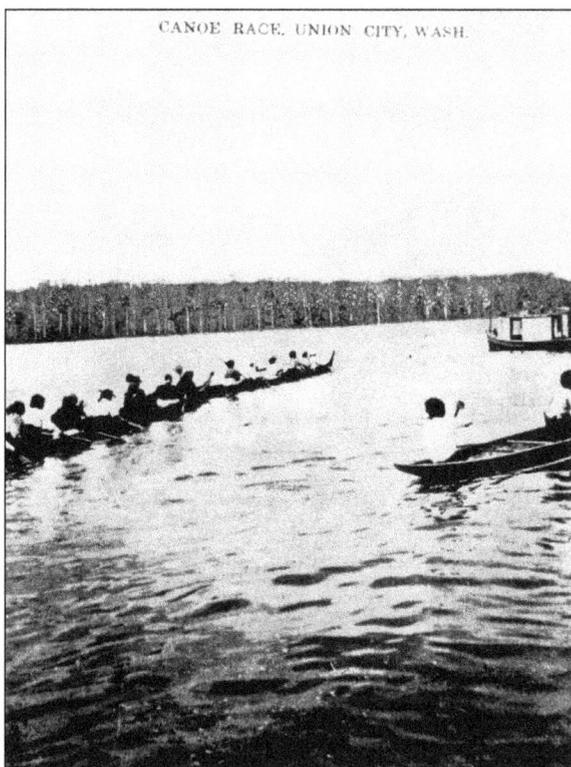

CANOE RACE, UNION CITY, WASH.

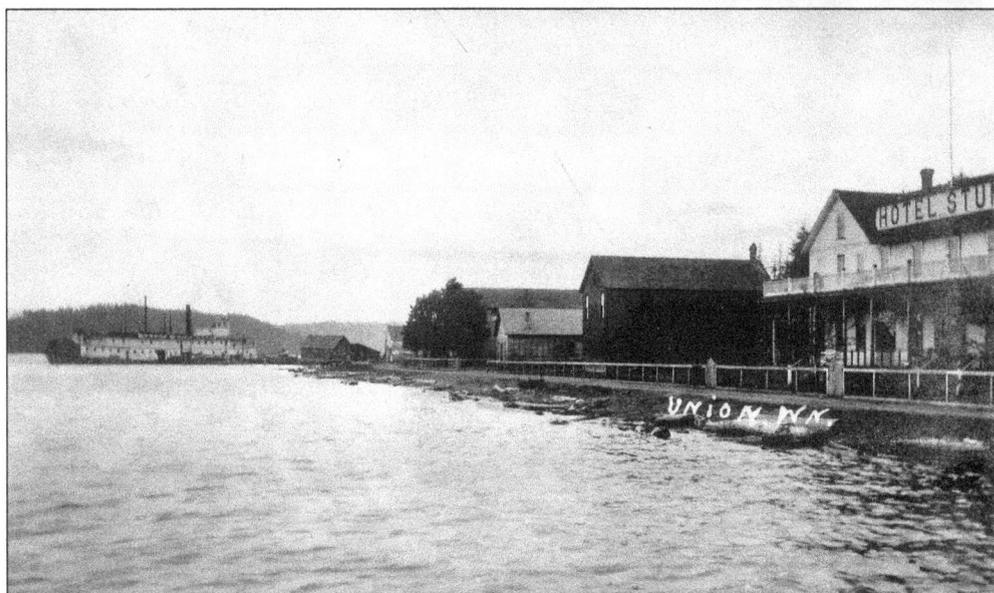

By 1916, the Union City waterfront looked like a sleepy seaside village with no railroad to give it purpose. At the right is the Hotel Stumer, and to the left, the *State of Washington* is docked. In 1913, seventeen-year-old Orre Nobles first visited Hood Canal on the steamer SS *Chippewa* with 675 other sightseers. He purchased postcards of the Webb cherry tree and bought his first Skokomish basket for 25¢. He and his family later developed the lodge Olympus Manor, and from 1924 to 1952, it became the center of the Hood Canal artists' colony.

23

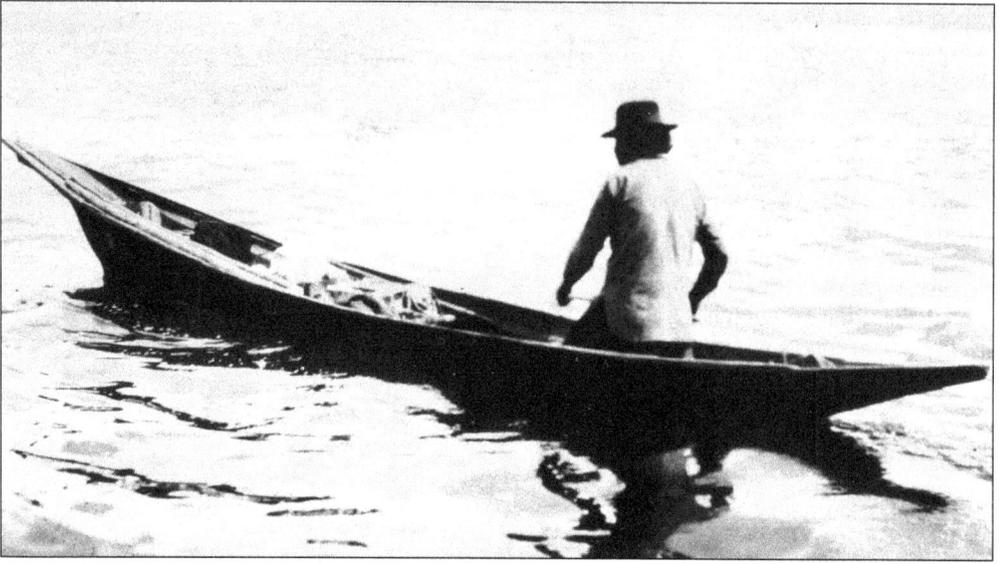

"Squawking George" was familiar to Union City residents. He trolled for salmon, and then he sold his catch to residents. Squawking George was so nicknamed because he called out loudly as he paddled the canal. In January 1920, his body was found off the Tahuya River and his swamped canoe off the boom at Potlatch in the choppy waters of the canal's west shore.

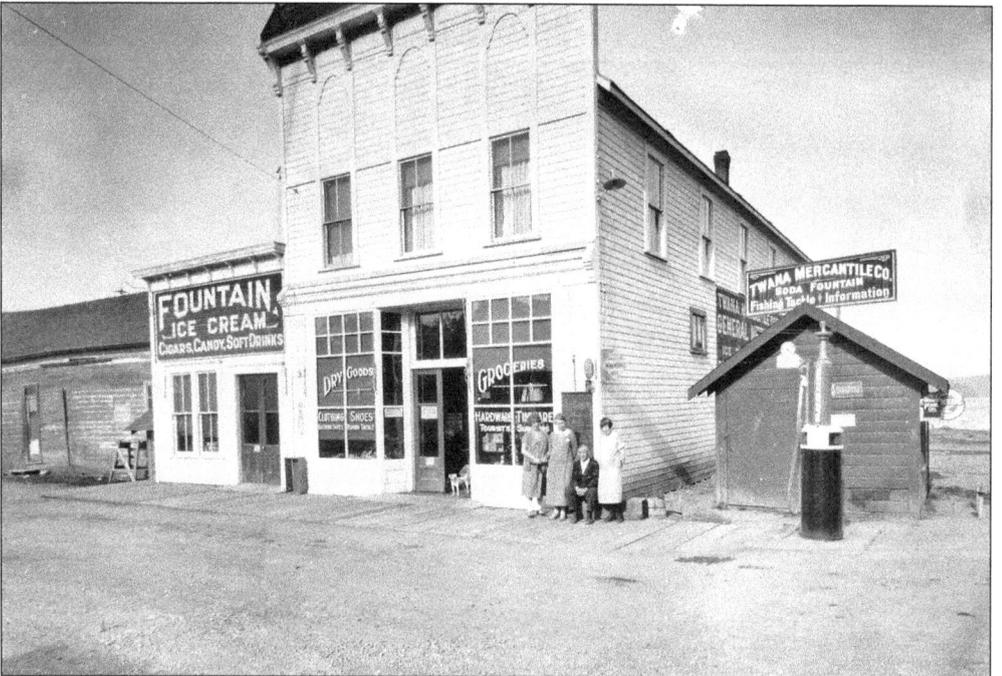

The Twana Mercantile Company store in Union faced west, fronting Alder Street before the highway changed it in 1925, straightening the road by removing the sharp turn toward the water. Owner Guy Garfield (1873–1942), President Garfield's cousin, operated the store with his wife, Hattie Callow Garfield, from 1924 to 1942. During the Depression, for lack of cash, Garfield employed a barter system based on woodblock artist and socialist Waldo Chase's Hood Canal dollars.

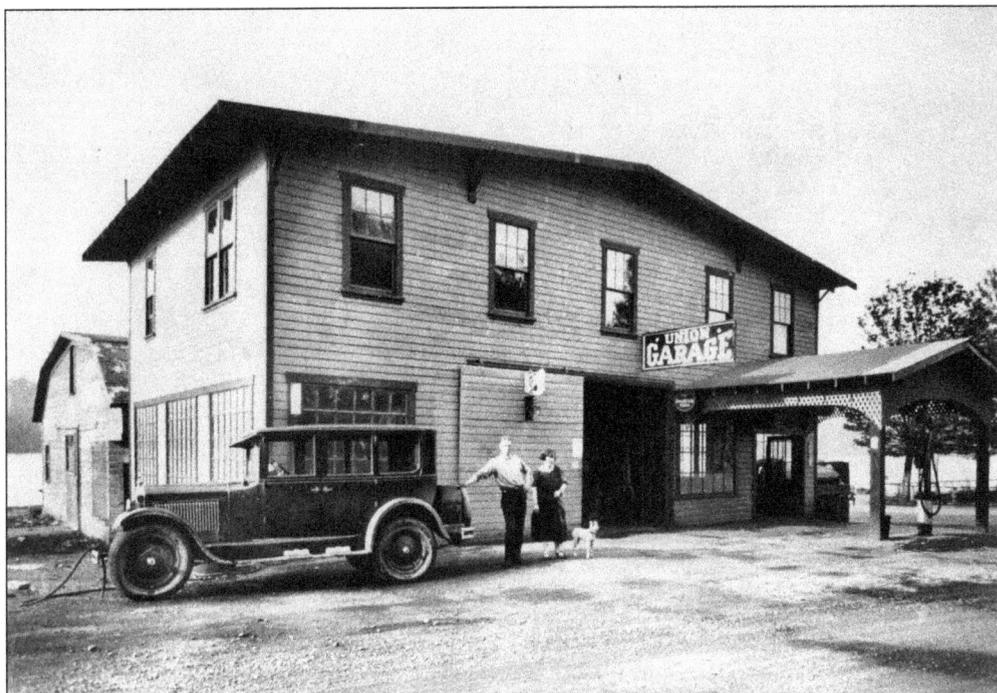

Al and Louise Dickinson built the Union Garage in 1929, after the highway was relocated to its present right-of-way. He moved from Hoodsport, where his brother had a garage, to Union City, where, for a garage, he rented Tom Webb's barn, located directly behind the building. He built his Union Garage from lumber rafted across the canal from Potlatch. Now the building houses an antiques store.

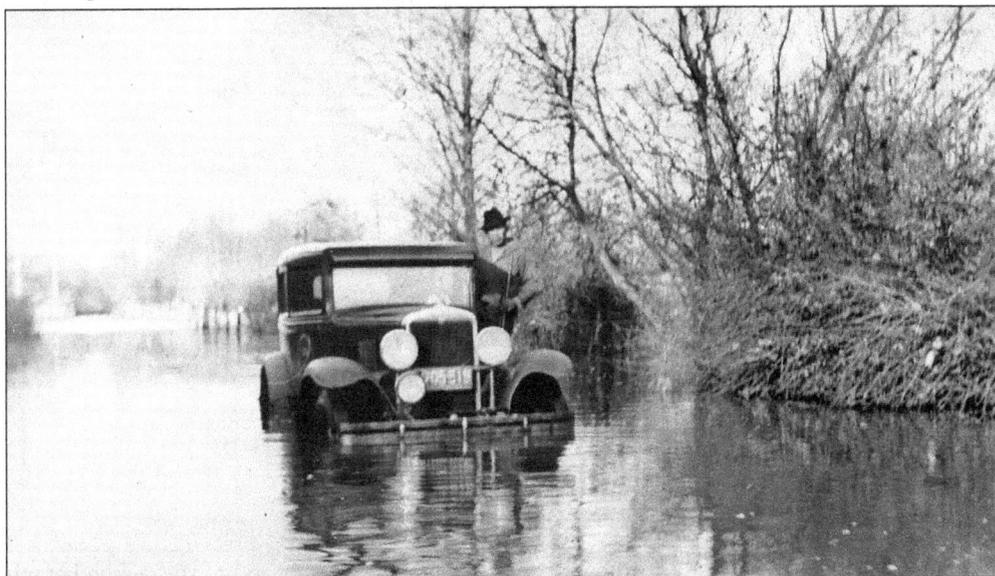

This January 12, 1931, photograph displays the Webb ranch during the nearly annual Skokomish River flooding. The highway, not yet raised, is also underwater. In his book *King of Fish*, David Montgomery posits that as logging denuded the south Olympics and the Cushman Dam closed the North Fork, silt raised the river bottom six feet from 1950 to 1990.

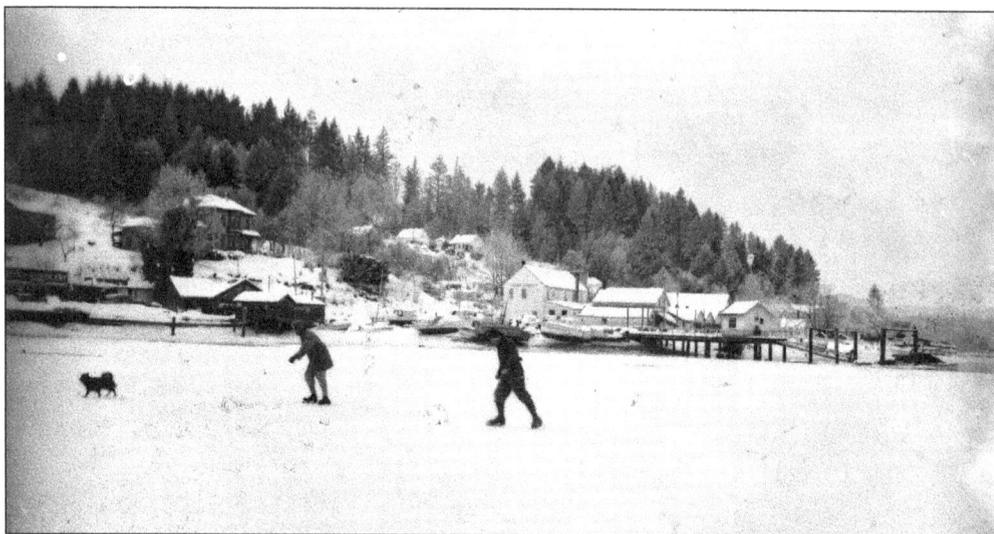

A 1946 Forest Service paper reported that in 1924–1925, the Hood Canal froze from Lilliwaup to Belfair. Stories abounded of Native American Henry Allen driving a wagon across the ice from Hoodsport; of Frank Pixley walking across to Tahuya; of Fritz Dalby ice-skating near Robin Hood; and of Art MacDonald ice-skating off Tahuya. The freshwater from the rivers freezes on top of the saltwater. It also reported that in 1916, Hoodsport received 4 feet of snow, and on January 20, 1943, it snowed 27 inches. Hood Canal also froze in 1950. Here the Dalby brothers and their dog walk on frozen canal waters at Union.

Union, on July 4, 1948, was bustling with speedboats in the water and at the public launch (extreme right). John McReavy's mansion is at upper right center, and the school grounds, with the Quonset huts, are in the upper left. After the 1952 school consolidation, Union students began attending the Hood Canal School on the Skokomish Reservation. Currently the Union Fire Hall occupies the old school site.

# Two

# HOODSPORT, LAKE CUSHMAN, AND POTLATCH

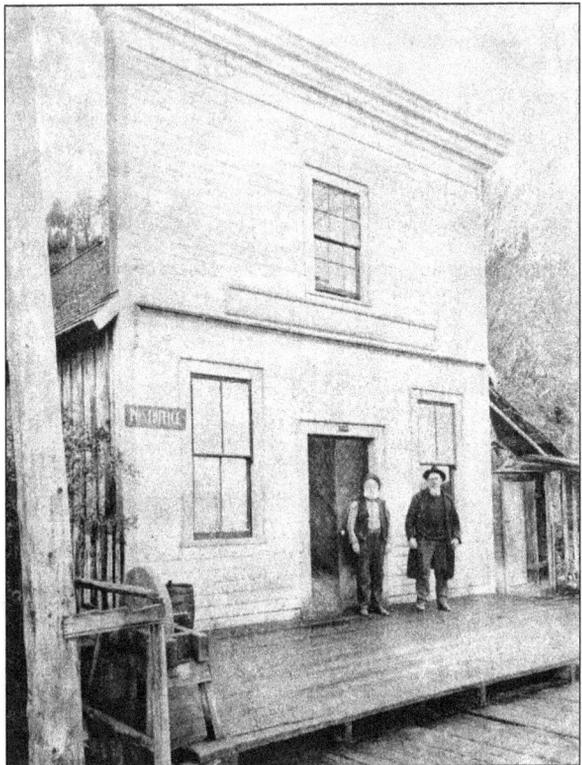

Capt. George Robbins (left), with postmaster Henry Jackson, poses in front of his Hoodsport store and post office about 1890, during the Hoodsport railroad and mining boom. In 1872, Robbins, with his wife and nine-month-old daughter Ida, arrived from Maine to sail lumber schooners from Port Gamble to California and South America. In 1880, the family settled on Finch Creek, named after Vincent Finch, Robbins's son-in-law. Postmaster Jackson originally settled on the Skokomish River, moved to Clifton after the treaty resettlement, and finally moved to Hoodsport with his daughter to work as postmaster, though Jackson couldn't read. The Twana called the slave-trading post and winter village *Sla-atl-atl-tol-hu*, "land of the disk game."

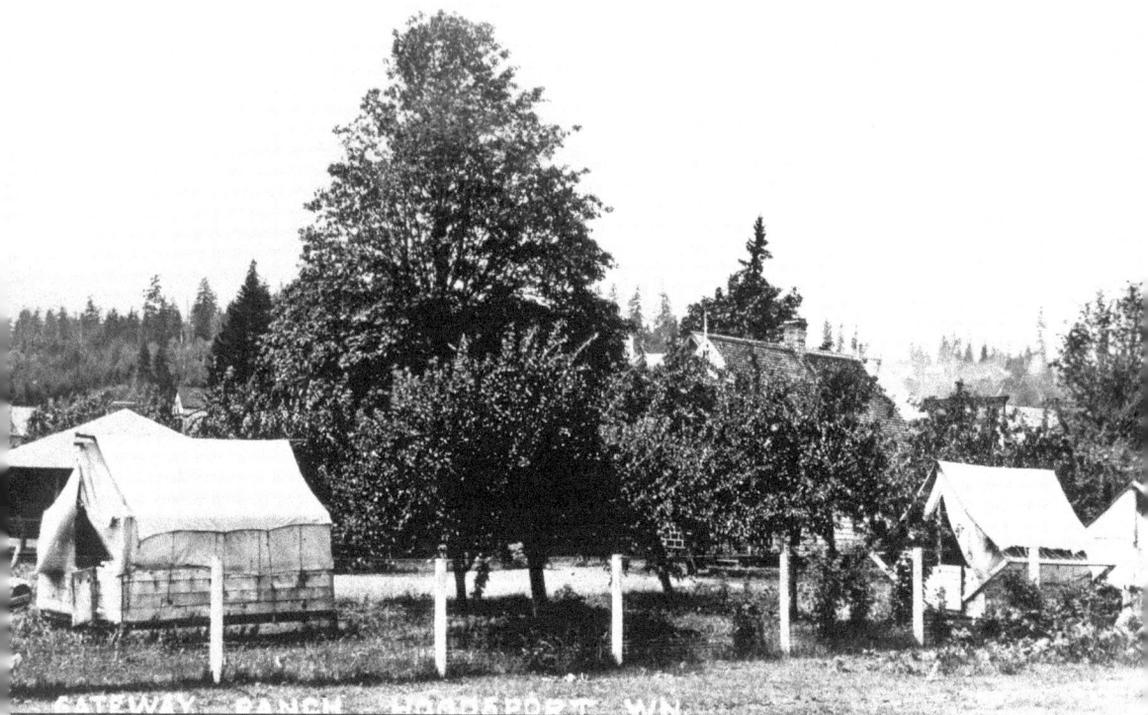

By 1909, Mary Jane Dickinson owned the Finch house and, with the demise of the Hoodsport Hotel, her Gateway Ranch offered tent cabins and horseback rides to Lake Cushman. Sightseers, hunters, hikers, and fishermen would ride Oscar Ahl's ferry to the luxurious and elite Antlers Hotel or the Cushman House. In the summer of 1913, the Cushman House registered 790 guests.

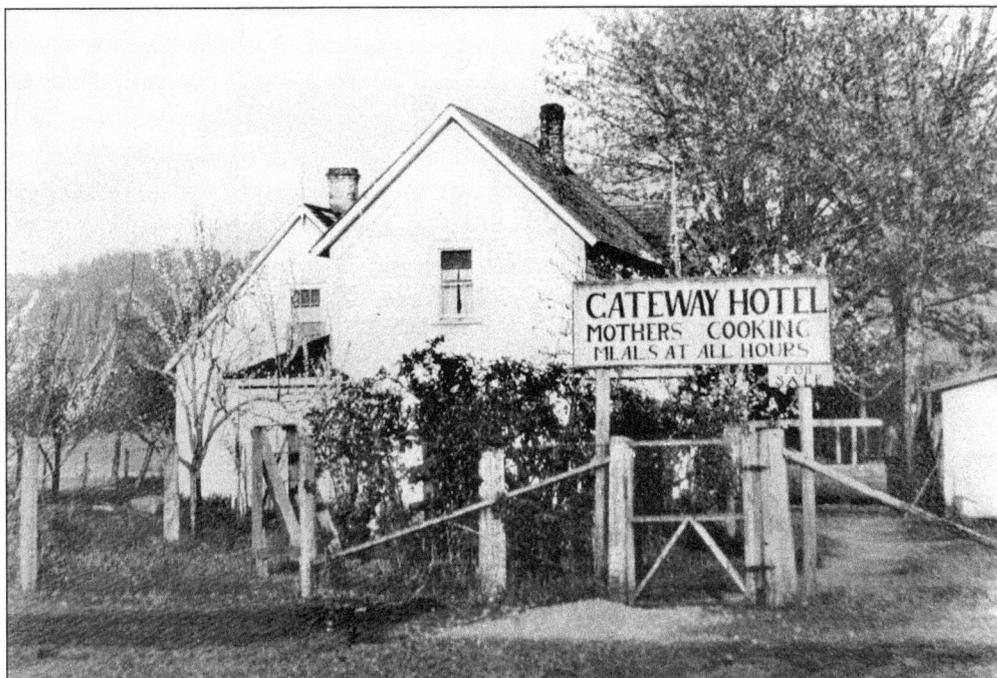

In 1916, the ranch became the Gateway Hotel, "The Gateway to the Olympics." Guests would be transported to Lake Cushman. Although Mary Jane sold the Gateway Inn in 1920, the Dickinson family promoted hunting and fishing in the Olympic Mountains until 1937, when the Olympic National Park was approved. By 1953, the State of Washington had purchased the property and had built a salmon fish hatchery, a favorite fishing spot during king and chum runs.

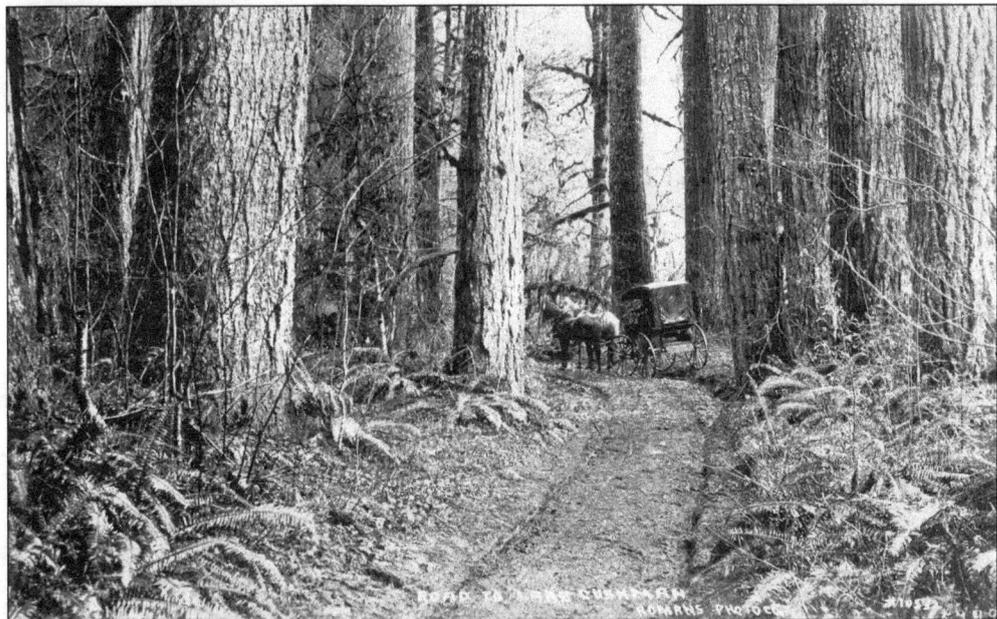

The Lake Cushman watershed grew some of the world's finest trees. Early travelers to Cushman braved the trees and sword ferns and muddy, meandering road. The dense forest ride must have awed Eastern visitors with its arboreal magnificence as well as wearied their fancy-pants bottoms.

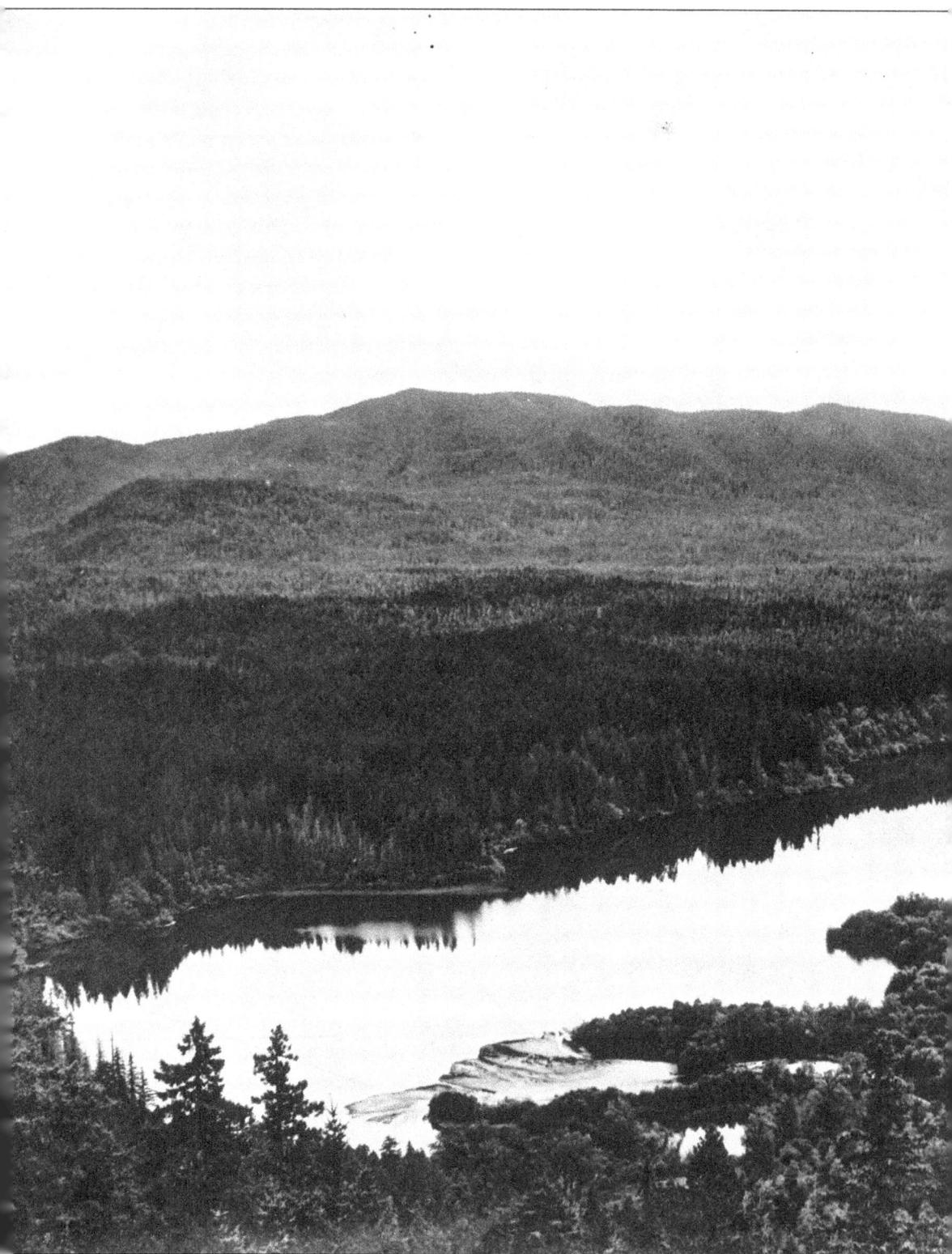

The original Lake Cushman was 4,000 acres of fishing, so excellent that dandies from New York society would railroad across the continent, ferry to Hood Canal, and then jostle by horse and buggy through the wilderness for the fly-fishing pleasure. The cleared farm on the right is W. T. Putnam's ranch.

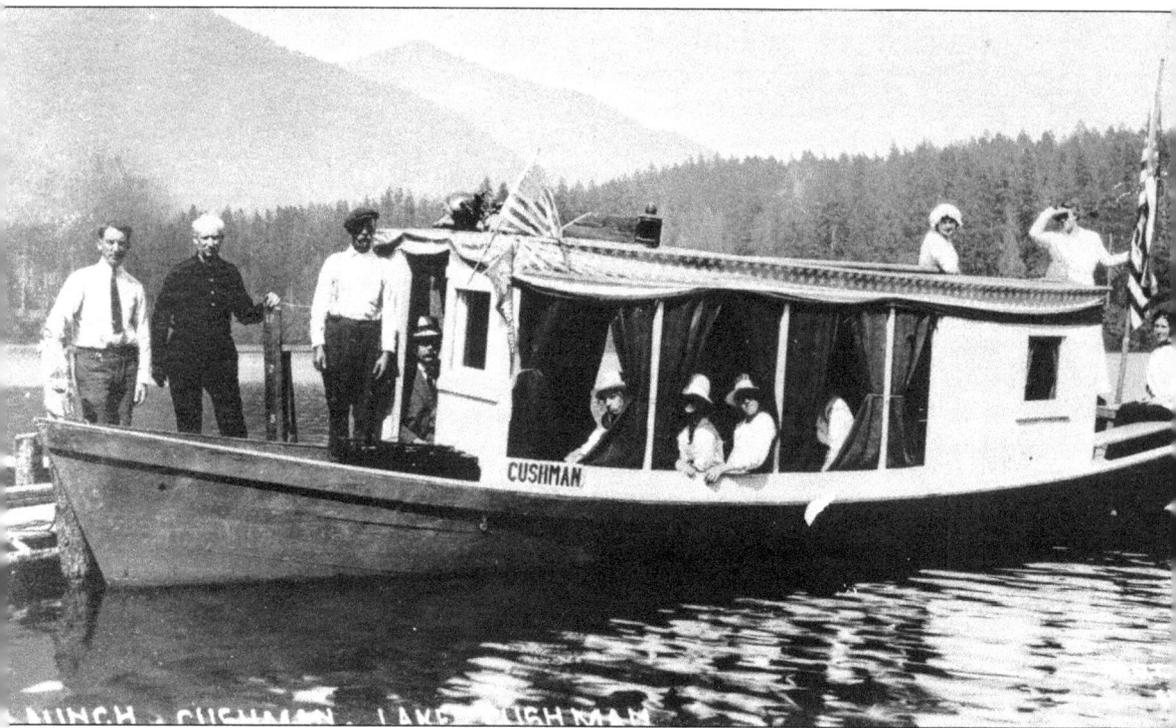

Oscar Ahl transported visitors across the lake with his launch, *Cushman*, to the Antlers or the Cushman House. Captain Ahl is standing by the door, and Pres. Teddy Roosevelt is just inside the door. In 1903, President Roosevelt visited Lake Cushman to inspect the wilderness park first proposed by Lt. Joseph O'Neil and Judge Wickersham. His visit prompted the bully president to exude, "There may be some place in the world equal to Puget Sound, but I don't know where it is." In 1909, he set aside 450,000 acres for a national monument inside the forest reserve.

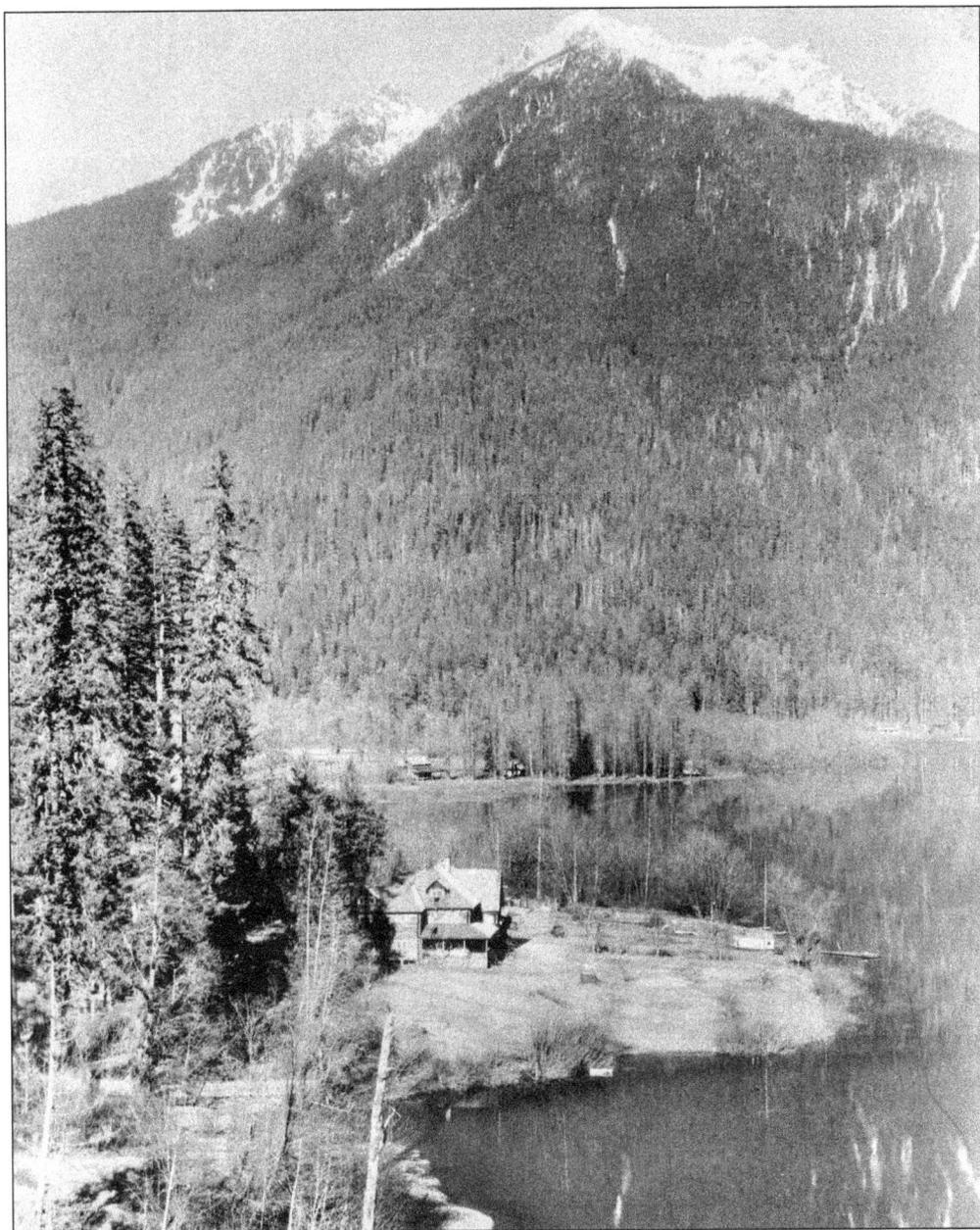

On June 15, 1899, another Lake Cushman resort, the exclusive Antlers Hotel, charging $2.50 a day, was opened by Russell Homan, son of the Erie Railroad magnate, and Stanley Hopper, heir of the Singer Sewing Machine company—two rich, confirmed bachelors from the East with a taste for hunting, fishing, and whiskey. Many of New York society's "List of 400" visited the Antlers. The Antlers, perched on Lake Cushman beneath majestic Mount Ellinor, inspired poet Robert W. Service to pen his poem "The Mountain and the Lake." The hotel was destroyed in 1926 as the lake rose behind Tacoma's Cushman Dam.

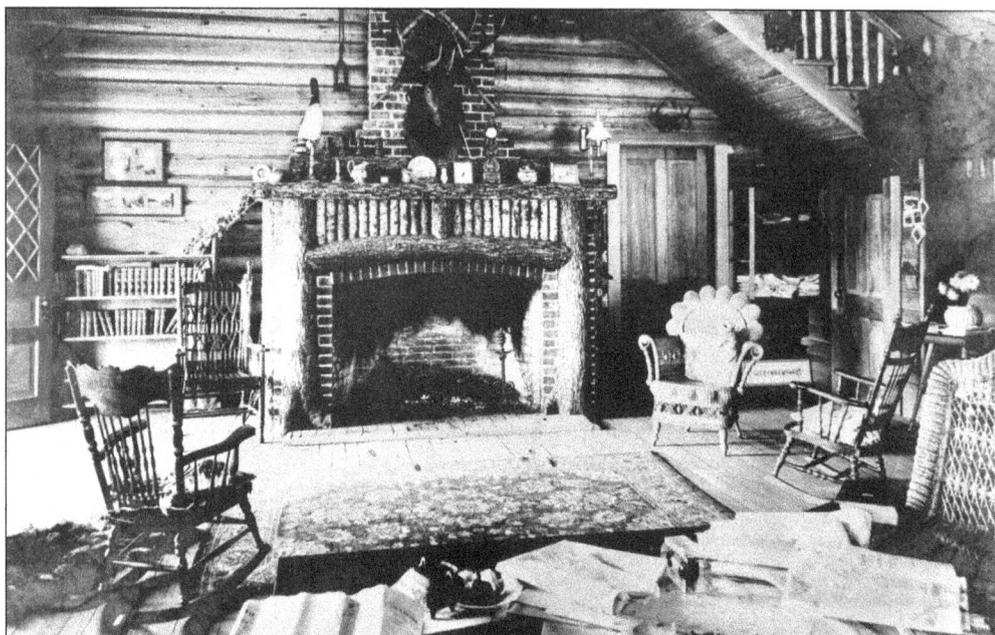

The Antlers was a hunting lodge, and the surrounding Olympic foothills were home to bear, deer, cougar, and elk. The lodge's three large rustic log buildings cost a princely $10,000 to build, and each room was decorated with a rack of deer antlers. After a day of hunting, the dandies could relax with a drink in the bar or pool room and then enjoy the electricity that lighted the dining room. At dinner, Russell Homan played his Eolion organ, and diners were required to wear formal attire. The Antlers resort foreshadowed the summer resorts of the 1930s on Hood Canal.

This 1906 photograph of the Cushman cottages at Lake Cushman is as blurry as its reputation. Founded as a tent resort in 1890 by three men from the East—William Putnam, Elton Ainsworth, and William Lake—it catered to fishermen and hunters. Judge Wickersham likened the habitation to a "gin mill," saying that "the poor accommodations and extortionate rates . . . robbed everybody . . . charging (Olympic Exploring Expedition) Lieutenant O'Neil 75 cents a meal for his men." Both Wickersham and O'Neil later lobbied for a national park, with O'Neil proposing Elk National Park.

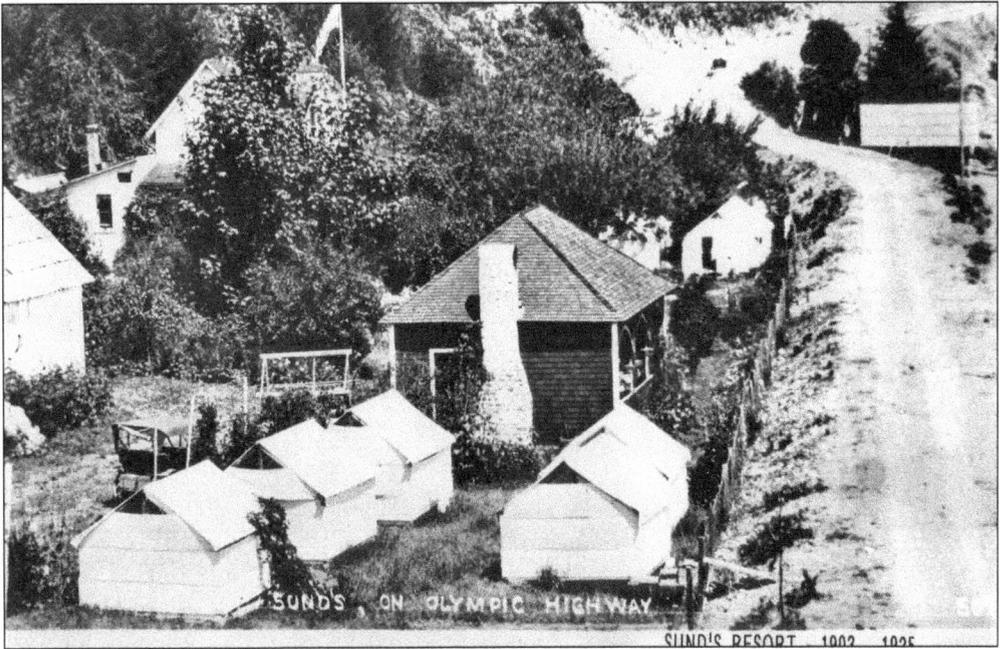

In 1903, John Sund founded Sund's Villa Resort in a small cove north of Hoodsport, where the Native Americans had a summer campsite at the creek. Captain Sund had hauled logs by tugboat from Hood Canal to San Francisco, but he brought his new bride to Hood Canal and built the tent cabins, continuing to haul logs. His dance pavilion is the building in the center with the chimney. In nearby canal waters, Sund Rock is a landmark for divers.

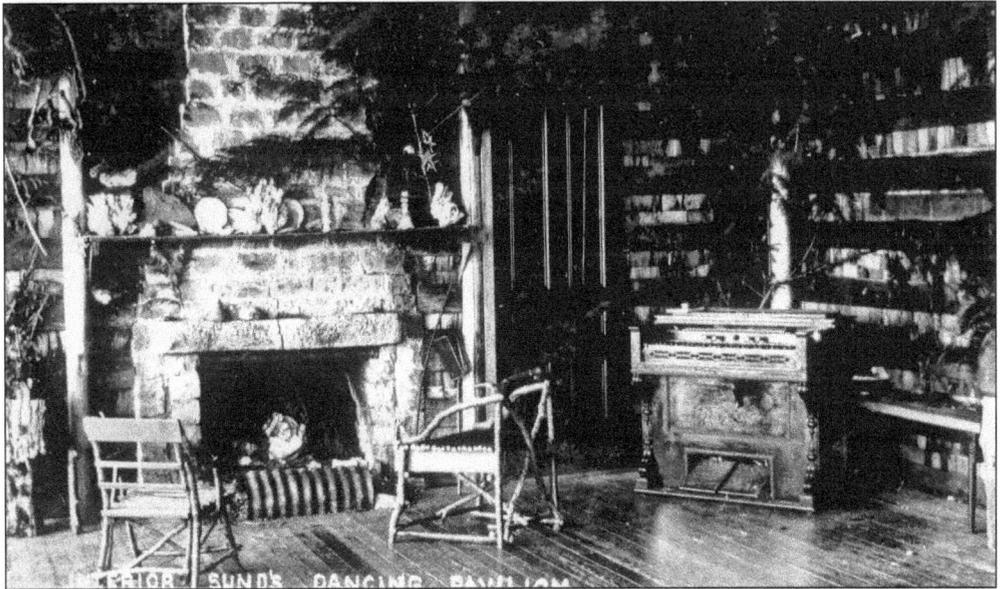

John Sund's dance pavilion proved popular with Hoodsport dancers as well as with resort guests. Sund's Landing could accommodate as many as 70 guests. It closed in 1925. In 1931, Sund visited Norway, the country he had left to homestead on the canal in 1890. In 1935, at age 73, he was killed when a car struck him as he was crossing the Olympic Highway. Several private residences, both permanent and summer, now occupy the site of his home.

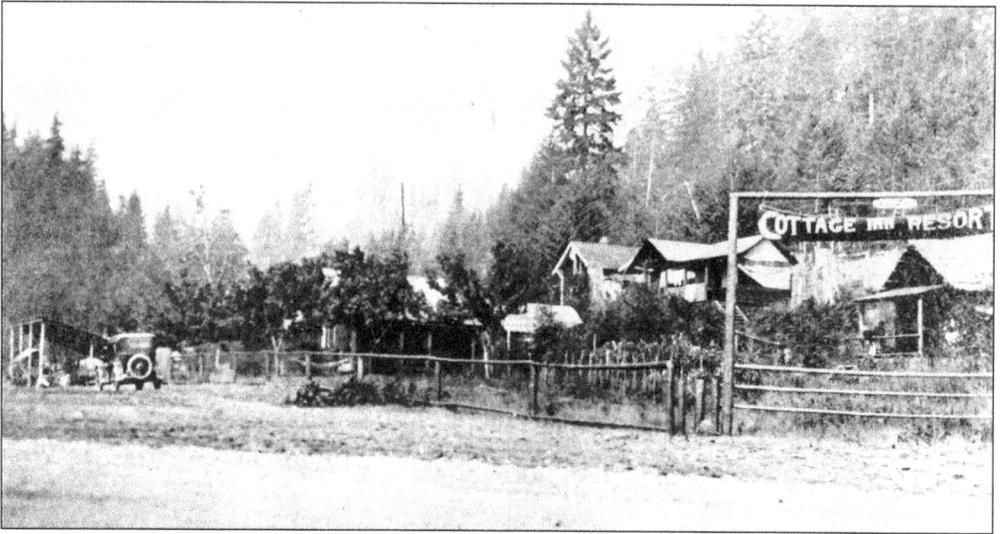

Another early resort was Robinson's Resort at Lilliwaup. This 1917 photograph shows the accommodations available for tourists visiting the storied Lilliwaup Falls, which had been featured in Northern Pacific Railroad's magazine, *West Shore*. The Skokomish name was *slel-a-wap*, meaning "inlet." Plank houses were built for the seasonal summer and fall fishing seasons.

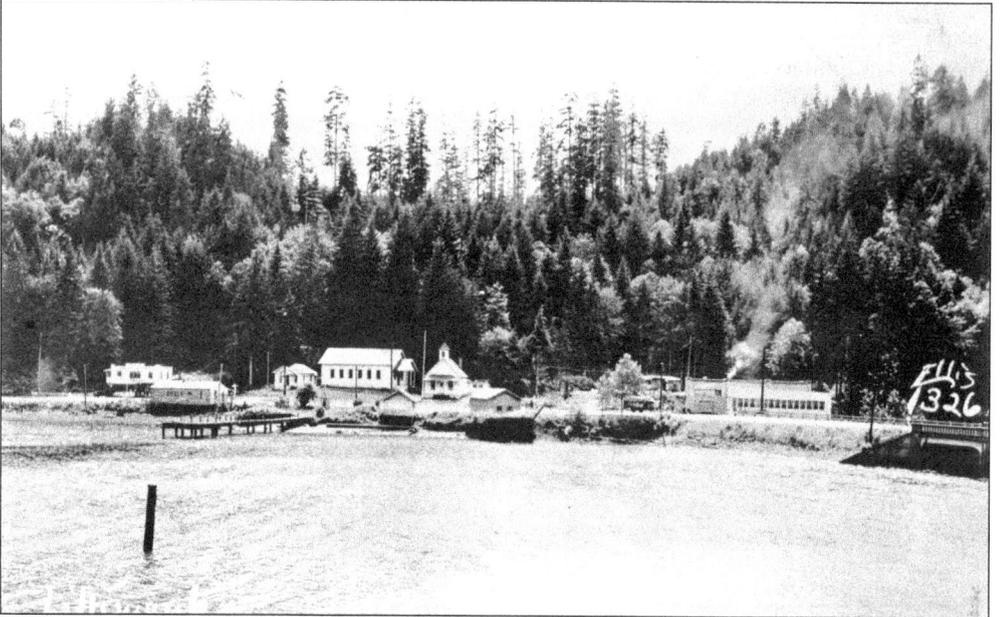

By 1927, Lilliwaup had a grocery (right), a school (center, facing with bell tower), and gym/community hall (center, facing school on left), with an oyster-opening shack or two on the waterfront. The growing community's principal employer was the Phoenix Logging Company. On the right down the river, the company built houses for their supervisors and families. Each morning, the supervisors would walk up the hill to go to work. However, true Lilliwaupians of the 1920s knew that a proposed summer colony for movie stars—to include Mary Pickford, Douglas Fairbanks, and Charlie Chaplin—had bought eight acres and Lilliwaup Falls, but it failed to materialize. In 1890, Lilliwaupians also had believed in the impending construction of the Port Townsend and Southern line, together with a Grand Hotel, wharf, and railroad station.

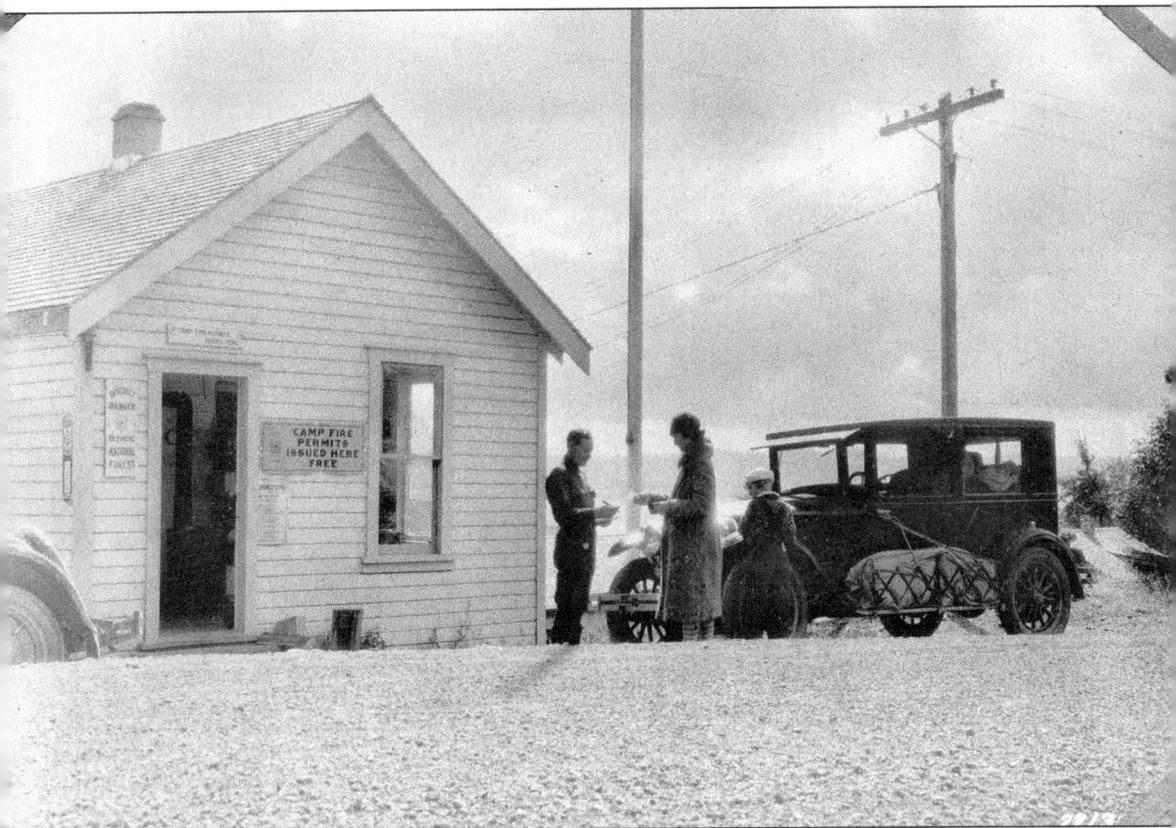

Even before the Olympic National Monument became a park in 1937, much of the south Olympics were federal land. Here National Forest ranger Ralph Hilligoss issues a free campfire permit to visiting campers at the Hoodsport Ranger Station. Lake Cushman and Staircase were popular destinations for Hood Canal visitors. Hilligoss resigned his district ranger position in 1931 to work in sales for the Simpson Logging Company.

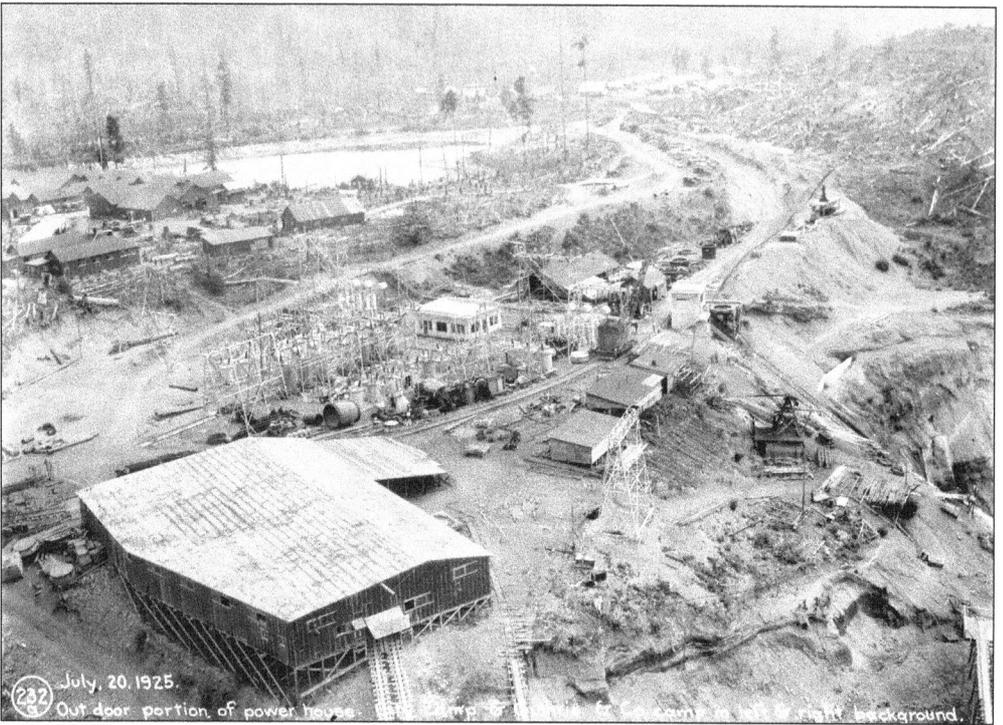

July, 20. 1925.
Out door portion of power house.

Prevailing after four years of litigation with lake pioneers and local tribal members, including Henry Allen, the City of Tacoma revised its plans and built two dams. The Cushman Dam project employed several hundred workers for over a decade. The City of Tacoma maintained a camp, as did the dam contractor, Guthrie and Company.

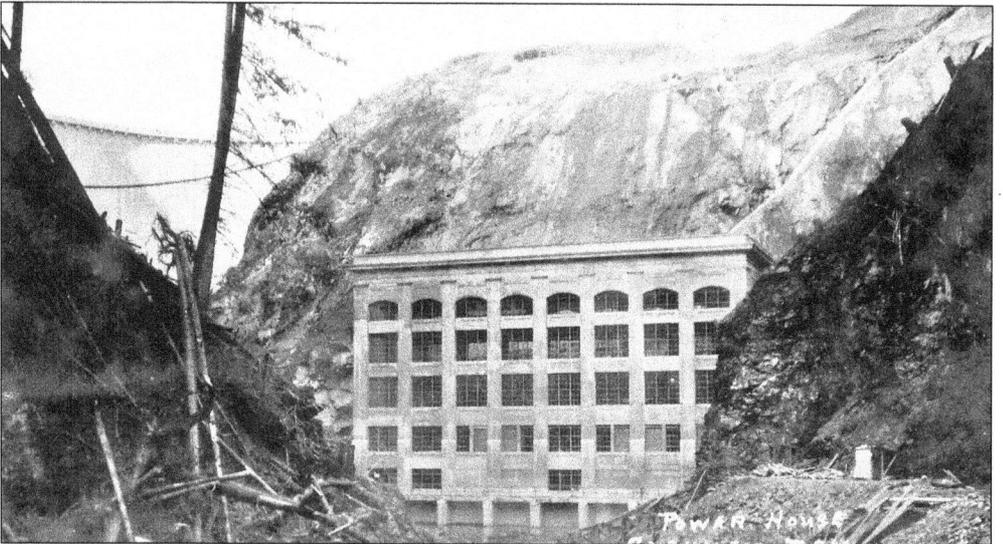

POWER HOUSE

The powerhouse for the first dam was located below the dam. The first of the two dams officially began operating in May 1926, when Pres. Calvin Coolidge pressed a button, sending an electrical current from Washington, D.C., to Washington State. Tacoma's Cushman Dam project finally flooded the old Lake Cushman's pioneer past, as it expanded the lake to illuminate a new society of grateful electrical customers on the canal.

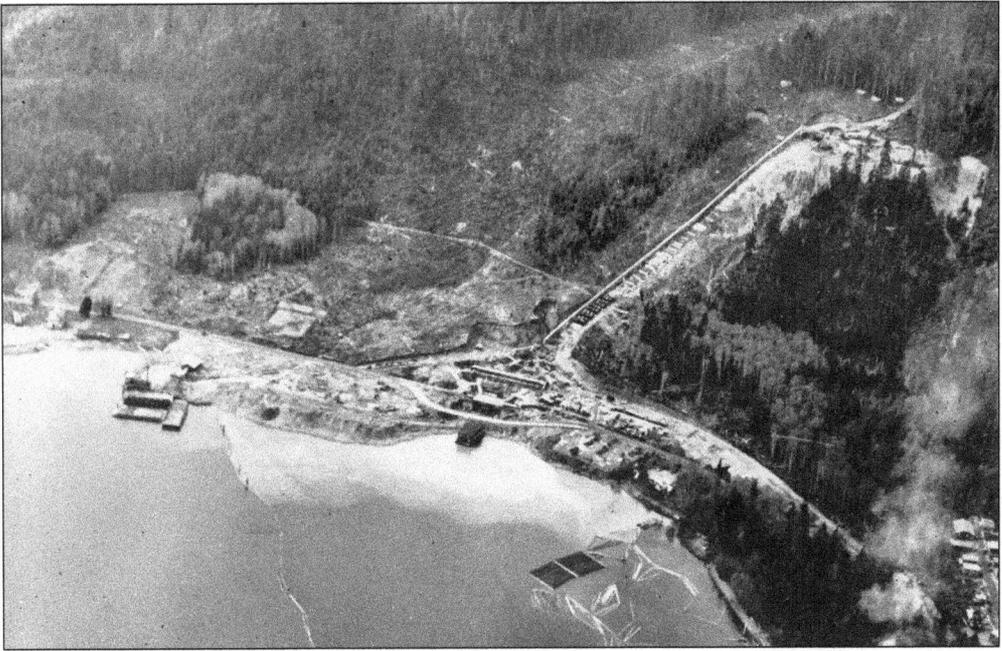

The Cushman Dam No. 2 was under construction in 1930. A tunnel directed the water flow into the three huge tubes down the mountain and through the generators in the powerhouse before swirling into Hood Canal.

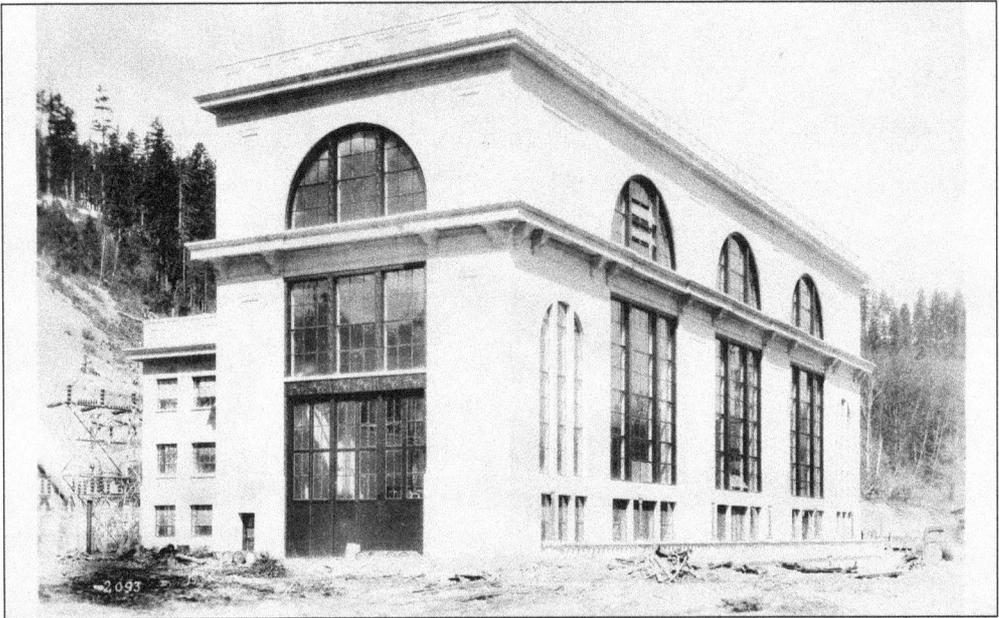

At Tillikum Beach, the second Cushman Dam powerhouse was completed, along with penstocks, powerhouse, and transmission lines. It channeled the falls of the North Fork of the Skokomish River through the powerhouse's generators into the little cove the Twana named the "herring place." After the 1855 treaty, the new 4,987-acre Skokomish Reservation was located nearby because the site had the most buildings. In 1883, the average tribal male measured 5 feet 6 inches and weighed 151 pounds.

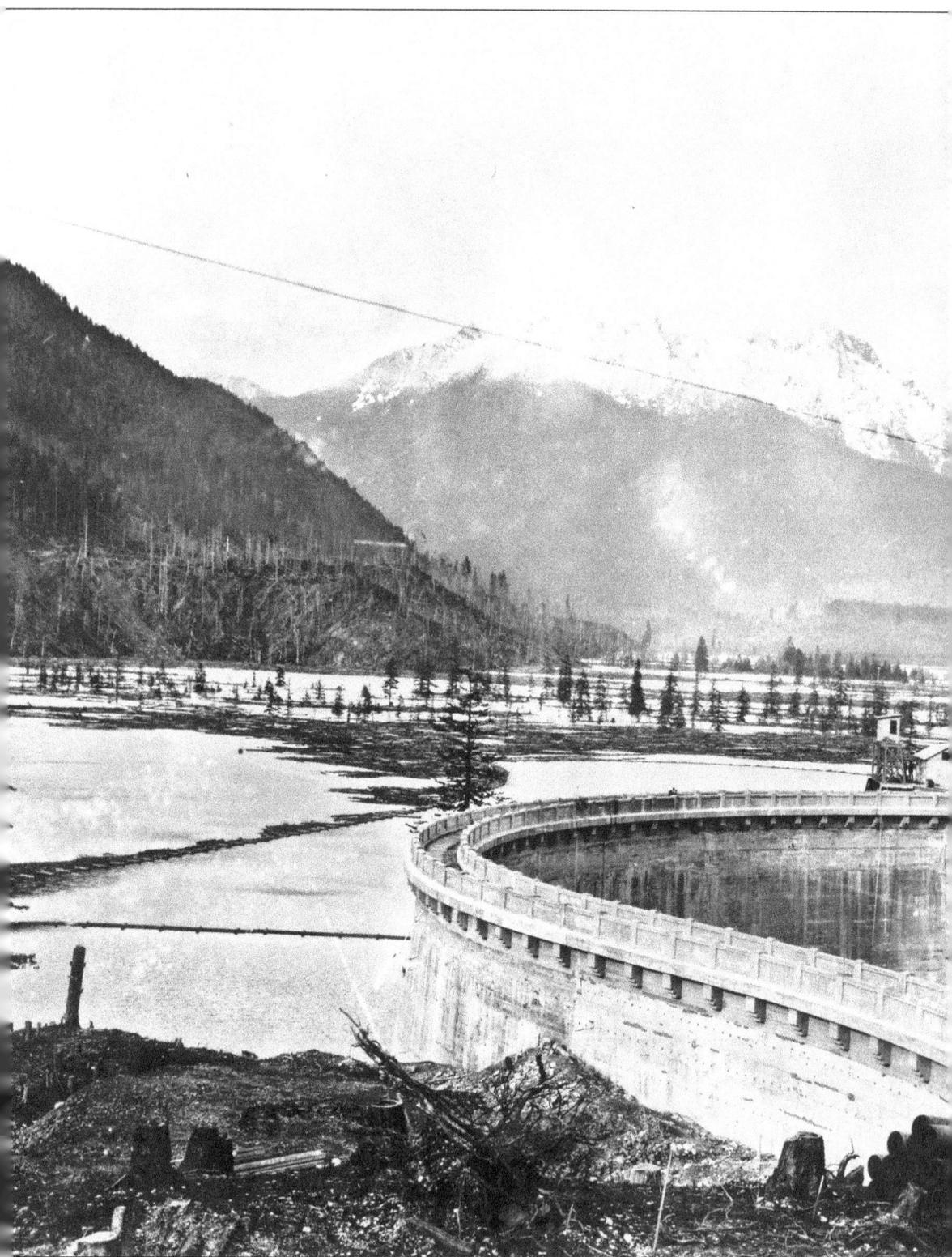

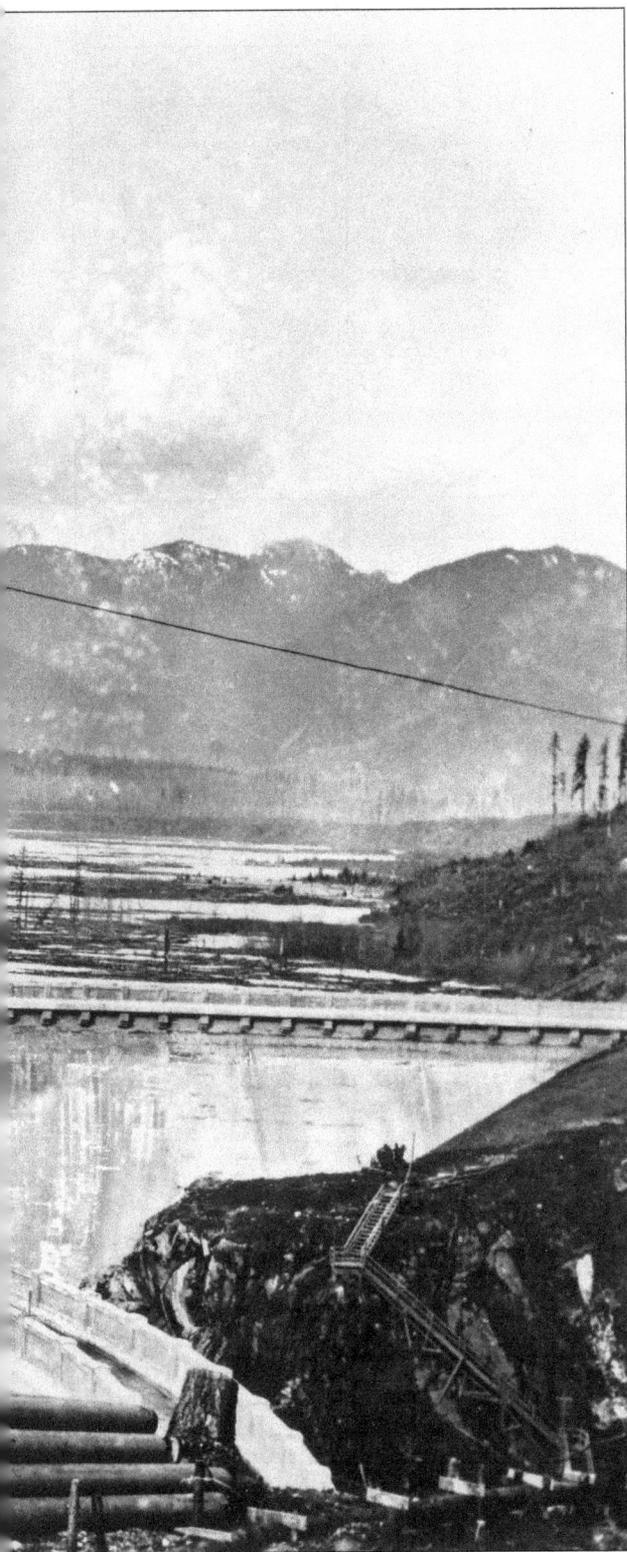

The $4.2-million Cushman Dam on
the North Fork of the Skokomish
River was finished by the City
of Tacoma on October 20, 1925,
forming a lake 10 times larger than
the original and the second largest
reservoir in the West. Trees not yet
felled were submerged by the rising
water. Now a large community
of second homes overlooks the
lake. Since 1974, the federal
relicensing of the dam has been
in litigation with tribal interests,
who contend that the dam has
destroyed traditional salmon runs.

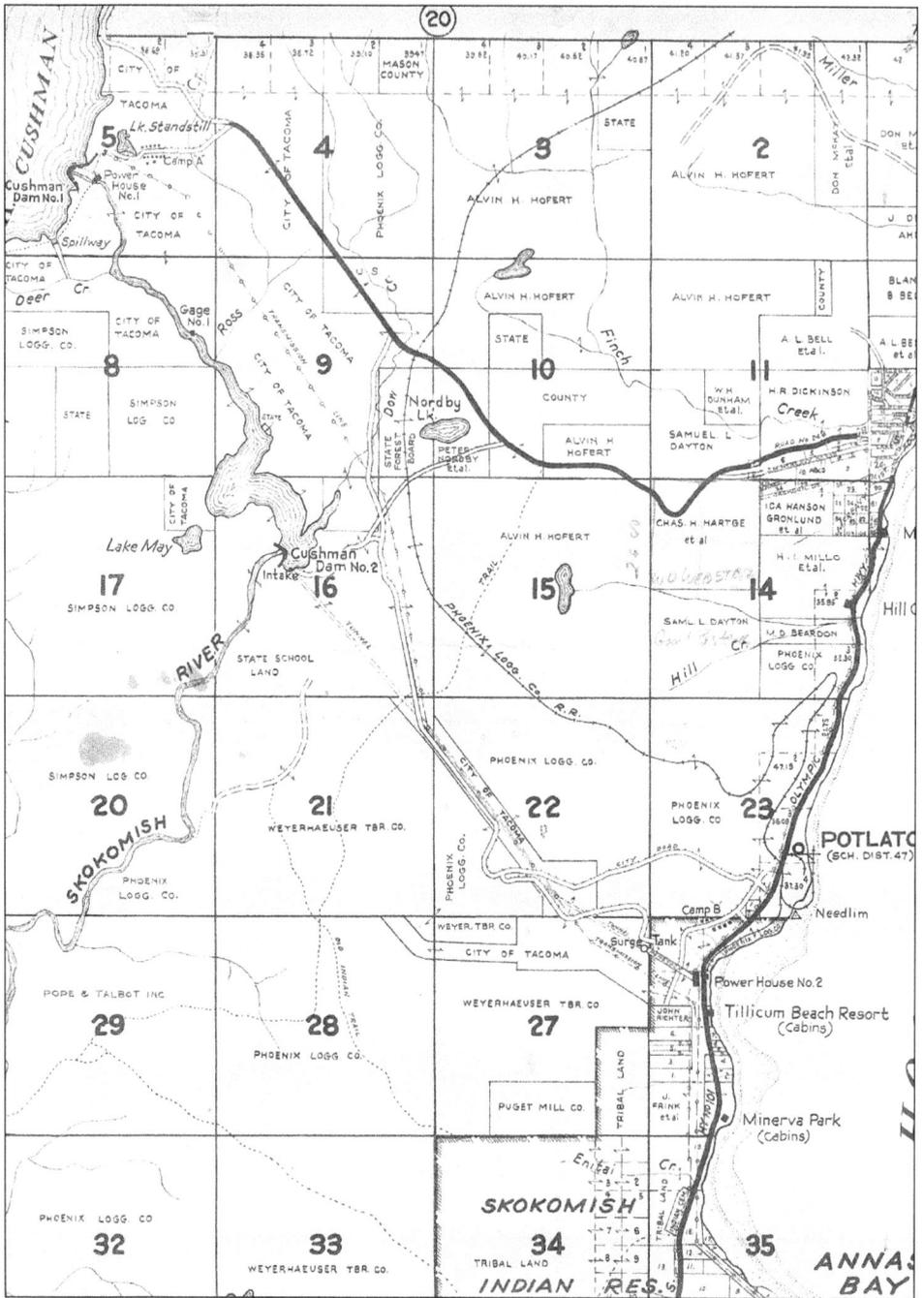

The Cushman Dam projects are the largest industrial development on the southern Hood Canal. This 1955 map reveals the extent of the project; the construction lasted from 1925 to 1935—note the lengthy tunnel. The dam impacted both forks of the Skokomish River. The Phoenix Logging Company railroad switchbacks demonstrate yet another engineering attempt to scale the steep bluffs surrounding Hood Canal. Later Alvin H. Hofert located his early Christmas tree farms on old Phoenix Logging Company grounds. The seasonal industry thrived until the 1990s, when growers moved to Oregon.

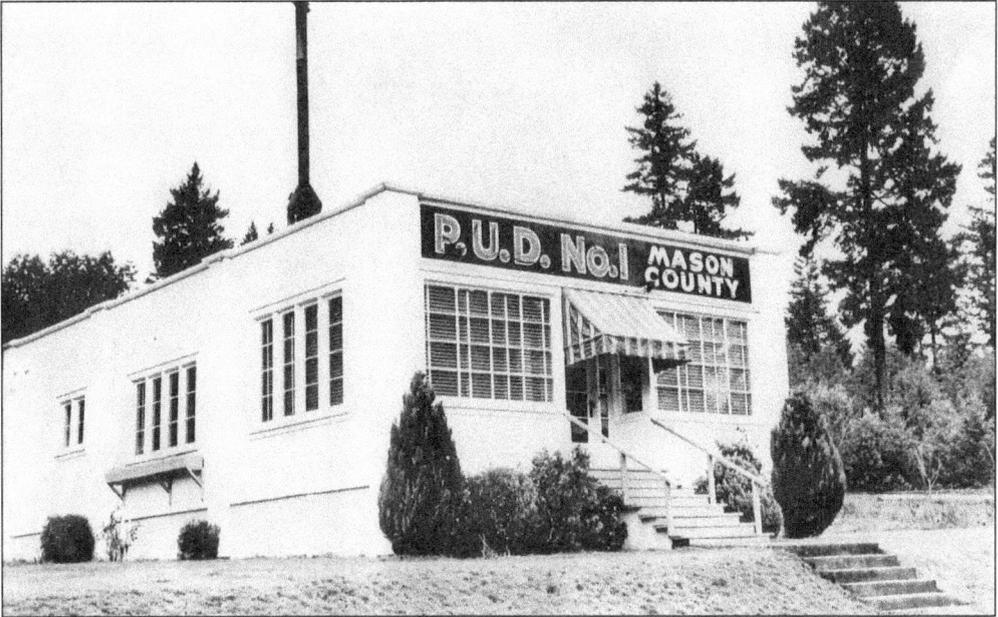

Public Utility District (PUD) No. 1 was the first publicly owned utility in the state when, on February 1, 1935, it purchased the electrical franchise from Hood Canal Mutual, which served 150 customers from Hoodsport to Brinnon. The Grange was instrumental in the formation of the PUDs, and C. M. Pixley served as manager. PUD No. 1 sold power generated by the Lake Cushman dams to Hood Canal residents. In 1959, PUD No. 1 began purchasing power from Bonneville.

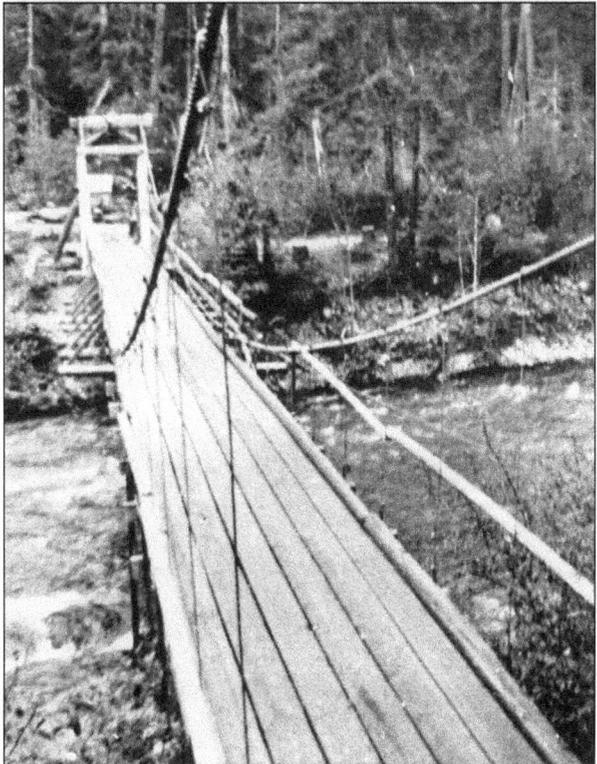

The Dickinson family steadily developed and maintained Staircase Resort. This 1930 photograph is of the original bridge to Staircase. The U.S. Forest Service has greatly expanded the camping area, and the bridge has been replaced. Early residents believed in the dream of Hood Canal and the Olympic Mountains, and many worked hard to build facilities to adequately host tourists seeking peace or fun, recreation or relaxation, togetherness or solitude.

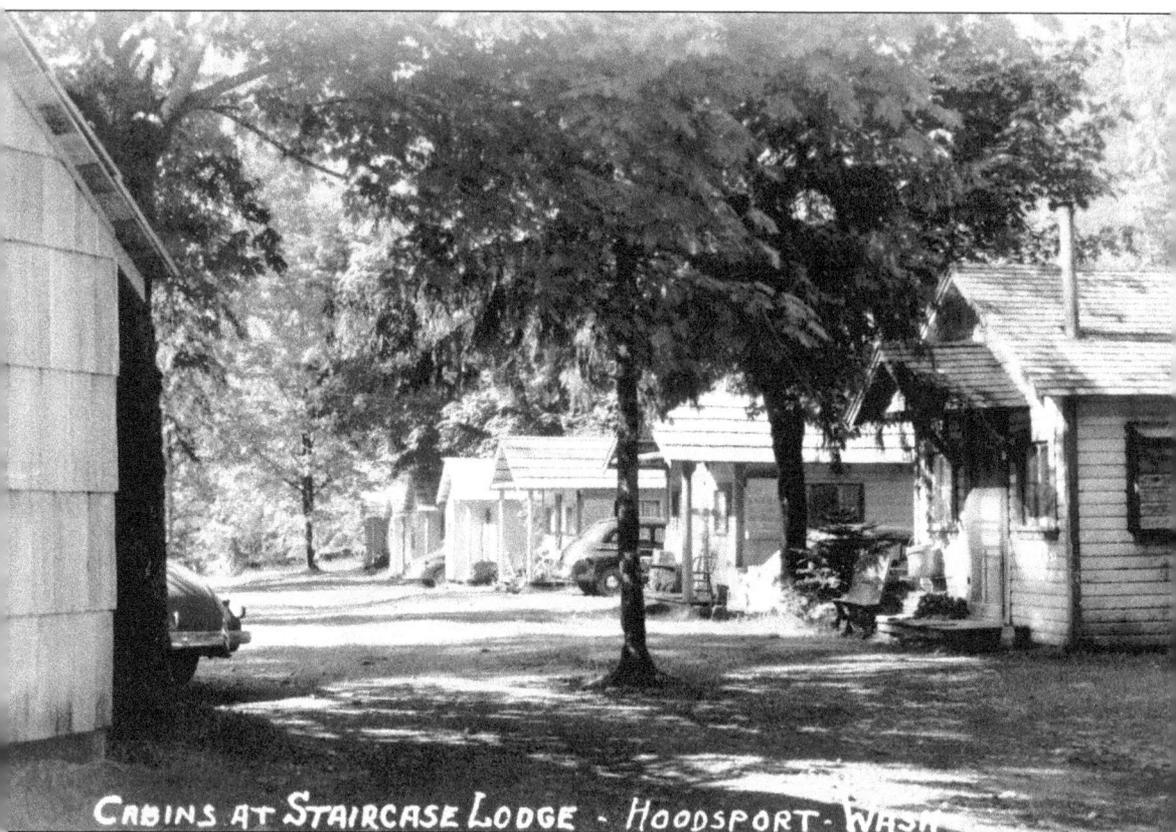

CABINS AT STAIRCASE LODGE - HOODSPORT - WASH

In 1931, after roads were built for automobiles, Lester and Anna Dickinson leased Staircase from the U.S. Forest Service, installed a Pelton wheel to generate electricity, and built a store and 14 cabins, leased from $1.50 to $6.25 a day. Lester offered guided fishing and hiking parties into the mountains. By the early 1950s, Staircase Resort ceased operating. By 1983, only one Staircase Resort cabin remained, serving as U.S. Park Service quarters.

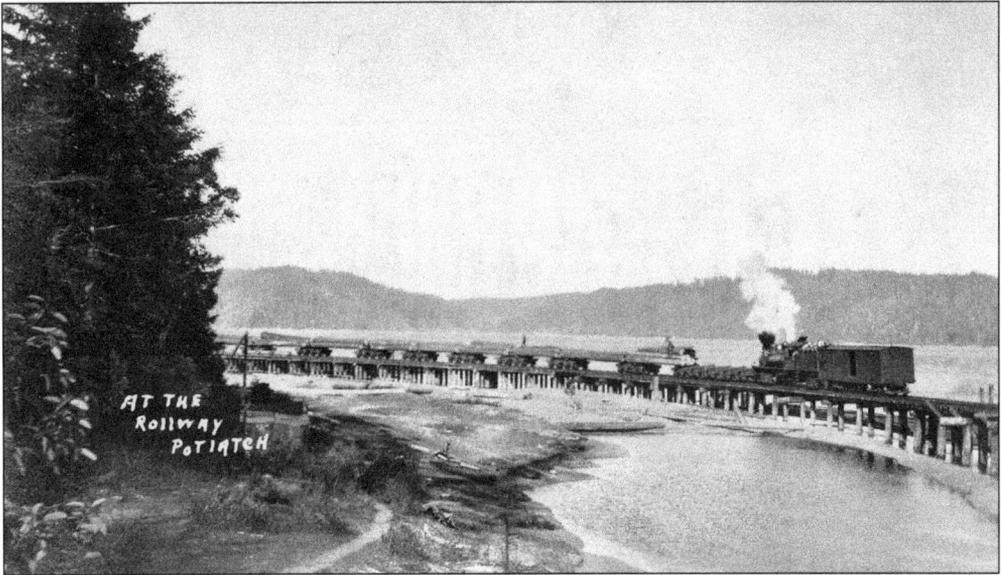

AT THE
ROllWAY
POTlATCH

In 1900, Shelton lumbermen Sol Simpson and Alfred Anderson sited the state's second largest logging company and a town at a former Native American potlatch ground. The town of Potlatch housed the Potlatch Commercial and Terminal Company, later to be renamed the Phoenix Logging Company. The steep canal slopes required a unique method of hauling; 18 or more logs would be dogged together and dragged behind the locomotive as a braking system. However, the practice soon proved impractical and "rattler" cars were brought in. (A loop laid across two trucks formed a car to be coupled onto a train; the weight of the log span between the trucks was sufficient to keep the train together.) The rollway arced out parallel to the shore as protection from the heavy tides.

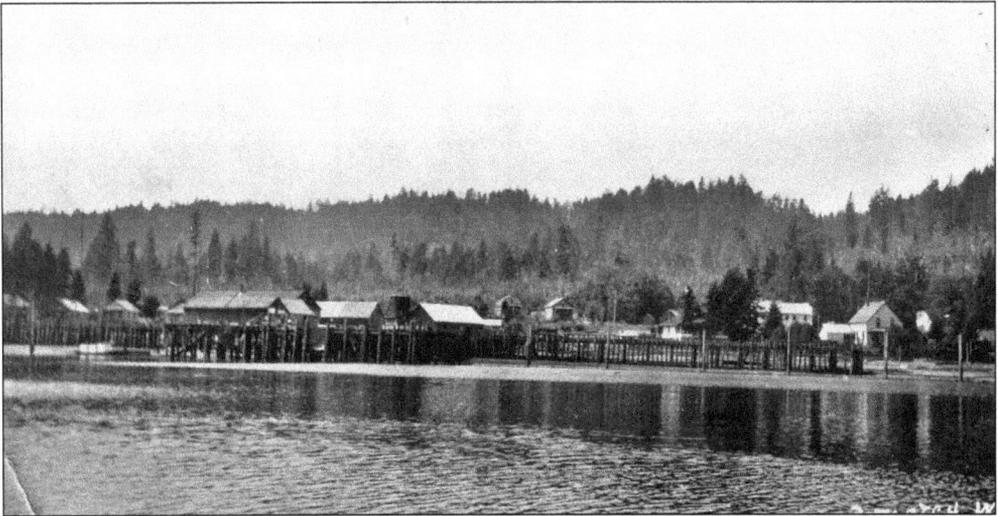

By 1935, a log bulkhead protected Potlatch, which included a two-story hotel and dining room, a store and post office with telephone, railroad shops, bunkhouses, and a cookhouse. In the 1910 census, Potlatch listed 245 people, Hoodsport 84, and Union 177. In 1939, the logging operations ceased, and the tracks were torn up and sold to Pakistan for telephone poles. In 40 years, 1.5 billion board feet were cut, almost 40 million annually. One contract supplied lumber for building the Panama Canal.

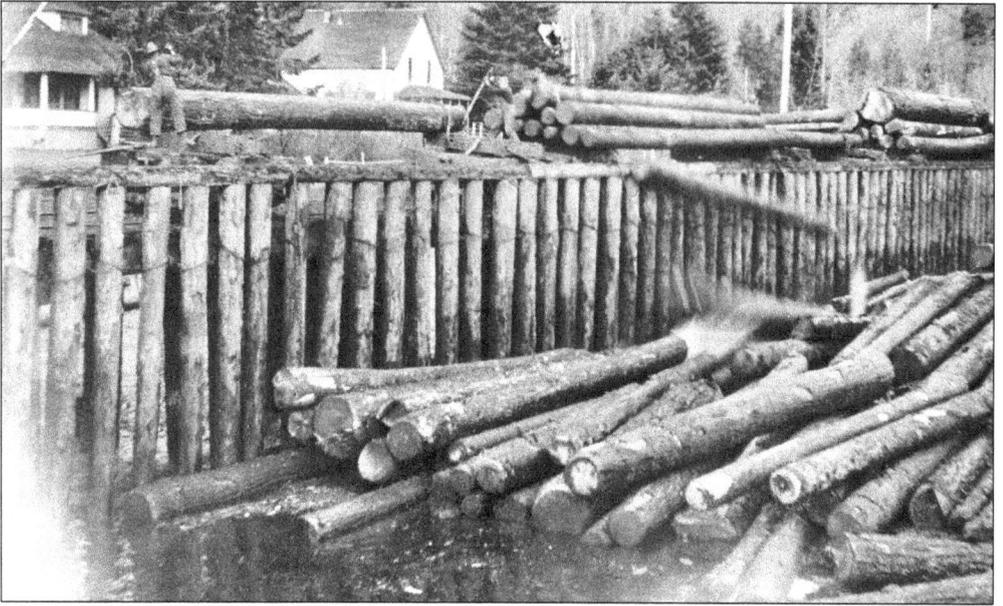

Off the Potlatch wharf, logs are rolled into the tidewater by hand peavey. The logs were rafted into booms by log scalers, who calculate the logs' board feet. Tugboats would then tow them up Hood Canal to mills, using it as a highway to move goods, just as John McReavy had done in the 1860s.

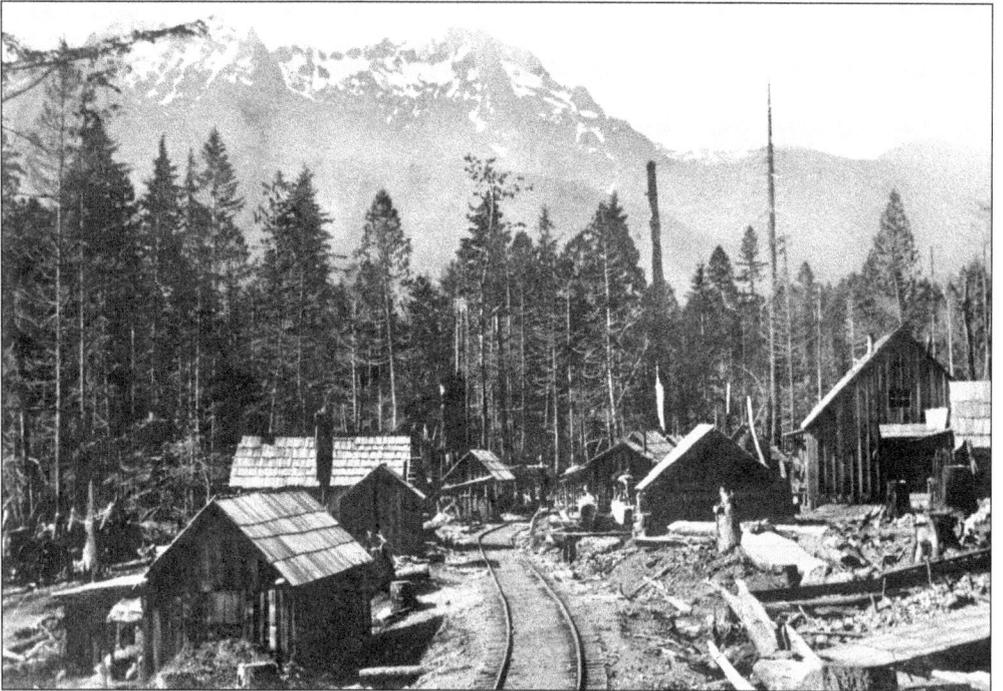

The Phoenix Logging Company operated two camps and miles of track as they logged from Hood Canal to the National Forest boundary. The company also cut timber for the Lake Cushman dam until the rising water forced cutting to cease, leaving trees standing underwater like a tomb of totem poles. The present Lake Cushman Road follows the railroad right-of-way.

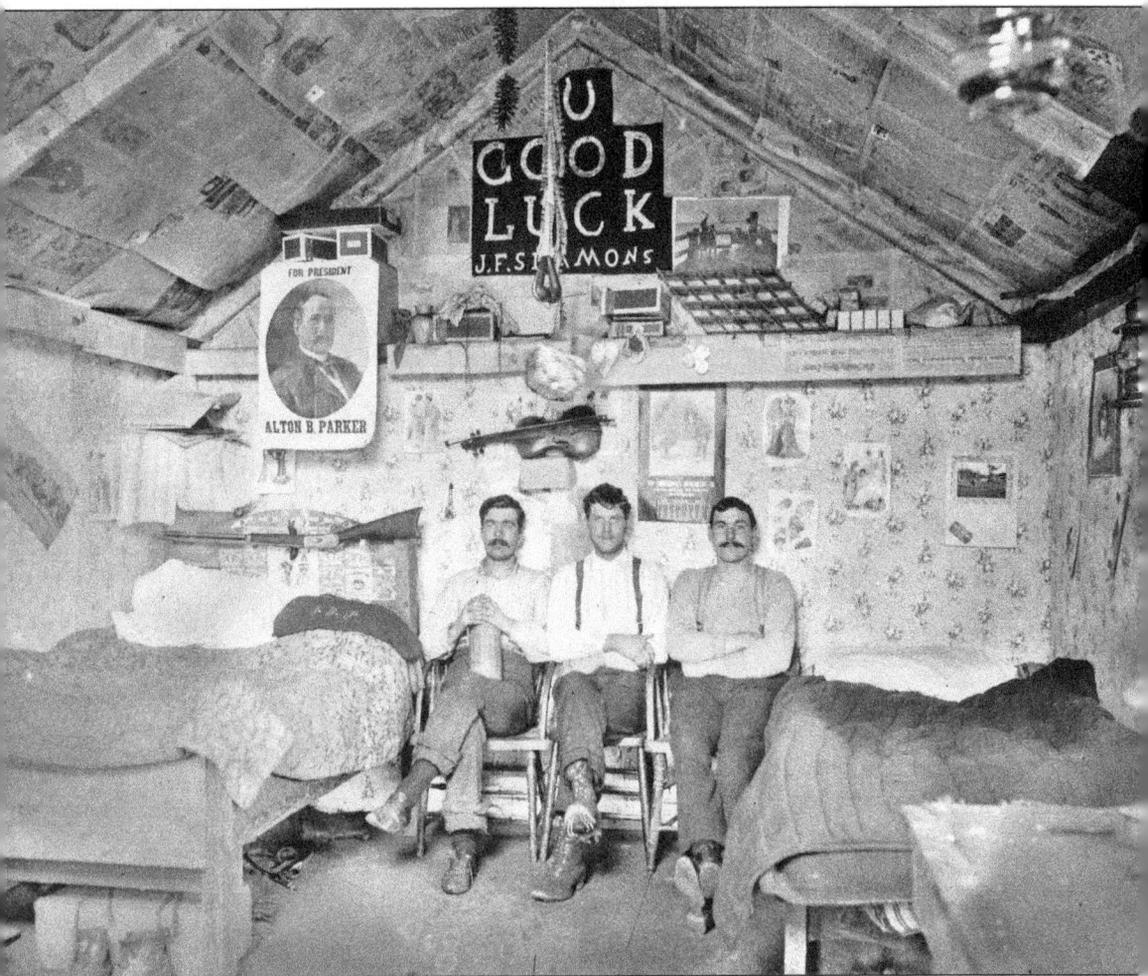

This Phoenix Logging camp bunkhouse even had wallpaper behind the rifle and Jim Simmons's fiddle. The soon-to-be-wed Jim Simmons is seated in the center. Newspapers were pasted to the roof to cover the raw wood, with gas lamps hanging nearby. Alton B. Parker was the Democratic presidential candidate in 1904 and was defeated by Teddy Roosevelt. The bunkhouse almost looks civilized.

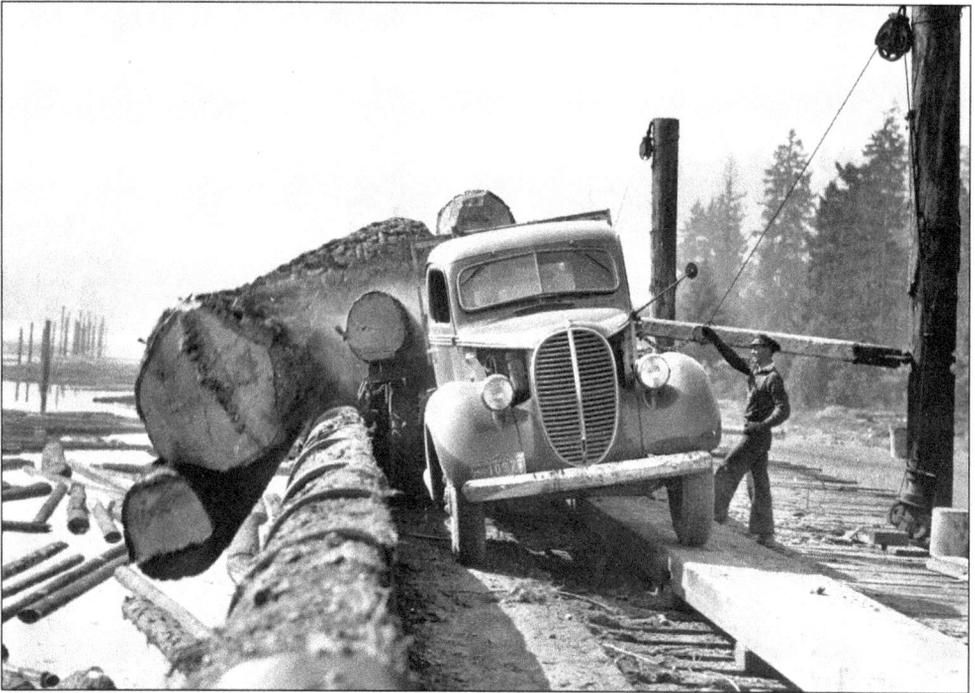

By the late 1930s, much of the log hauling had transitioned to trucks, as railroad building is expensive. This is Don McKay's first truck unloading. Note the timber railing under the driver's tires, which tilts the truckload, making it easier to roll the huge logs into the water without injury. Logging is a dangerous trade, and the first man killed at Potlatch was superintendent Albert Johnson.

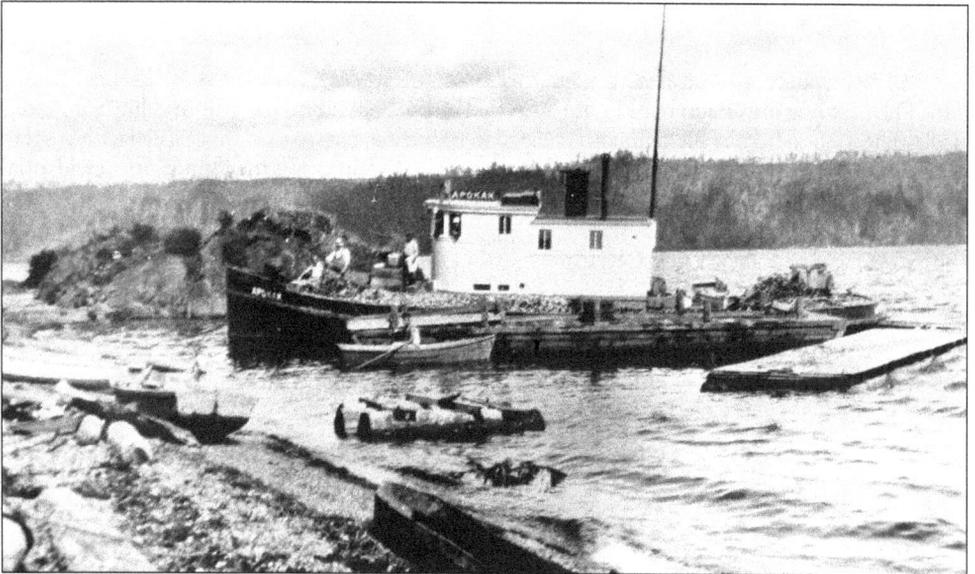

The tugboat Apokak was owned by Abner Sund, who was the son of John Sund. Here the deck of the tug is covered with the canal's first shipment of Japanese oyster seed. The tug also towed log booms for the Phoenix Logging Company. Another tug operating out of Hoodsport was the Trio.

*Three*

# HAMA HAMA AND NORTH HOOD CANAL

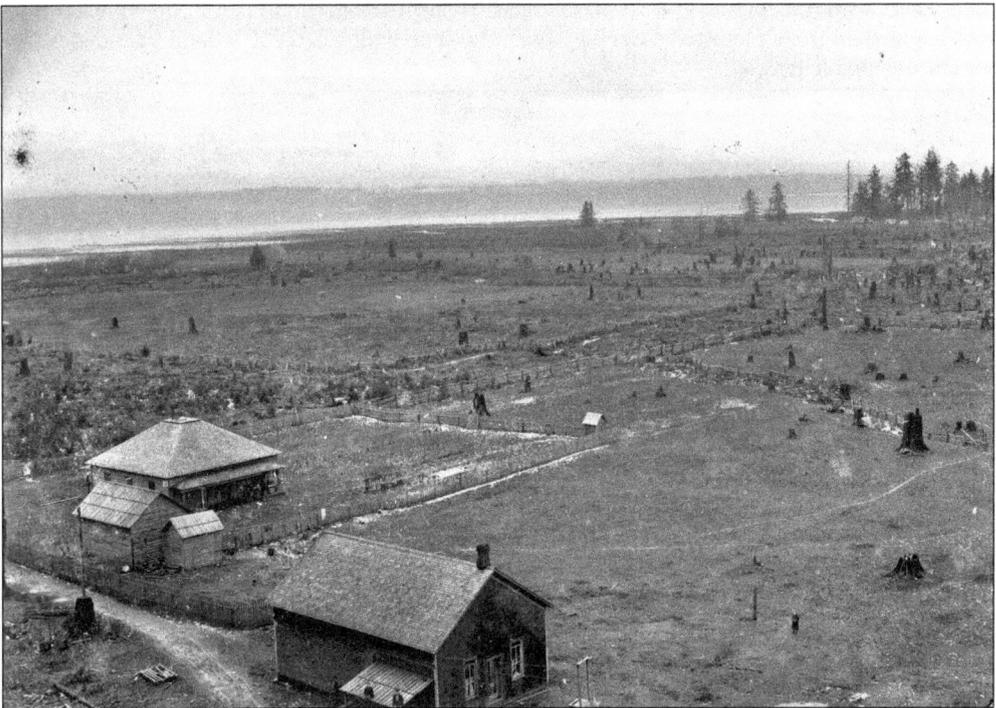

This is "Brinnon Bottom" about 1900. Brinnon was cleared first by Washington Mill Company loggers from Seabeck. Early canal logger Ewell Brinnon purchased land before 1868 with his S'Klallam wife, Kate. Brinnon donated property for a school and a cemetery. The post office was named for him because the Twana name *Ducaboos* was too difficult to spell. By 1880, the Brinnons moved up to the Dosewallips River because Kate was concerned about flooding.

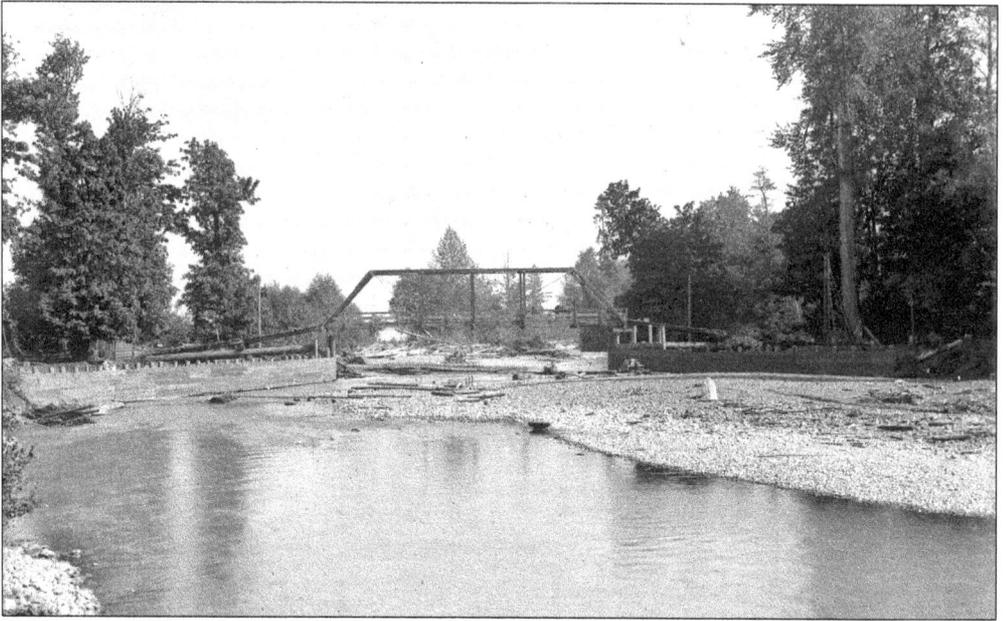

In 1902, another "new" bridge spanned the Dosewallips River, built by Puget Sound Bridge and Dredge for $2,489. Hillsides denuded by logging resulted in "new" bridges being washed out in 1889, 1890, 1894, 1902, and 1910. Studies indicate that the storm runoff is 100 times greater from a clear cut than from a forested parcel. In 1923, the state built a $70,000 federally funded bridge for the Olympic Highway.

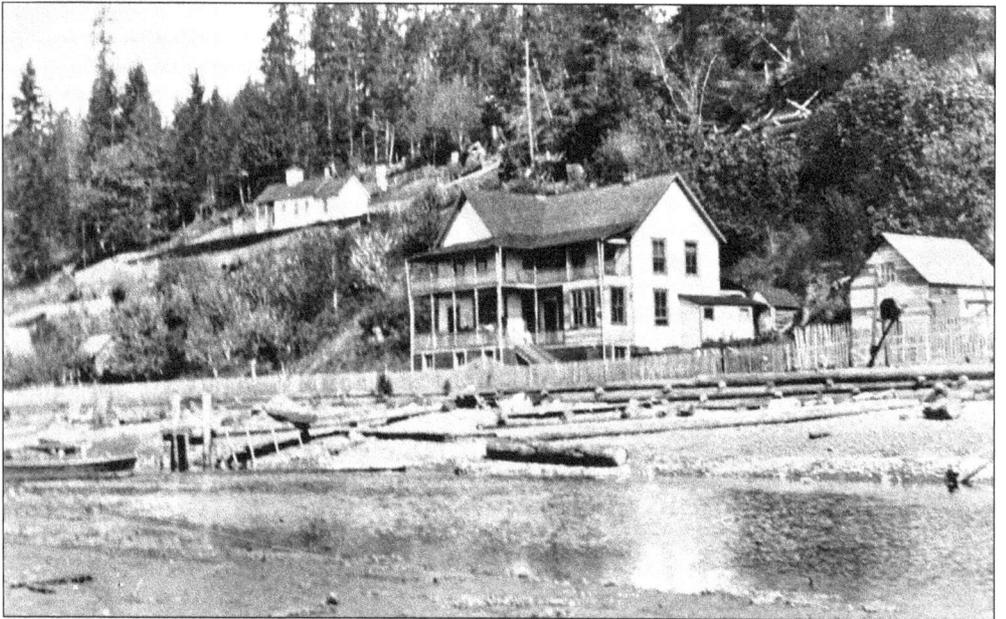

The Hama Hama School, on the hill on the left, was built in 1896. Each canal community built a school first, including Eldon, Tahuya, Brinnon, Hoodsport, Belfair, Dewatto, Union City, Upper Skokomish Valley, Middle Skokomish Valley, and the Lower Skokomish Reservation. The house on the waterfront was the Allie Ahl home, an early Hama Hama settler. Hama Hama, sometimes spelled Hamma Hamma, means "stink, stink."

The mosquito fleet transported supplies as well as passengers. From 1910 to 1918, this 40-foot tugboat owned by August Greiner towed logs from Quilcene to Seattle and carried passengers from Seattle to Quilcene. The mosquito fleet that included rowboats and stern-wheelers declined as the road system improved.

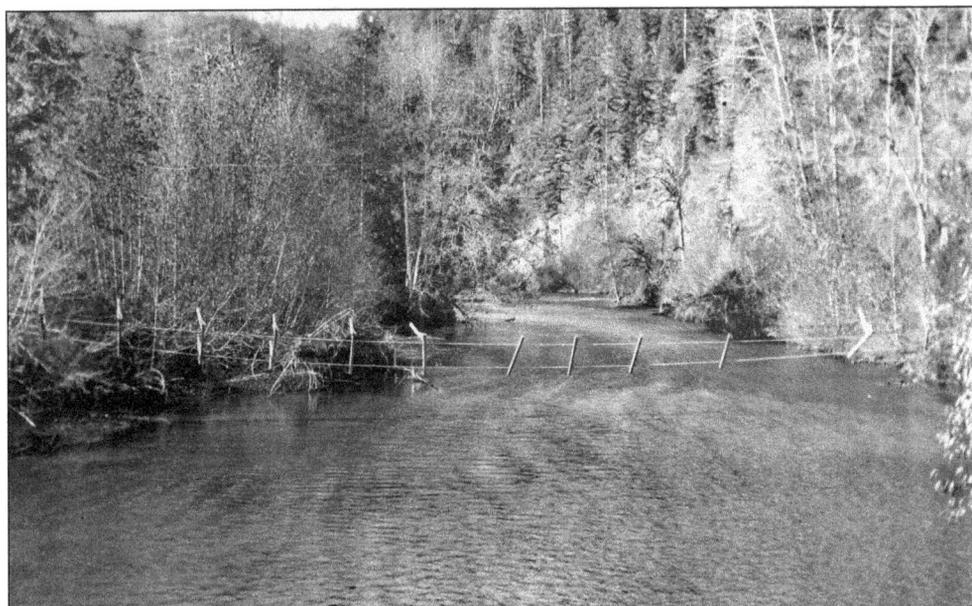

This footbridge across the Hama Hama River demonstrates the primitive transportation system of early canal settlements. Lon Webb walked this way to get to Eldon School. The Olympic Highway bridged the Hama Hama in 1925.

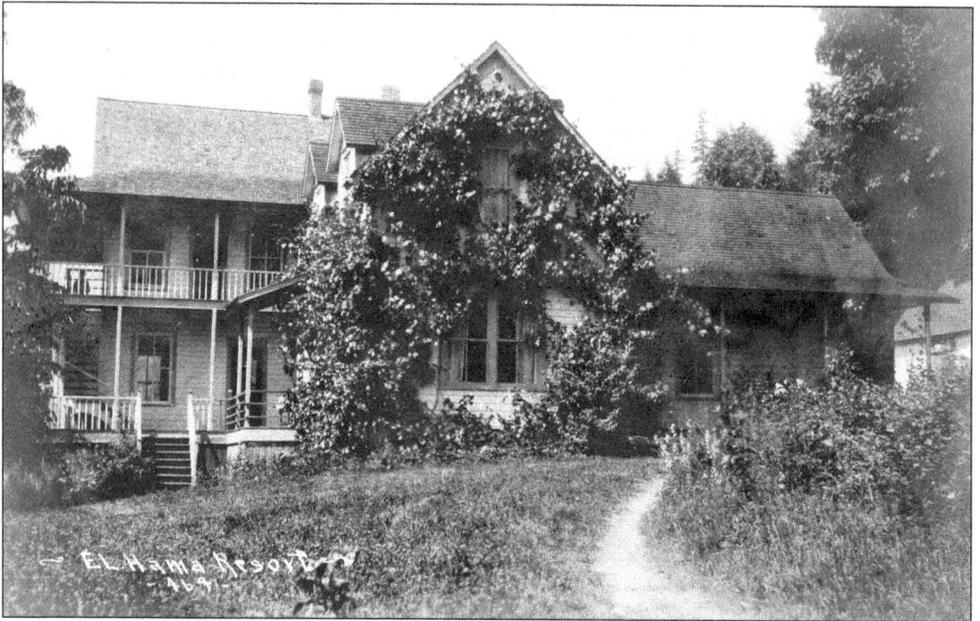

Later the Ahl house became the El Hama Resort, with the road behind it to issue in tourists. Like many early Hood Canal settlers, the new owners believed the halcyon summers would attract tourists. The Diesen family erected a dance pavilion as further attraction, but the fall rains always dampened tourism on Hood Canal.

This dance pavilion at Diesen's at Hama Hama is one of several that sprung up along the canal as the roads improved. Other potential guests included the loggers from the Hama Hama Logging Company camps. Of course, John Sund included a dance floor at his resort, and Dickinson erected a pavilion at her Gateway Inn. Near Alderbrook, the Dalby family operated another pavilion as an attraction to young tourists to dance and rent their waterwheel cabins.

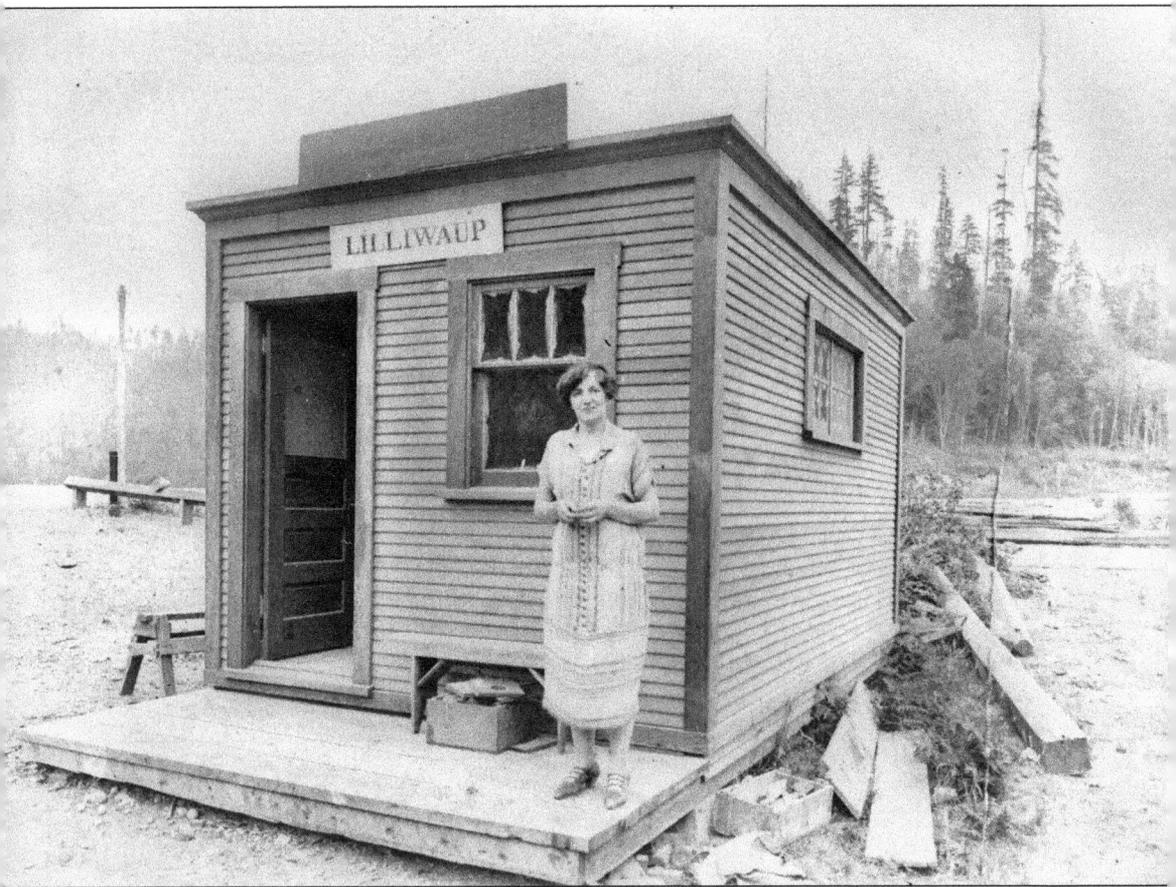

This 1920s photograph shows the Lilliwaup Post Office and the postmistress. The postal service frequently leased local facilities. This building appears to be constructed especially for the post office, as demonstrated by the compact design, recent land clearing, and the sawhorse cached by the door. The residents of Hama Hama, mostly employees of the logging company, received their mail from Lilliwaup.

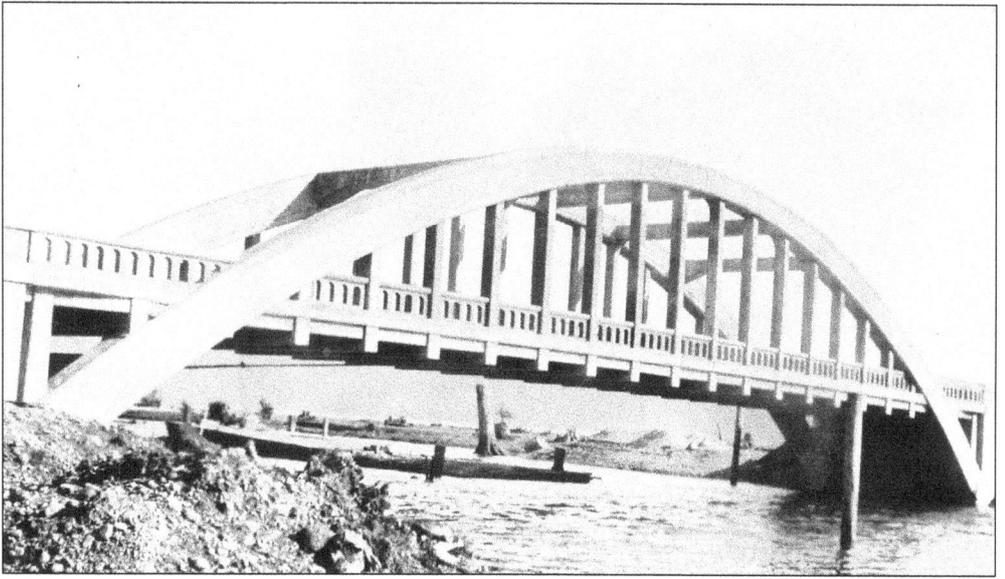

The new Hama Hama River Bridge was built in the late 1920s for the new Olympic Loop Highway. The new highway crossed the estuary, and bridges spanned the several meandering creeks. Hama Hama locals still refer to it as the "new bridge."

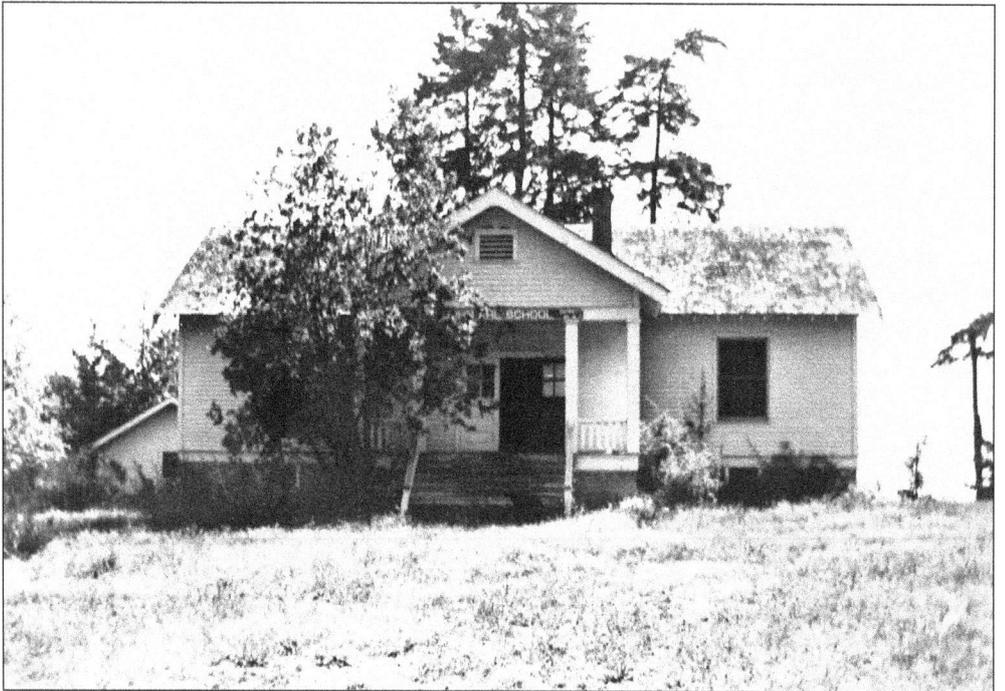

In 1927, Eldon built the John Ahl School on the bluff overlooking Hood Canal. The one-room school generally held 8 to 10 students. Henry Allen reported a large summer settlement on the beach at Eldon, called "place of horsetail rush," where the Native Americans gathered the edible roots as well as fished for salmon.

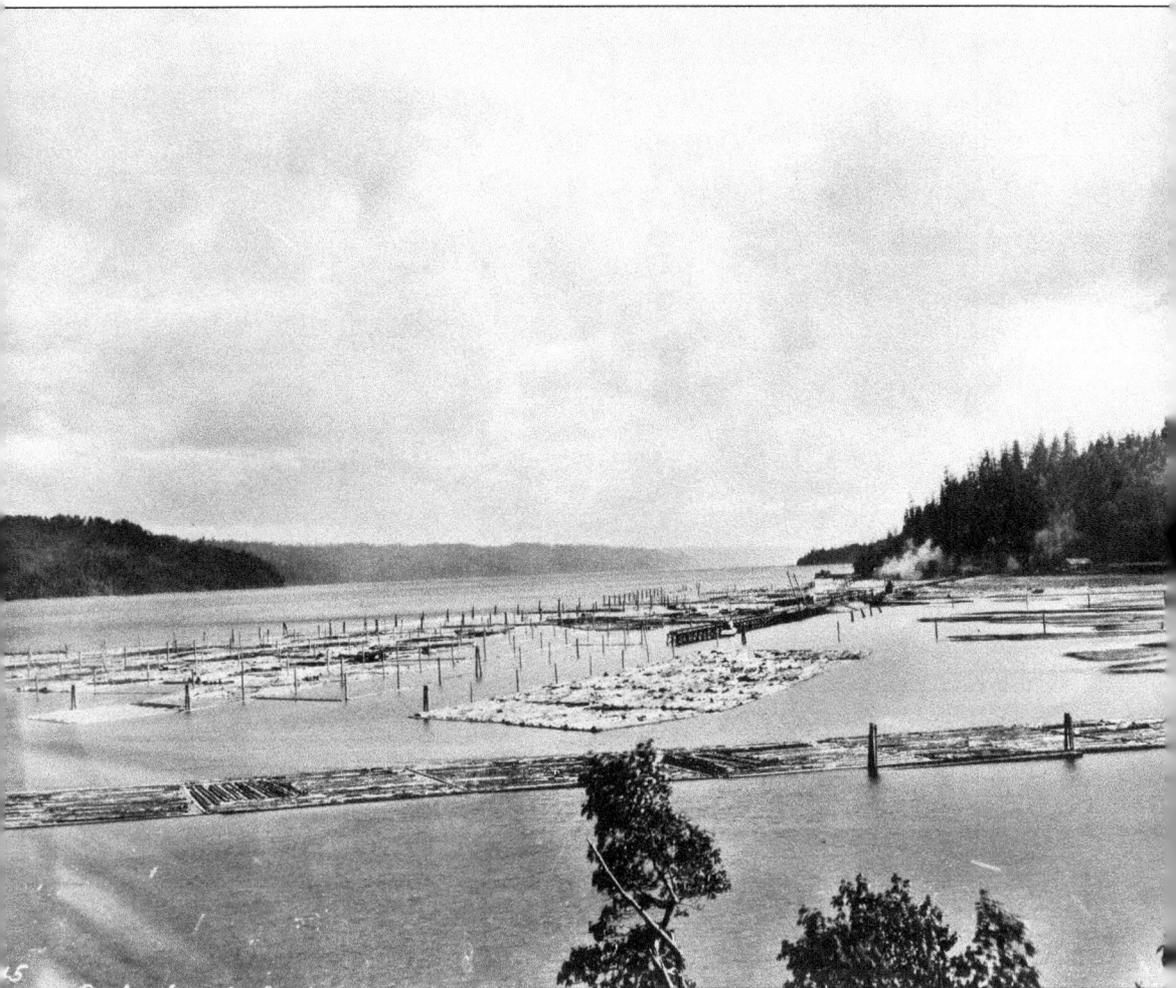

It took from 1923 to 1933 for the Hama Hama Logging Company to cut out. It had been producing 50 million board feet a year with a crew of 300. Other companies logged other river drainages, including the Webb Logging Company at Waketickeh Creek and the Duckabush River. The Canal Logging Company, associated with the Phoenix Logging Company in Potlatch, logged the Jorstad Creek drainage.

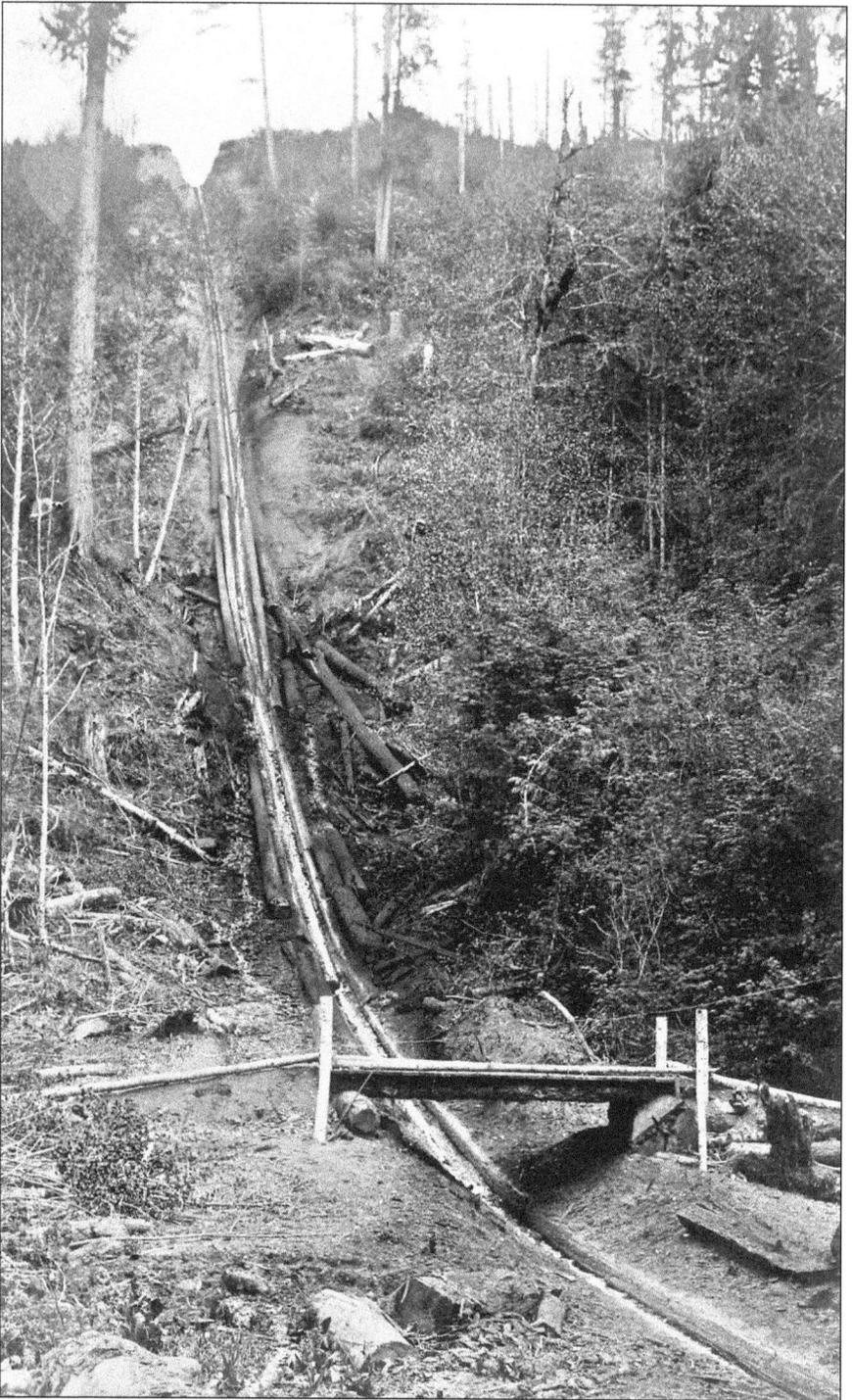

This log chute in Skokomish Valley is still visible on the hillside. By 1907, Hood Canal loggers had cut the tidewater timber. Burt Kneeland built this two-mile log chute, reaching to the Skokomish River. A man was posted at the road crossing, but accidents still happened to the unsuspecting passerby.

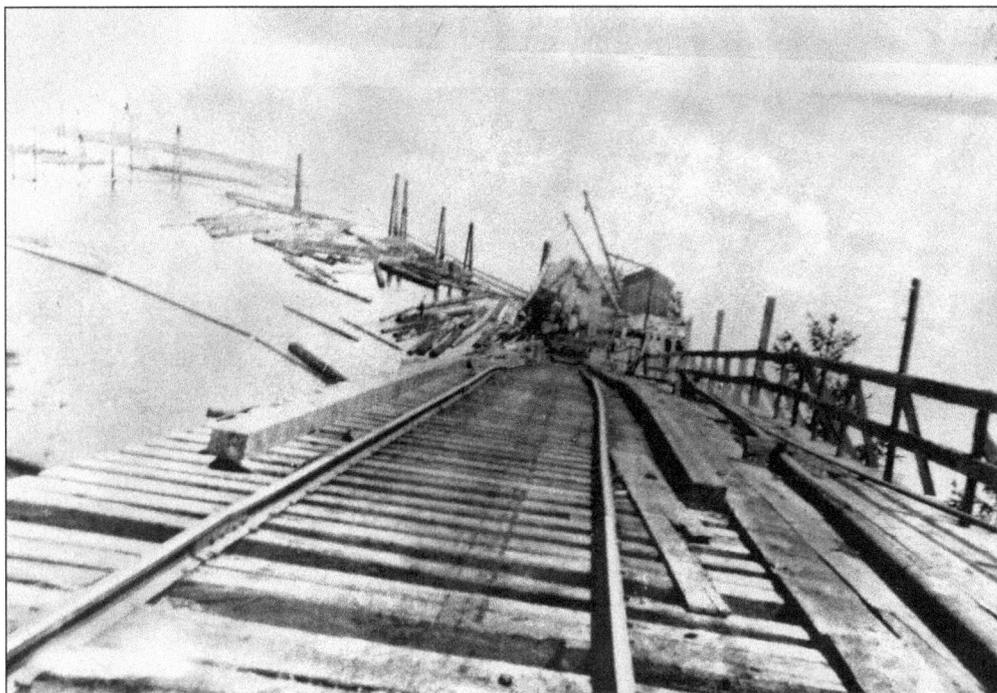

In October 1922, the Hama Hama Logging Company constructed a 2,800-foot tracked incline to reach the 12,000 acres of timber in the Hama Hama drainage. The owners included Everett mill owner Herbert Clough and Harry M. Robbins. The steep bluffs surrounding Hood Canal were surmounted through difficult engineering and hard work. The incline was abandoned in 1925 in favor of a new freight dock on the river.

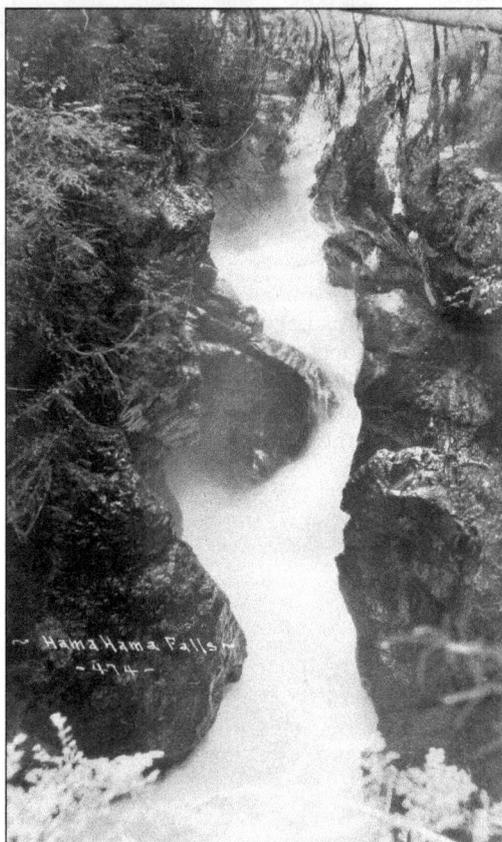

~ Hama Hama Falls ~
~ 974 ~

The Hama Hama Falls crashed down the steep bluffs holding in the canal. In 1928, the Hama Hama Logging Company offered the watershed to the City of Tacoma for use as a hydroelectric power dam site. Studies found inadequate storage. Most of the rivers plunging into the canal off the Olympic Mountains are only a few miles long, but the abundant rainfall makes them powerful, and many were studied as hydroelectric sites.

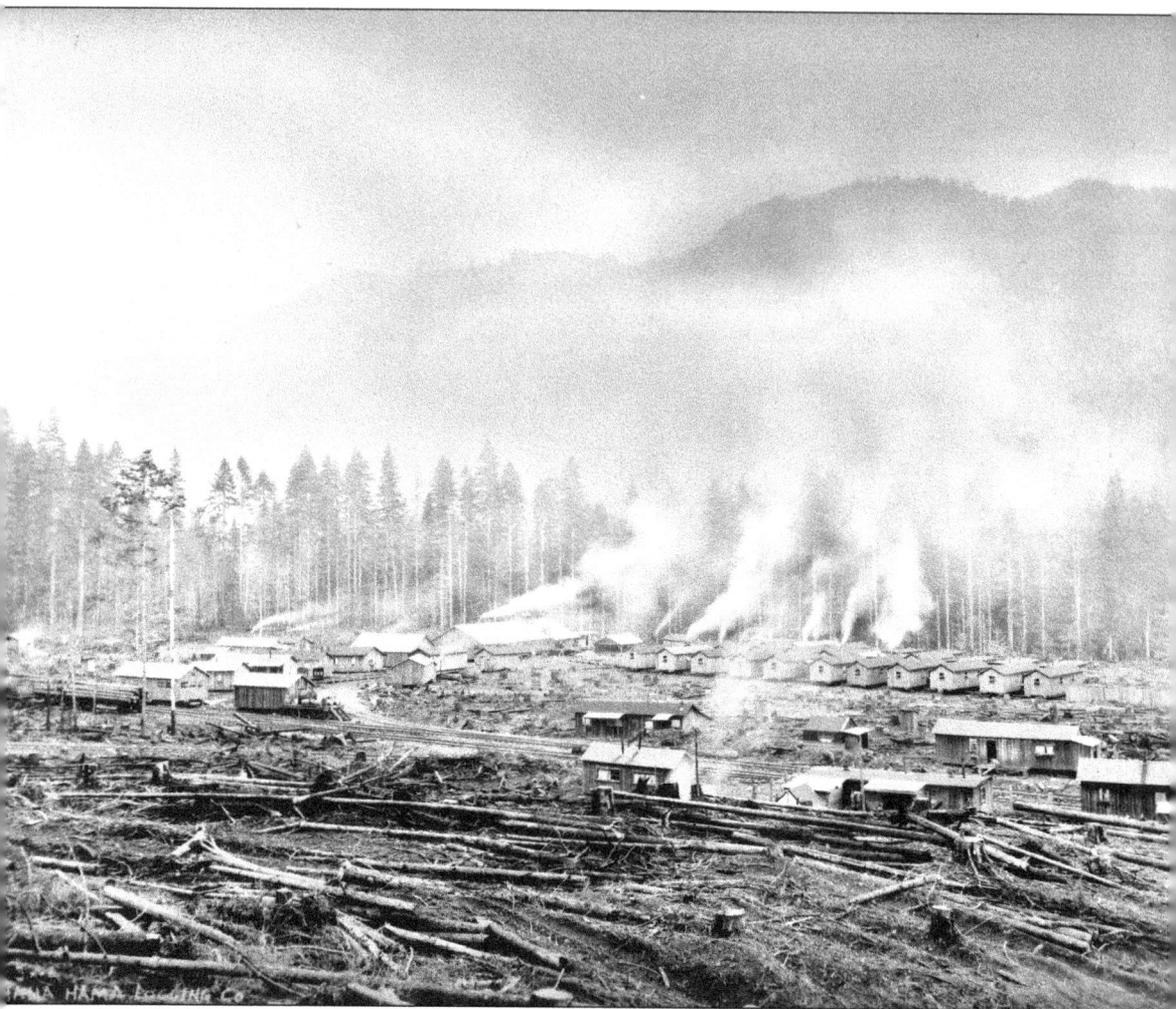

The Hama Hama Logging Company worked two camps. This is the lower Camp No. 1, for the maintenance shops and housing for married men, which is the neighborhood in the rear. To shop, the wives would travel to the Eldon Store by automobile, by railroad speeder, or by caboose. The upper camp housed the single men and the railroad. The upper camp moved as the railroad was extended into the timber.

The Civilian Conservation Corps built Hama Hama Guard Station in the 1930s as headquarters for crews replanting U.S. Forest Service (USFS) ground that had been logged in 1928 by the Hama Hama Logging Company. A side camp of 70 men built the cabin, a standard USFS plan that was altered to include the angled office space. The USFS now rents out the cabin and uses the receipts for repairs and maintenance.

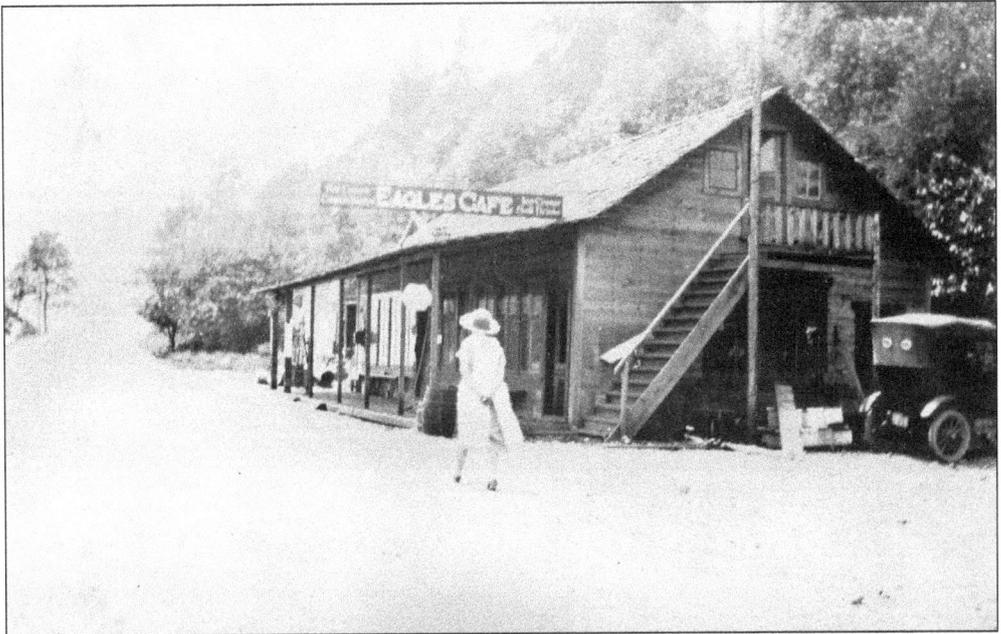

When the Olympic Highway looped along Hood Canal's west shore, both amusements and eating establishments dotted the shoreline in short order. The Eagles Café at Jorstad Creek offered ice cream and soft drinks. The Native Americans named Jorstad Creek "battle field" and camped during the summer at its mouth.

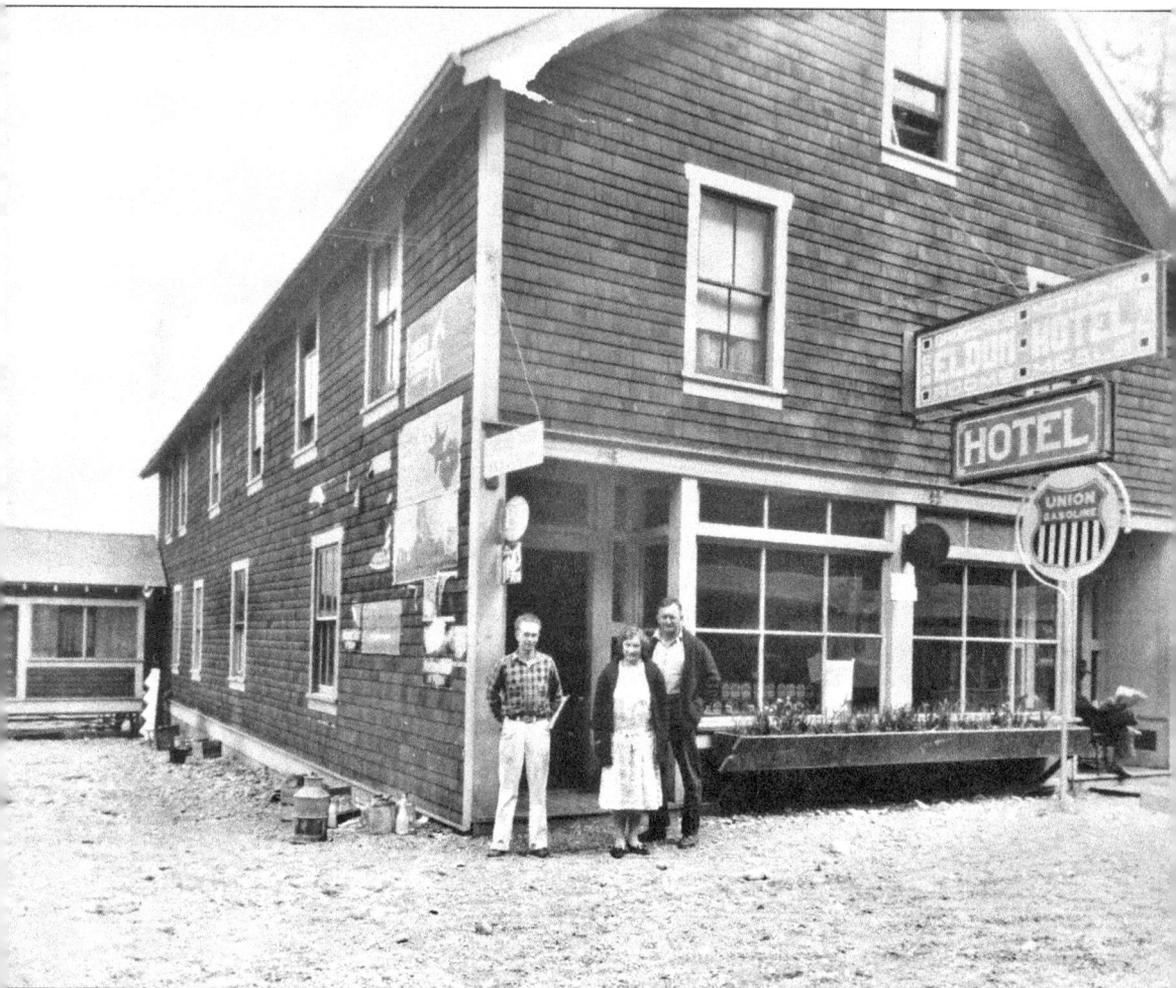

The Eldon Hotel was built in 1924–1925 to house the Hama Hama Logging Company boom crew, the train crew, and passing travelers. The company employees paid $1.40 room and board; the transients were charged $5 for a room and $1.20 a meal. From 1927 to 1932, Eva and Max Latzel (center and right in photograph) managed the hotel, grocery store, and fountain, serving Green River soda, much to the delight of local children. Max later owned a dairy in the Skokomish Valley.

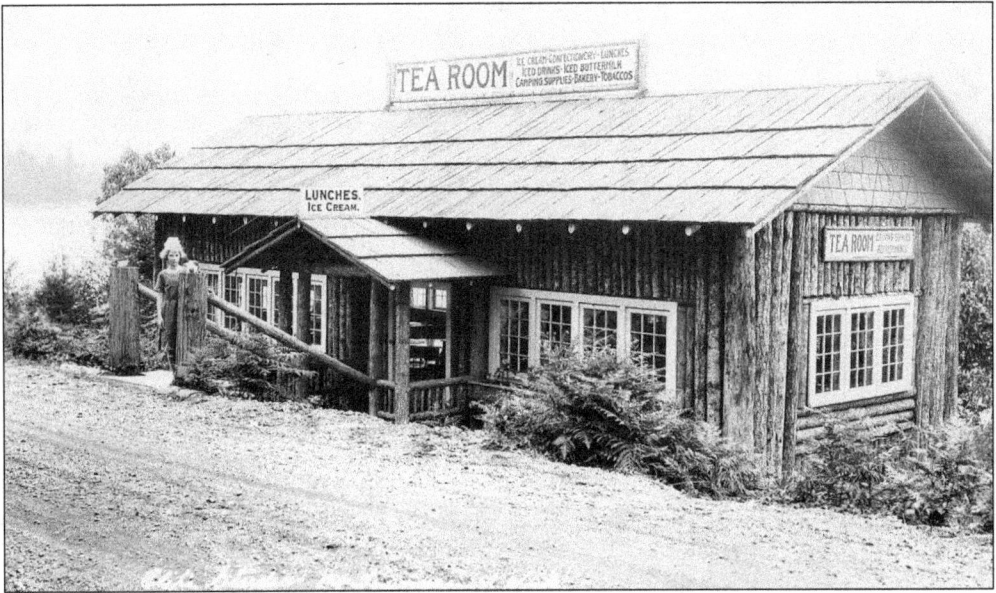

The Tea Room was across the highway from the well-known Olympic Inn resort at Brinnon near Seal Rock. Guests of the resort could visit for an afternoon tea or iced buttermilk. The inn burned in 1936, but it was repaired and operated until the land was sold for homes. The Tea Room— like many early tourist buildings—was built from indigenous timbers and shakes.

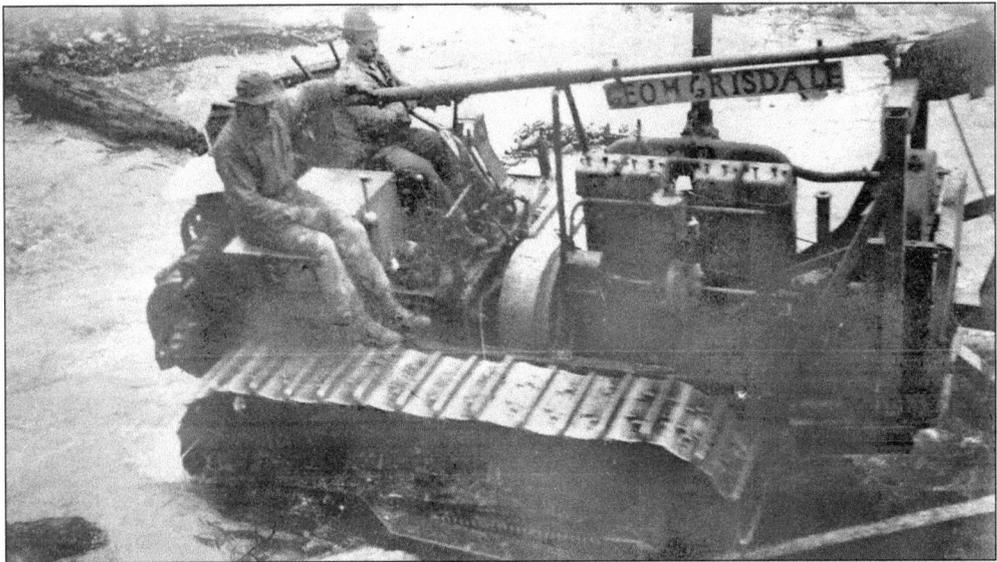

A George Grisdale bulldozer navigates up Wicketickeh Creek and over a creek bottom full of boulders. With no gravel bottom suitable for spawning, Henry Allen called the creek "no salmon run up." According to Twana legend, Dukwibal, the Transformer, slipped on the boulders when crossing and cursed the stream. In the 1920s–1930s, Grisdale logged timber on the canal's west side, and then he built a summer home near Union, on the canal's south shore.

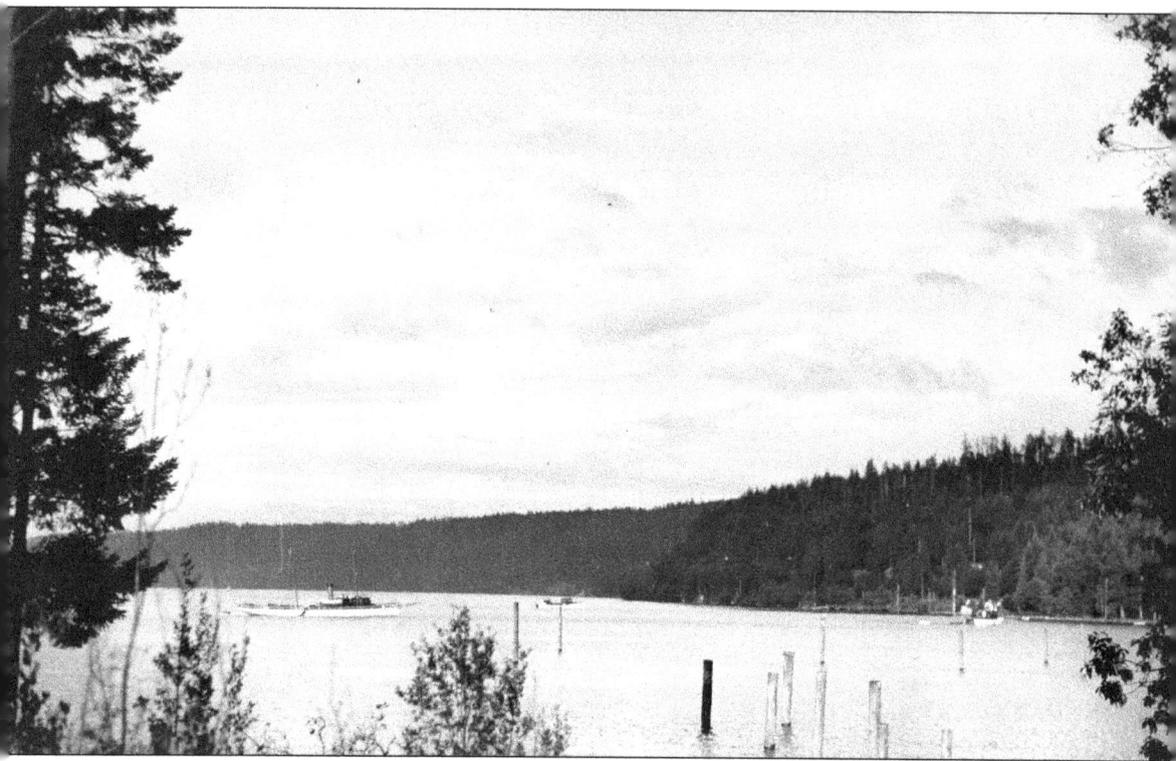

From 1896, the U.S. Navy fleet would call on Puget Sound ports, including Seattle and Port Angeles. In 1938, a federal patrol vessel penetrated the placid canal waters. The military presence foreshadowed the eventual establishment of Bangor Submarine Base on Hood Canal.

## Four

# BELFAIR AND NORTH SHORE ROAD

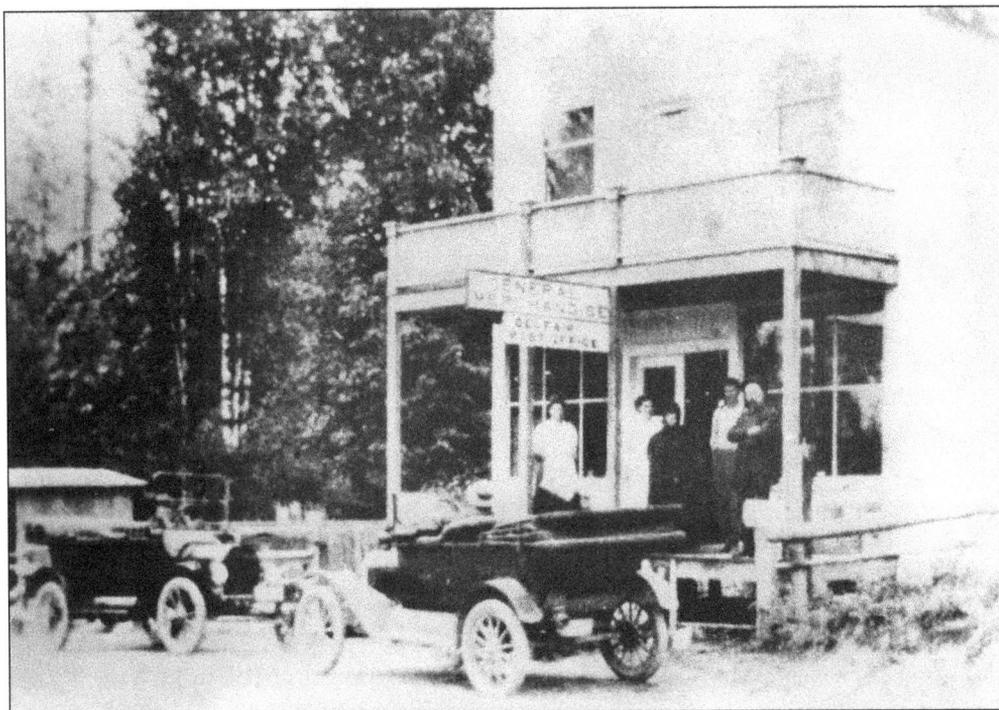

In 1915, the "new" Belfair Store and first post office was built on the North Shore Road near the Union River by John Murray, the first Belfair postmaster, and his wife, Elizabeth. Sam and Mary Theler began managing the store in 1926. Mary served as Belfair postmaster from June 1929 until 1944.

In 1915, the first Belfair School was hammered together near the Union River. This replaced the 1880 Clifton School. The 1916 school term educated 22 students. A popular annual event was a baseball game with rival Allyn School. The building was used until 1937, when the Chalet School opened on the almost-completed Navy Yard Highway.

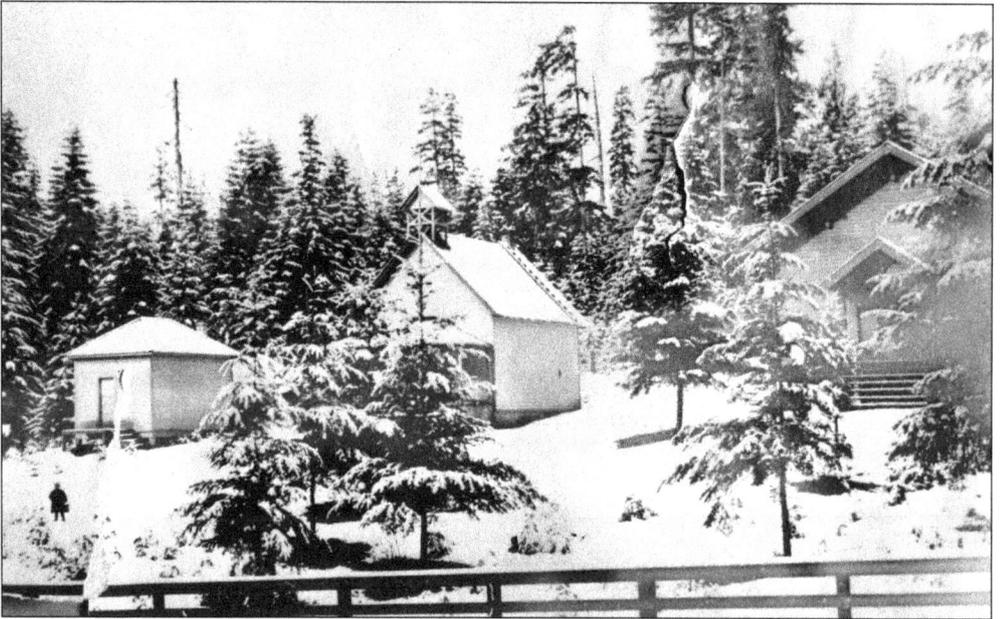

Each Hood Canal community's first and proudest building was the school. In 1917, the Tahuya School District had not only a one-room schoolhouse, but also a gymnasium (right) and a teacher's cottage. From 1914 to 1917, Bellingham Normal graduate Orre Nobles taught music and jewelry making as well as reading, writing, and arithmetic. The Tahuya school district's 99 percent attendance was the highest in the county. With his family, Nobles later developed the Olympus Manor, a China-themed resort near Union City.

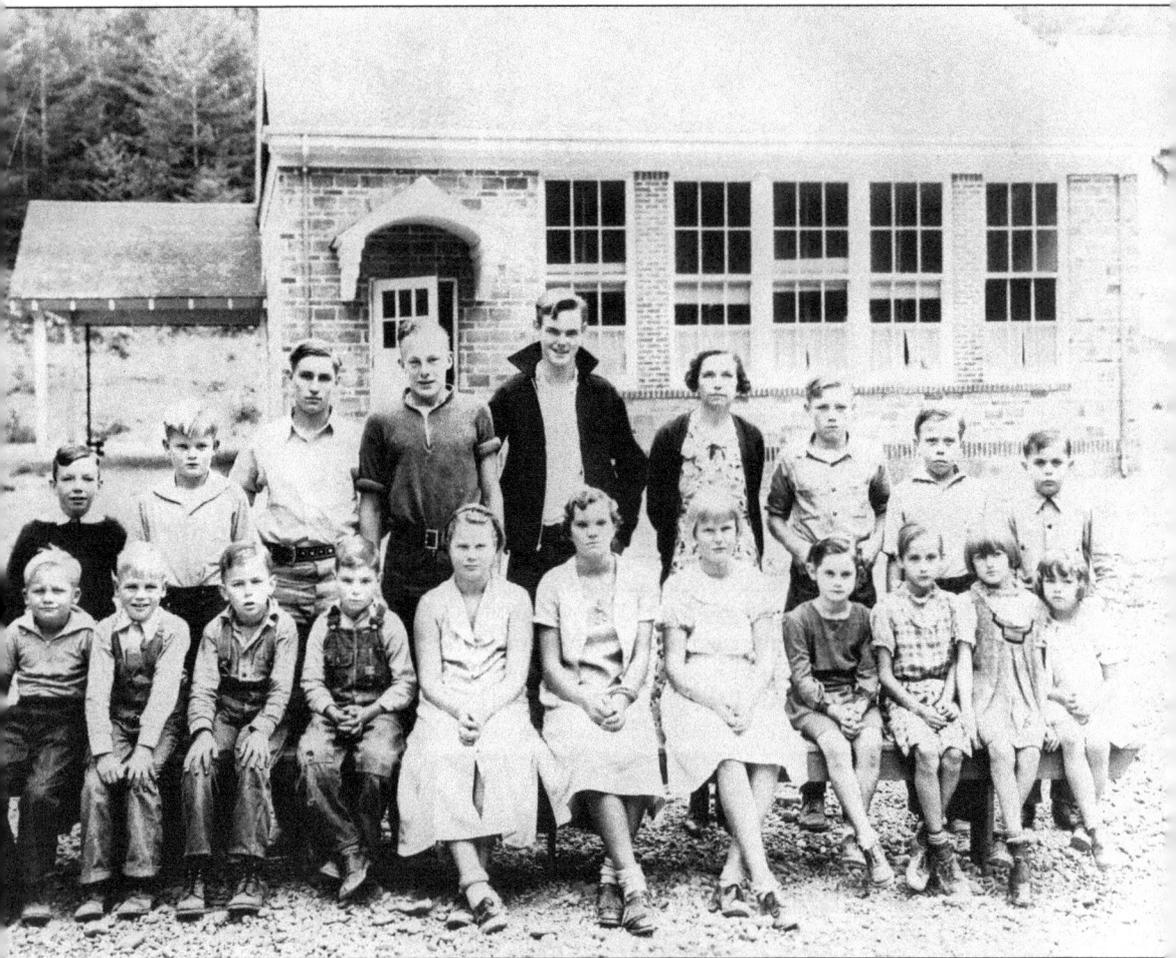

The Tahuya School was designed similarly to the Dewatto schoolhouse. This 1935 photograph of the students of District No. 20 is before the consolidation of the Hood Canal schools. In 1913, Mason County operated 50 schools. In 1936, Tahuya had 250 residents, who were principally loggers, including the McFadden, Mickelson, Rendsland, Gabelein, Leiske, Dobson, Dupruis, and Art Bunn families. Frances Huson served as postmaster.

By 1912, Rodney White homesteaded 160 acres near Maggie Lake, but he lived at Tahuya. He and the other blacks were likely hired from Roslyn to tunnel an 800-foot mine for John McReavy. White survived a rowboat accident in which three of the five passengers drowned. White made a sled of vine maple for his two burros, Babe and Baltimore, and two oxen, Duke and Diamond; he also built a road to Dewatto by himself. He called himself the first "white" man on the Tahuya Penninsula.

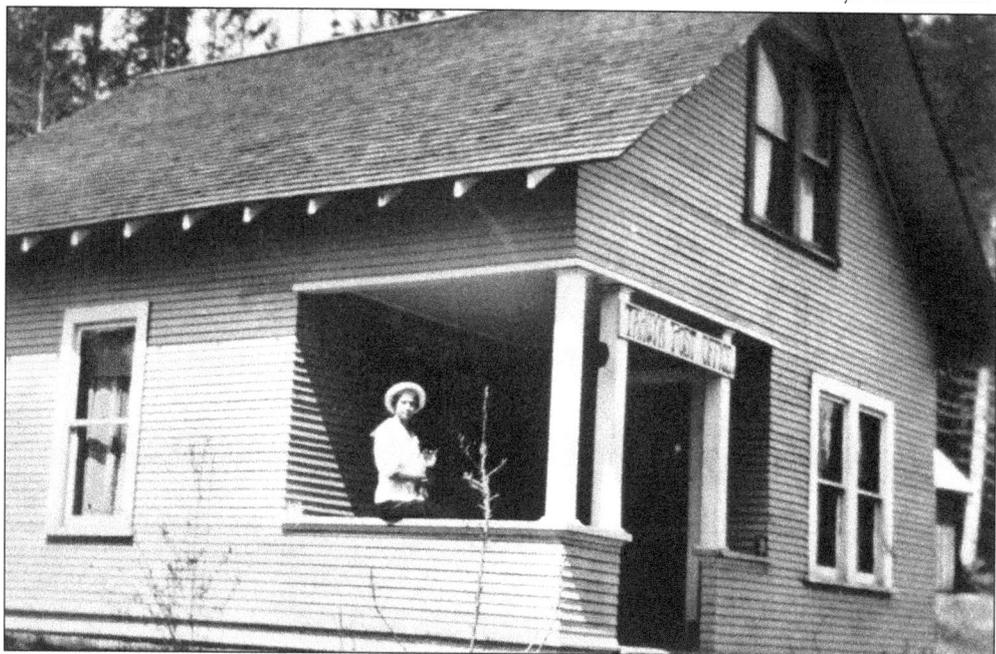

In 1915, the first Tahuya Post Office was established in the home of John Rolie, located near the Tahuya River mouth. Rolie converted a bedroom into the post office by cutting a door directly to the covered porch. The U.S. Postal Department changed the spelling from Taheyeh, meaning in Twana "that done." The winter village was burned around 1860, when the Native Americans were moved to the Skokomish Reservation.

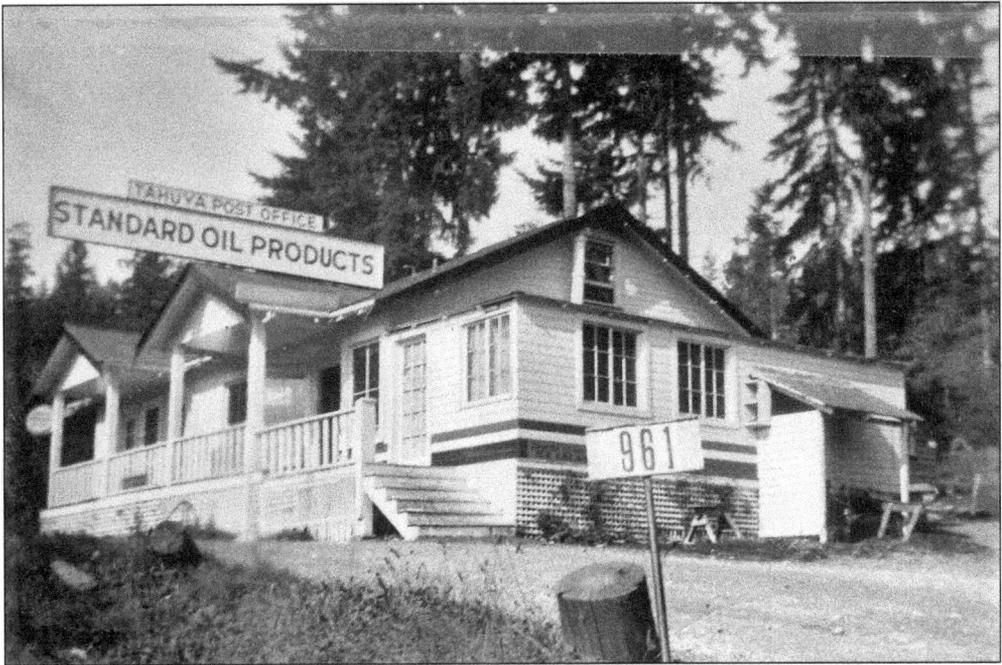

In 1931, the Tahuya Post Office moved to Jorgen Coldevin's, Rolie's neighbor. He set up the post office in the bathroom, so when the bathroom was used, the post office was closed. Even in those days, Standard Oil delivered to the end of the road.

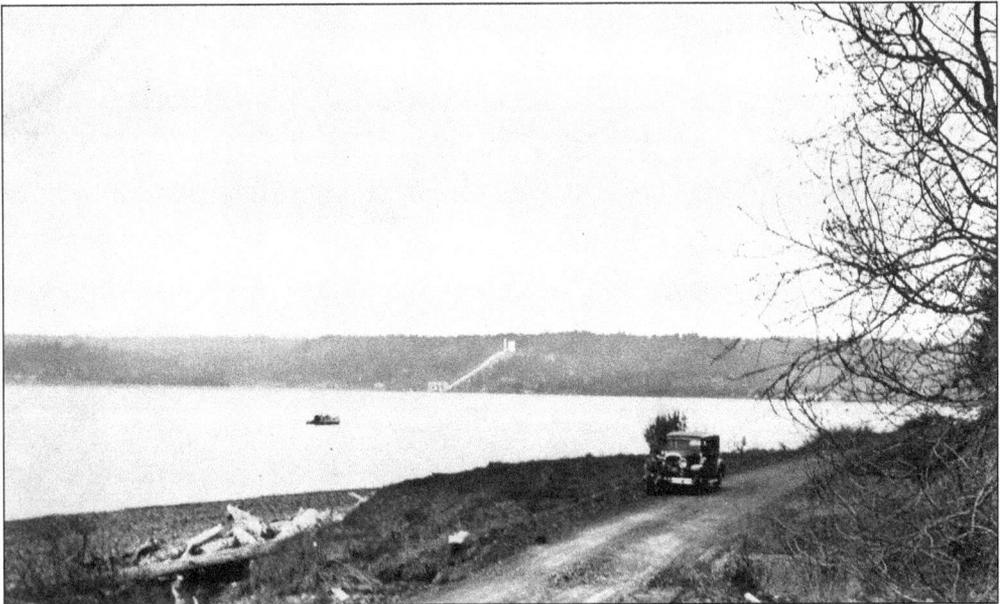

The North Shore Road offered driving challenges even after 1936, after the second Cushman Dam's powerhouse was built. With the road, school buses could transport children, though frequently bridge collapses or seasonal landslides caused lengthy delays.

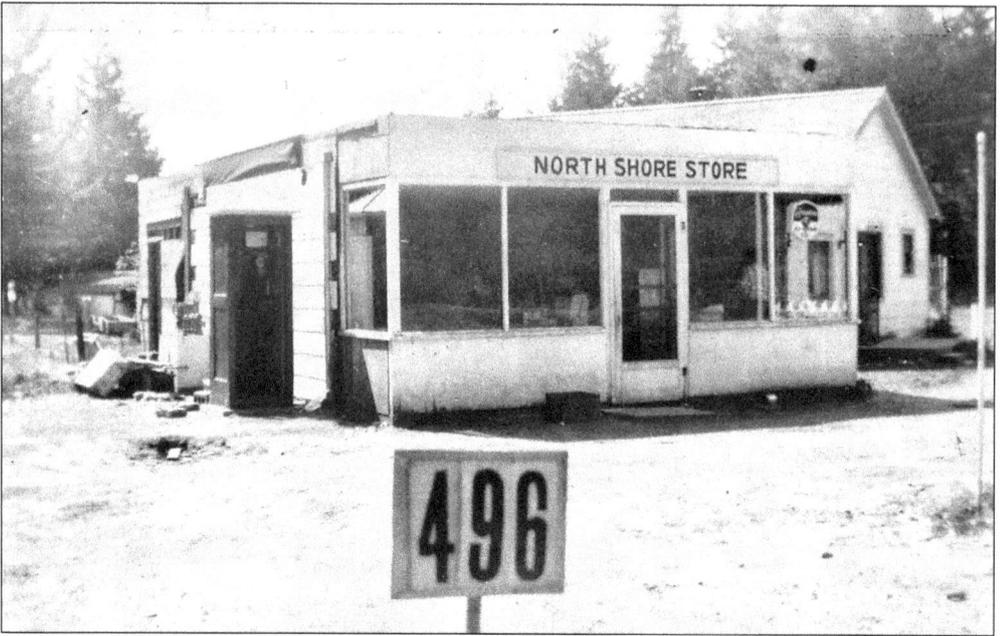

The North Shore Road connected Tahuya and Dewatto to Belfair and the road to Bremerton. Some sources say the road was much more windy and twisted in the 1920s than it is now. The North Shore Store offered groceries to all those motorists, a sort of early fast-food quick stop.

Dewatto is another river valley issuing from Hood Canal's east shore, north of Bald Point. It has imposing views of the Olympic Mountains. Early settler Monroe Nance built the *Nellie G. McReavy* in 1886 and used it to haul mail and freight, tow logs, transport lumber, and fish around the canal. After logging in the 1930s, larger farms emerged after the root wads were burned out. In pre-white times, people from all over the canal camped at *duwa'tax* (Dewatto) for summer and fall salmon.

This 1935 photograph shows the Dewatto schoolgrounds. On the right are the gym and swings; in the center are the schoolhouse and students; and on the left are the teacher's house and bus garage. Built in 1929 to replace an 1897 log schoolhouse at nearby Harrison, it had a front with large windows to view the Olympics. In 1936, a stage ran daily to Bremerton and a freight boat ran twice weekly to Seattle. During World War II, buses ran daily to the navy yard. The school closed in 1944. In 1991, Dewatto electrical hookups almost doubled from 8 to 14.

Sam and Mary Theler were well liked and prosperous in 1938. Mary was active in Belfair community dances, dinners, and plays. Sam was a community businessman. In 1935, the couple had just purchased 500 acres and platted them into the Sam Theler Home and Garden Tracts. They donated land to lodges, churches, and schools. His will left much property to the community.

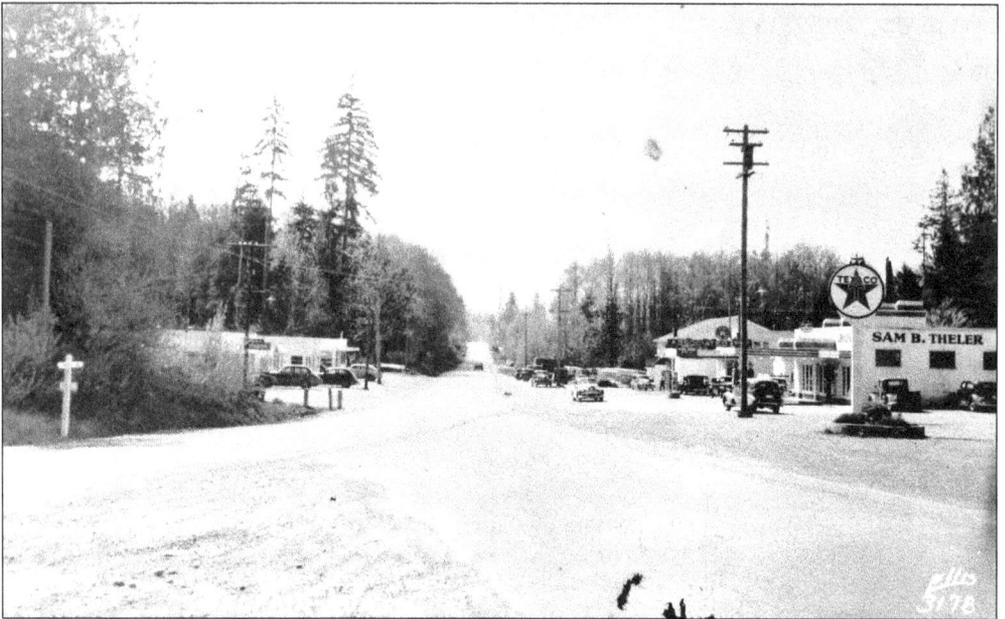

By 1936, the new highway passed Belfair by a half mile to the south. Sam Theler built his third and final store, and he offered meats; his neighbor offered Texaco gas to those touring Hood Canal's south shore by the Navy Yard Highway. After the bypass, a "New Belfair" quickly sprung up as businesses moved to the new junction.

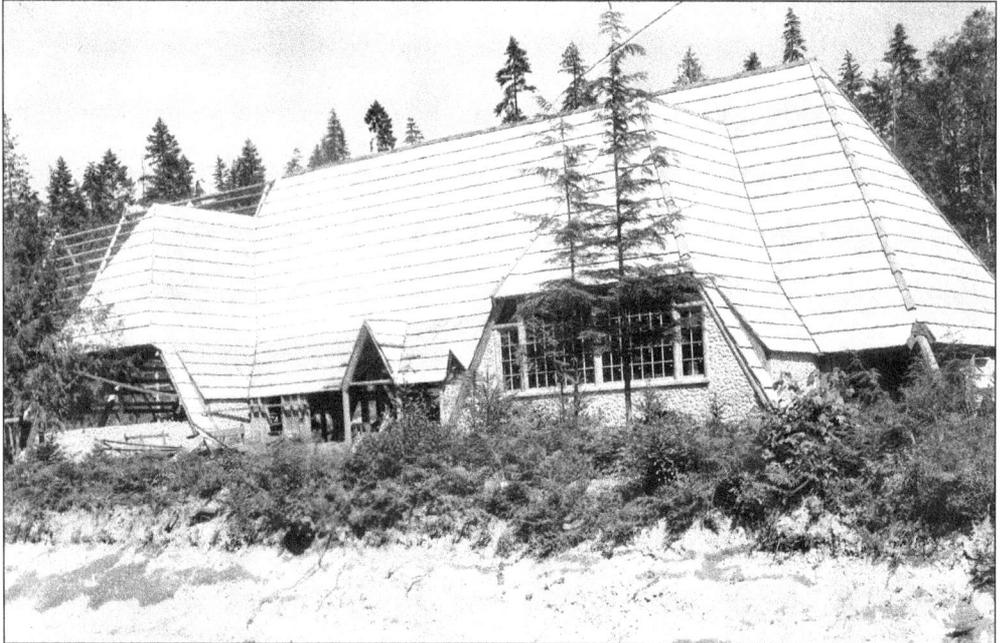

The Belfair Chalet School, designed by Bremerton architect Paul Ford, was finished in 1937 as a WPA project, with the WPA hiring men whose children would attend the school and using materials gathered from the canal forests, including hand-hewn fir and cedar logs, cedar shakes, and rock and gravel for the foundation. Sam and Mary Theler donated the land. The chalet was torn down in 1971, but the Theler Wetlands Center borrows from that Depression-era architecture.

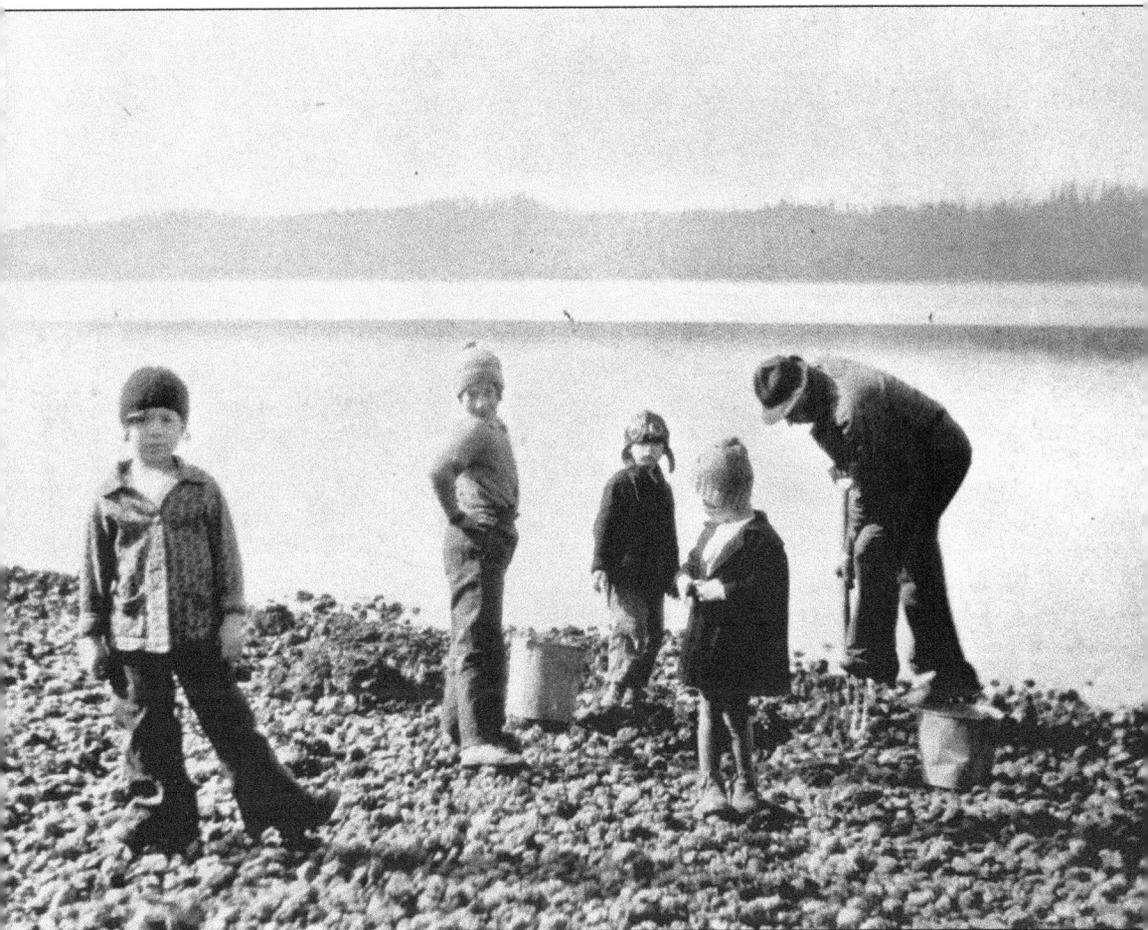

Clam digging has always been popular, no matter what the age or dress—even at Rose Point in the 1930s. Henry Allen reported that the Twana camped at the site while herring and salmon fishing.

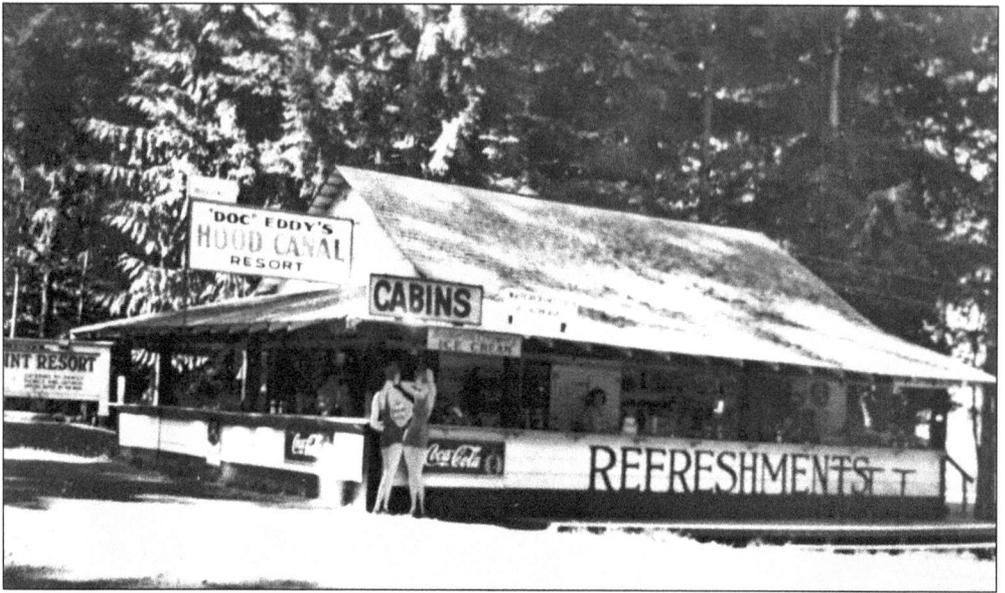

"Doc" Eddy's Hood Canal Resort was built in the late 1920s and offered rented cabins, leased fishing boats, and provided a dance hall. This popular resort operated until 1943, when a big snow collapsed the hall roof. After the war, the property was sold individually for home sites. Resorts dotted the Navy Yard Highway after it was built in the 1920s, though many closed after the war; perhaps tourists so enjoyed the canal that they became summer cabin owners themselves.

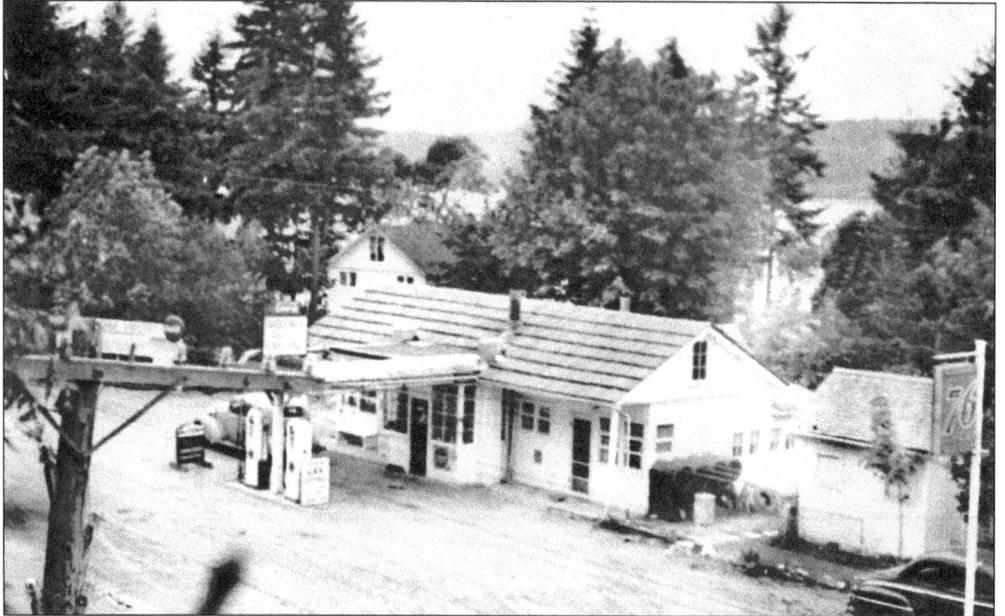

In June 1950, another gas and grocery stop on the South Shore Road—the postwar name of the Navy Yard Highway—was the Sunset Beach Grocery. Sunset Beach was developed in 1931 with summer rental cottages on the beach, though they were soon sold for private residences. Many visitors also would stop at the Chateau 7/11, a bottle club with a distinctive rock-and-petrified-wood fireplace. Bottle clubs were dance clubs where the patrons would drive to socialize after they purchased alcohol from state-licensed liquor stores.

Belfair in the 1950s offered hospitality services. Barker's Cabins were located on the east side of Highway 3, south of the Belfair School. The best road from Belfair was toward Bremerton, and in fact, the Bremerton Chamber of Commerce led efforts to build the Navy Yard Highway, which opened in 1927. Many residents worked in the Bremerton Shipyard, while other family members operated resorts or stores or shops along Hood Canal.

After World War II, Belfair's first fire department was housed in a Quonset hut. Among the volunteers is Robert Boad, standing on the driver's-side running board. Military surplus aided with several Hood Canal community projects as growing populations required more services.

73

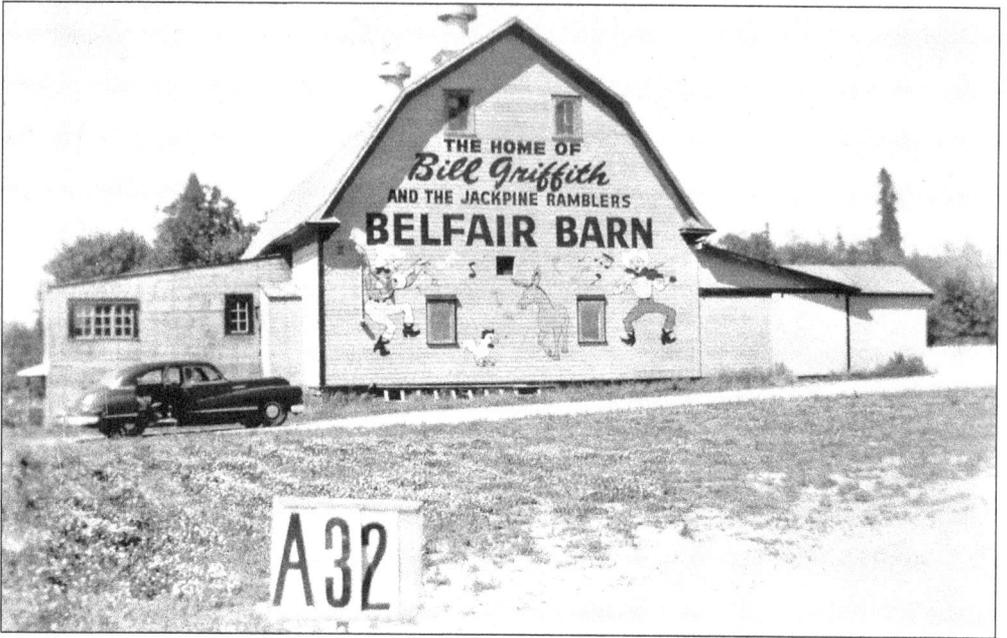

Used to store Joe Bulduc's automobile before 1920, this barn later became the Belfair Barn, a hot Saturday night dance spot and the home of local favorite Bill Griffith and the Jackpine Ramblers.

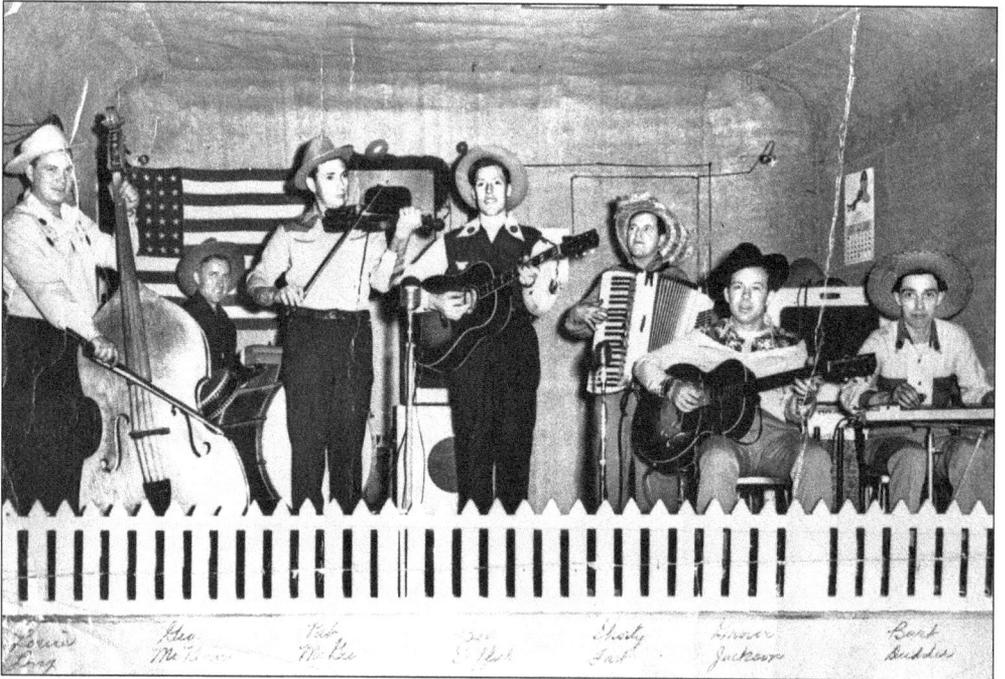

The 1950s country-and-western band Bill Griffith and the Jackpine Ramblers kept dance fans from Bremerton to Dewatto swinging at the Belfair Barn. Band members included (from left to right) Louie Long, George McKeown, Pat McGee, Bill Griffith, Shorty Fast, Grover Jackson, and Burt Dudder.

# *Five*

# NAVY YARD HIGHWAY AND SUMMER RESORTS

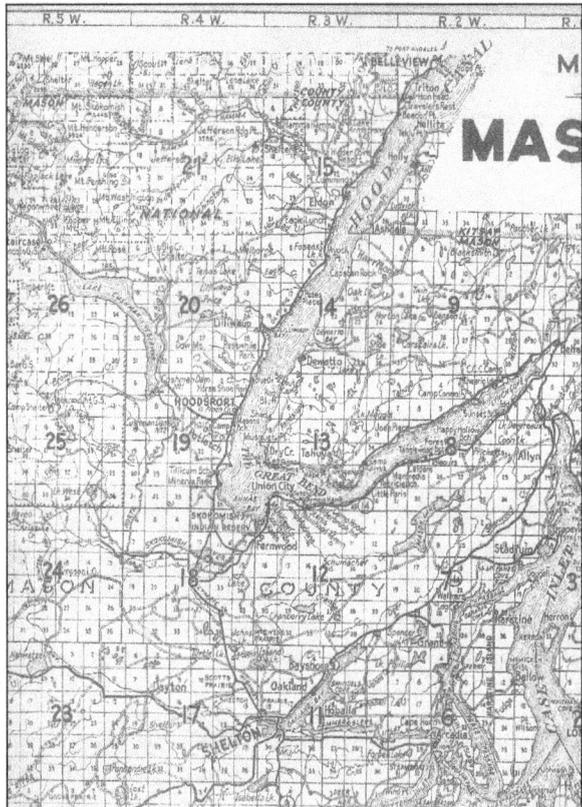

By 1941, several resorts were located on the south shore and the Navy Yard Highway, while along the canal's west shore, shaded by the Olympic Mountains, there were more parks for automobile camping. The setting sun lingers along the south shore, and the winds usually shoot down the canal, unable to make the Great Bend turn. Also of note are CCC camps, the Phoenix Logging Company railroad, and the Skokomish Reservation.

The Navy Yard Highway from Belfair through Union to the Olympic Highway 101 was not only critical to transport tourists from Bremerton to Hood Canal, but also to link Camp Lewis and the Bremerton Shipyard. In 1922, the state assumed control of the gravel-based, county-owned South Shore Road and widened it from a 40-foot to a 60-foot right-of-way. By 1927, Bremerton Chamber of Commerce president Wilfred Jessup led a 100-automobile convoy down the newly paved Navy Yard Highway. The highway opened up the canal to many new camping sites for tourists, and resorts for both fishing and families docked on the beach, including Doc Eddy's Rose Point, Robin Hood, Alderbrook, and Olympus Manor.

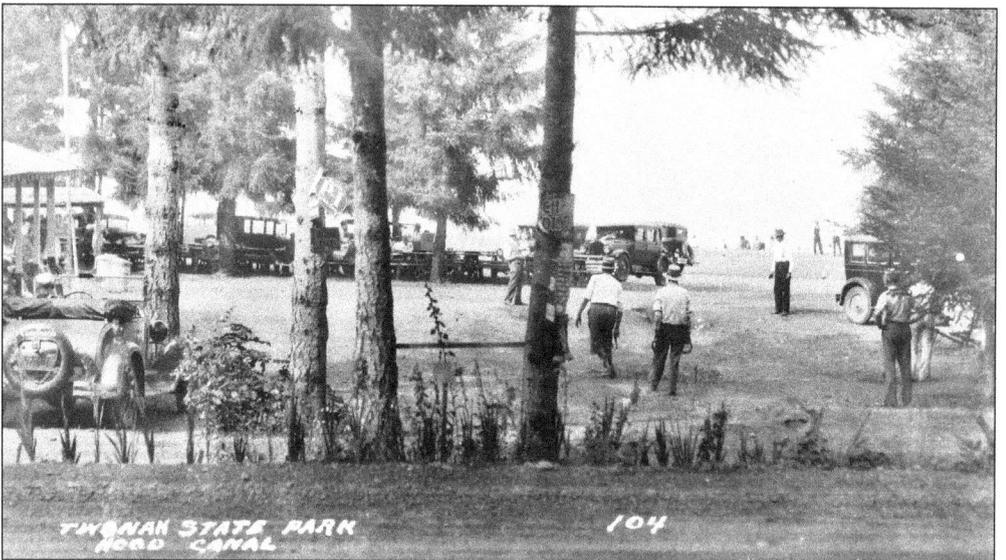

On June 9, 1923, the 35-acre Twanoh State Park was dedicated, the state having purchased a $4,000 note from Tacoma National Bank. It was Washington State's first land purchase for a state park. In 1936, one hundred and twenty acres were added. In 1936–1937, a CCC crew from Medora, North Dakota, Unit No. 4728, used local stone and logs to build picnic shelters, a park kitchen, restrooms, and the superintendent's house. The men in the middle are pitching horseshoes. The park offers campsites as well as beach access and was a favorite weekend site for families from Bremerton. The Twana had a camping site at Lone Tree Point.

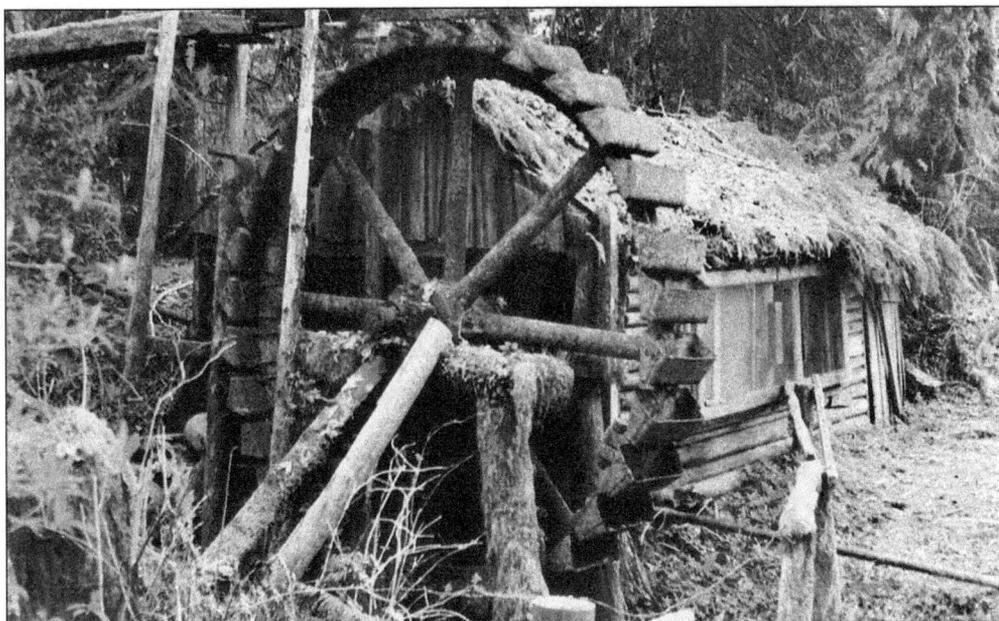

The waterwheel power plant was probably the most photographed scene on Hood Canal. Ed Dalby built it in 1922 to provide electricity for his residence and the Dalbys' 13 rental cabins. However, because it generated only direct current, the lights had to remain on continuously. By 1935, Dalby repaired it for the navy yard tourists. Electricity from PUD No. 1 replaced it in the 1940s. After the highway was moved in 2004, a local group raised funds and moved the building to a new site adjacent to the new highway for south shore tourists.

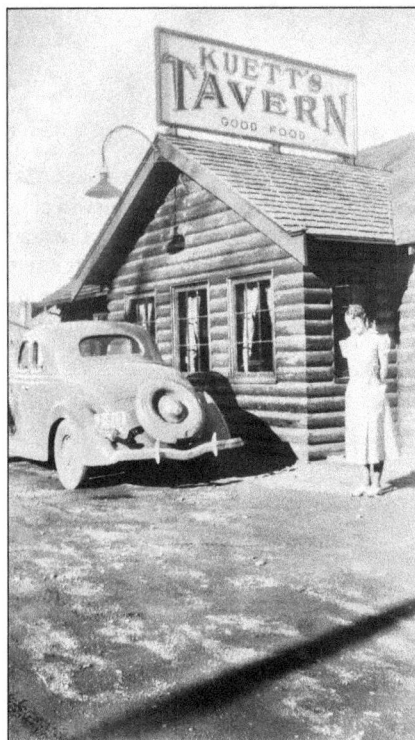

In 1935, after the repeal of Prohibition, Bremerton businessman Kuett, owner of the Charleston Club, built Kuett's Tavern at Union City, right on the newly completed Navy Yard Highway. Waitress Dot Bickel waits to greet customers. In addition to "Good Food," Kuett's offered fishing supplies and rowboats. One female fisherman hooked 22 salmon just trolling over to Bald Point. Kuett's Tavern burned down in the 1950s.

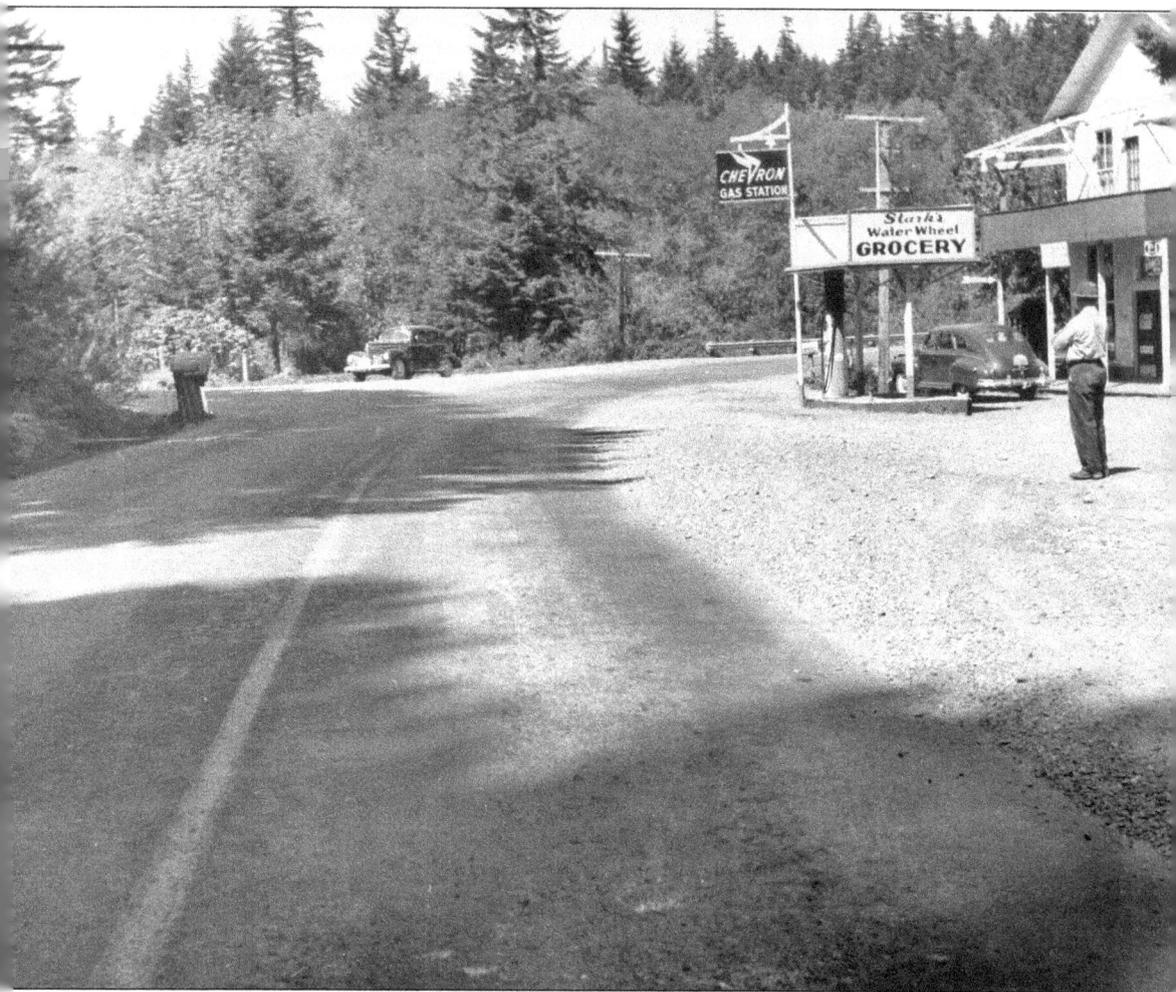

Merritt Stark owned the Waterwheel Grocery from the 1930s to 1950s. The next owner named it Gwen's Waterwheel Grocery. Located between Robin Hood and Alderbrook, it was first built in the 1920s by Roy Simpson, a relative of logger Sol Simpson. Dave Dalby soon owned it and added the gasoline pump cover. No matter who owned it, however, from the 1920s to the 1960s, children delighted in the Waterwheel's penny candy.

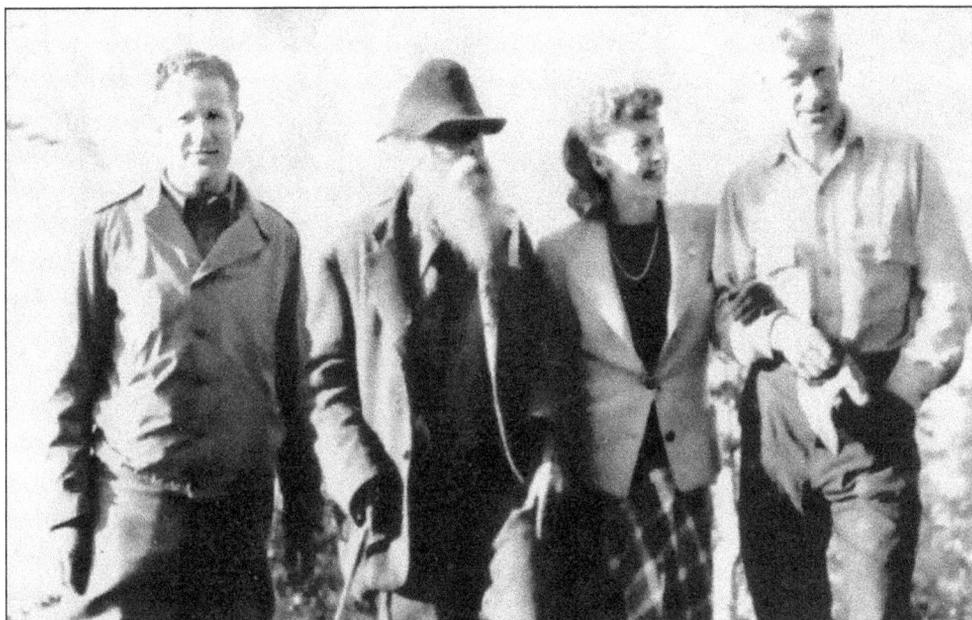

In this 1938 photograph, (from left to right) Louis Karl Weinell, Frank Pixley, unidentified, and Orre Nobles pose during construction of an Olympus Manor three-fourth-size "cottagette." Louis Karl Weinell was a neighbor as a boy, and he returned to sing classical music in Orre Nobles's Music Room. Nobles liked to be known as a friend of the famous, including popular poet Don Blanding, heavyweight boxing champion Gene Tunney, and political writer and correspondent Upton Close. Nobles's restless worldwide travel and artistic talent energized the artists' colony at Olympus Manor.

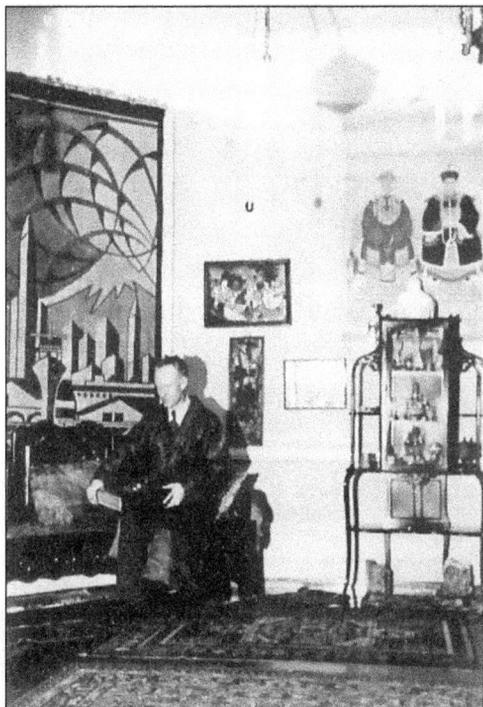

In 1930–1931, Orre Nobles took a sabbatical from his teaching at Ballard High School and from Olympus Manor to design art-deco carpets for the Helen Fette Carpet Company in China to export to the New York market. Nobles is seated in front of his stylized design of the Smith Tower on the Seattle waterfront. Nobles led several popular tours to China in 1935–1937, and his love for China influenced his design of Olympus Manor.

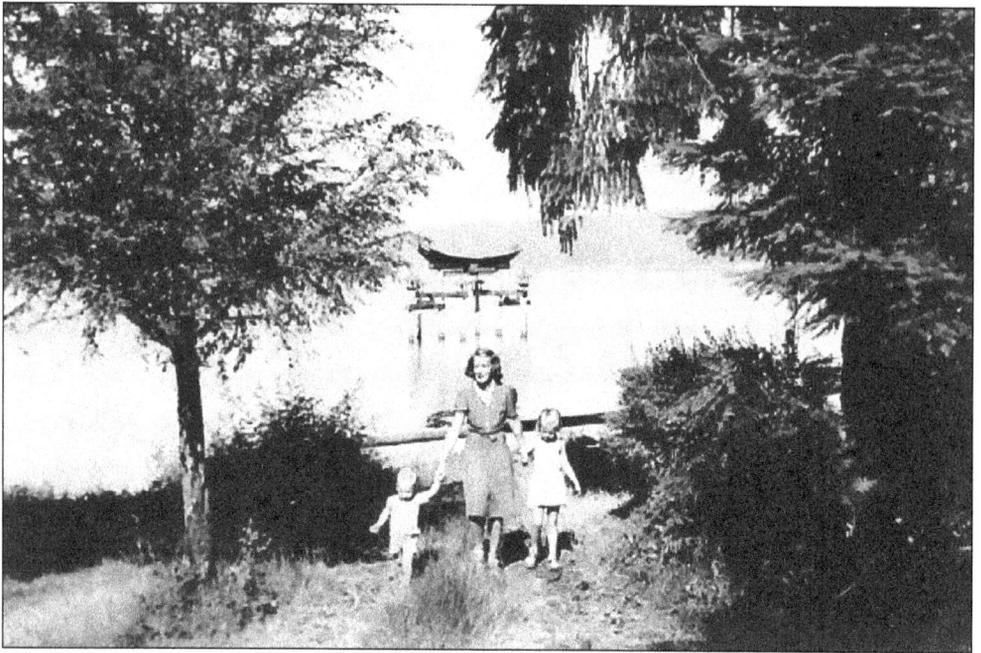

Orre Nobles's Olympus Manor captured the charm and joy of Hood Canal summers. Families with children could play on the beach during the warm days; after the children's bedtime, adults could enjoy classical music and warm camaraderie in the Music Room. In the water, the Torii gate welcomed all visitors to leave the cares of the world there, just as they do in the Far East at the entrances to the holy grounds of Shinto temples.

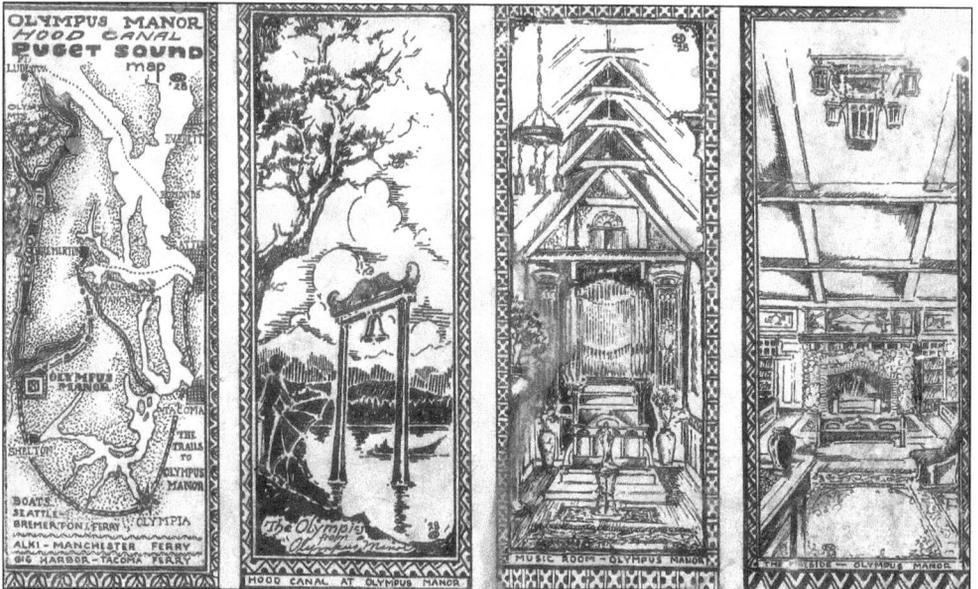

From 1924 to 1952, Nobles entertained the wealthy and the artistic at Olympus Manor. Beginning in 1928, in the high summer season, the Tacoma Drama League members stayed at Olympus Manor, posed for Nobles as he sketched them, paddled around the canal in Nobles's Native American canoe, watched plays, and attended concerts of classical music. In 1952, Olympus Manor burned to the ground.

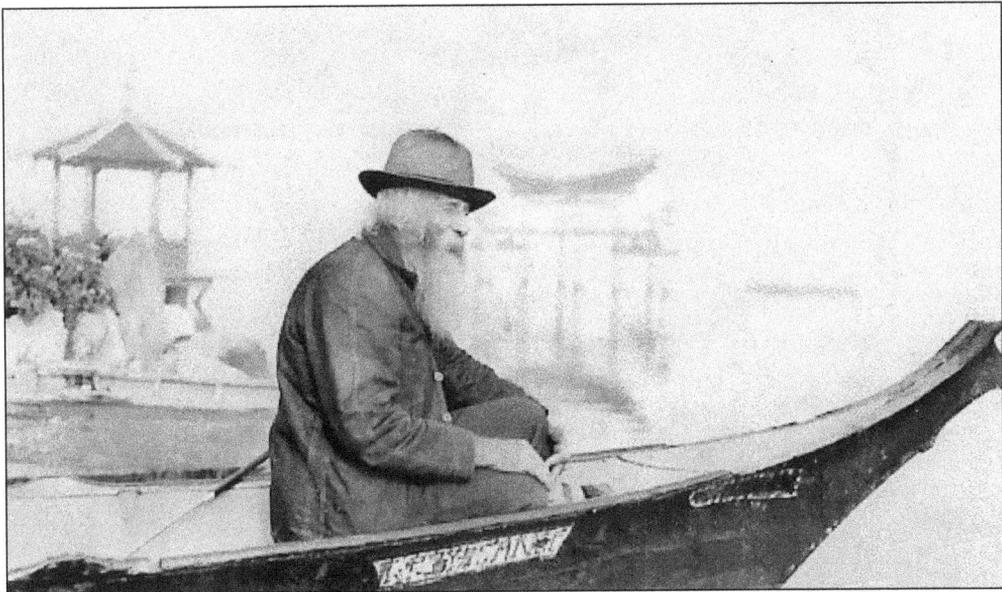

Morrison Frank Pixley was a San Francisco land developer who purchased much of John McReavy's Union City property from 1906 to 1916 with plans to found a new San Francisco free of what he called "small town mentalities" like law, religion, and morality. He built his home, Yachthaven, and sold land for Olympus Manor. He sits in the manor's Native American canoe with the manor's Japanese teahouse and the Torii gate in the background. He returned to California in 1950 and died in 1959, still remembered fondly as a foresightful and quirky eccentric.

Frank Pixley and his C. Morrison Pixley founded the Union Telephone Company as well as the water system to service his Yachthaven land sales. This 1935 Union telephone directory lists businesses and individuals. Even into the 1960s, a telephone operator manually connected the parties.

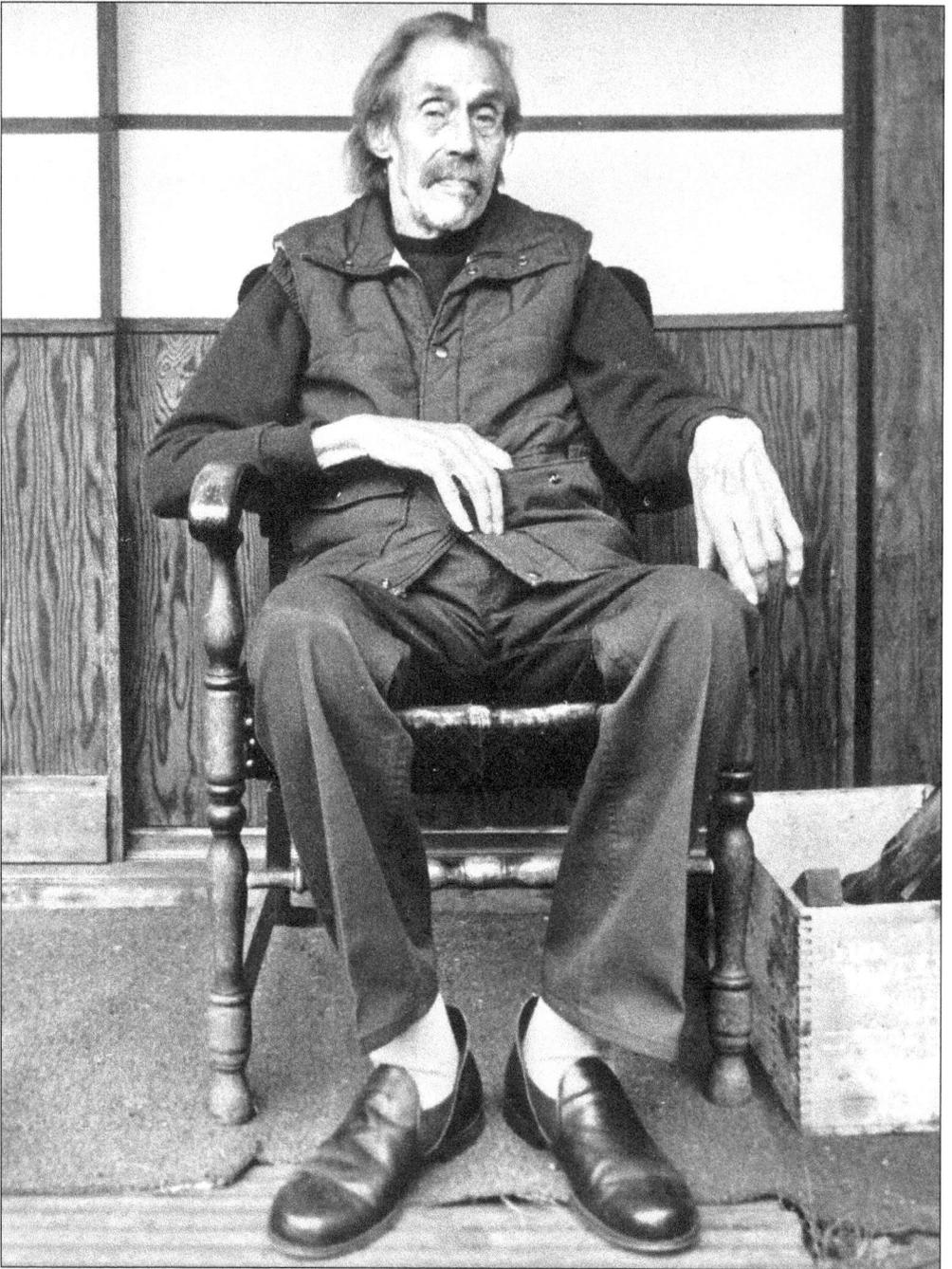

Waldo Chase (1895–1989) was a wood-block printmaker, artist, and philosopher. He and his brother Corwin lived in a teepee as part of the artists' colony that thrived on Hood Canal at Olympus Manor from 1924 to 1952. Waldo moved from Seattle to Hood Canal because of the serene beauty, the splendid isolation, and the cheap cost of living. He was a pacifist and a social critic who conceived the Hood Canal dollar barter system in the 1930s. As he aged, his printmaking declined, though his anti-establishment ideas attracted Vietnam veterans and hippies to his small cabin.

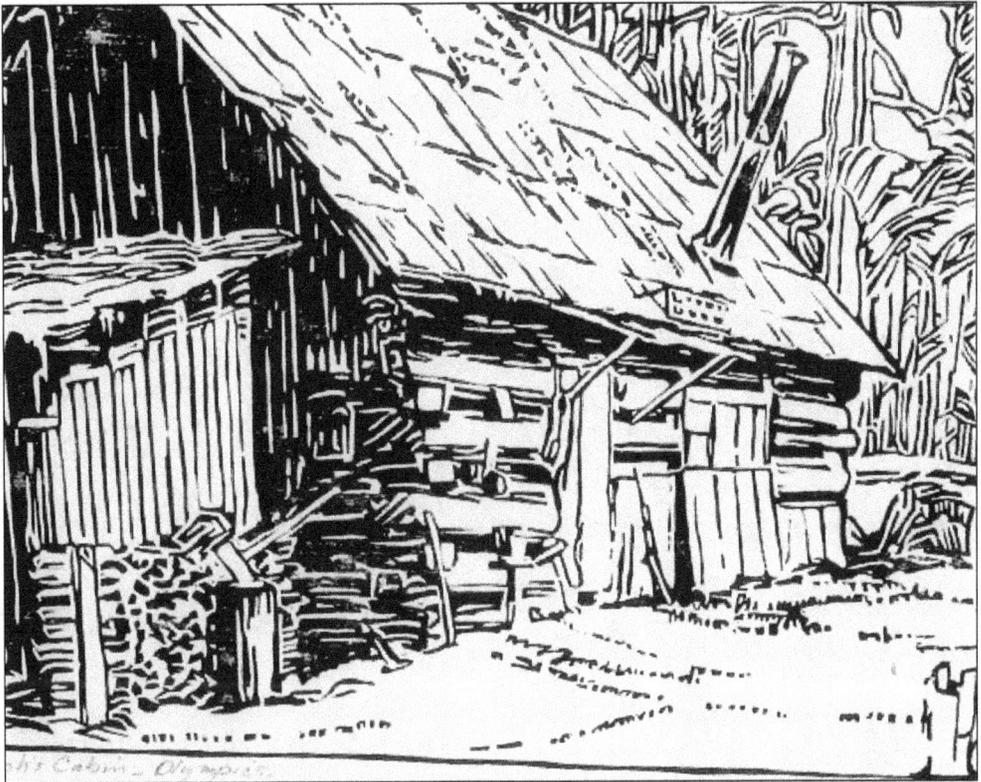

Waldo Chase's wood-block printmaking required that he carve a different block for each color. This early-1930s black-and-white design of Frank Church's cabin in the Olympics demonstrated the articulate detail of Waldo's carving, from the splitting ax by the woodpile to the comically ajar chimney. Prints from the block span from 1931 to 1988. Waldo was the spiritual center of the artists' colony at Olympus Manor.

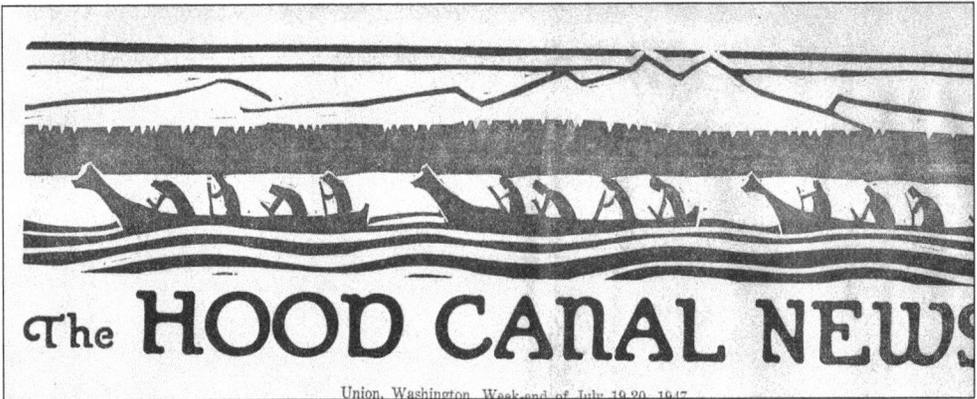

Three newspapers have reported on Hood Canal, including the *Union City Tribune*, 1893–1894; Hoodsport's *Hood Canal Courier*, 1932–1935; and Belfair's *Hood Canal News*, 1947–1951. *News* editor Cal Mann was a navy veteran who reported on fishing, be it salmon, smelt, or cod, as well as the water pollution and state-approved dragnetting and herring roe harvest, which decimated the fishing in Hood Canal. Waldo Chase crafted the *News* masthead of canoeing Native Americans.

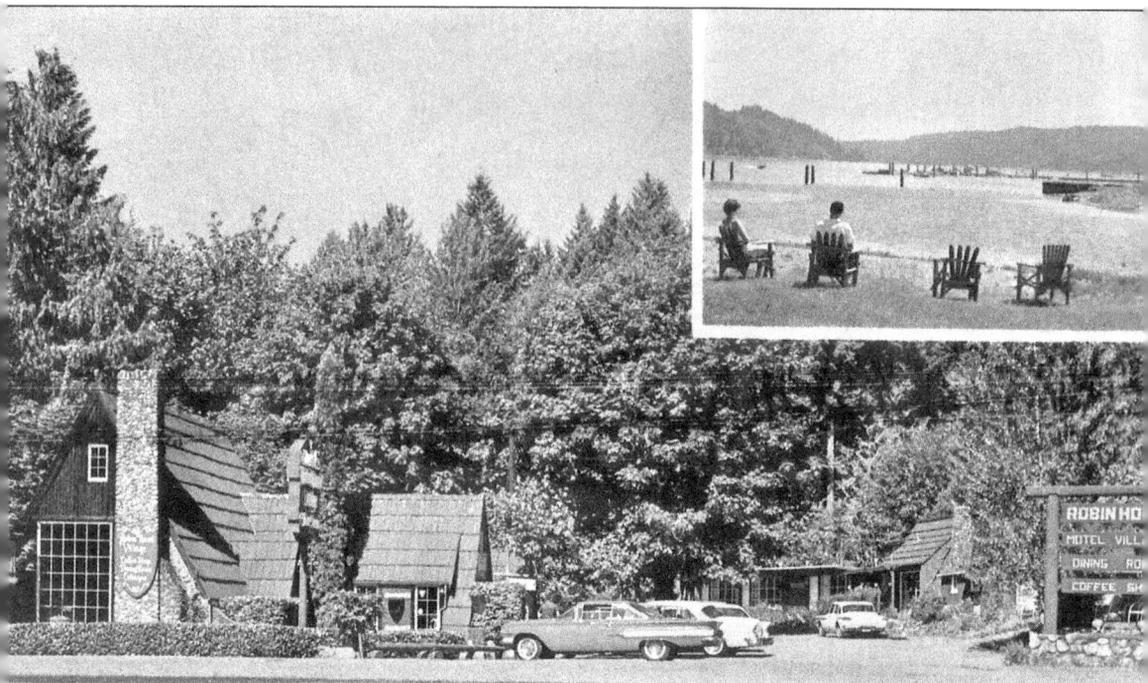

## At Union, Wash., on Famous Hood's Canal

Just around the cove from Alderbrook Inn, Robin Hood, with its chalet architecture, was built in 1934 almost like a movie set. In fact, owner Don Beckman was a movie-set designer and poster publicist who worked on the movie *Robin Hood* and originally named the lodge and cabins Nottingham Village. Robin Hood's dining room charms guests with its rock fireplace, vaulted ceiling, and fine food. Several roadhouses, restaurants, and resorts were built when Washington state liquor laws changed in 1934.

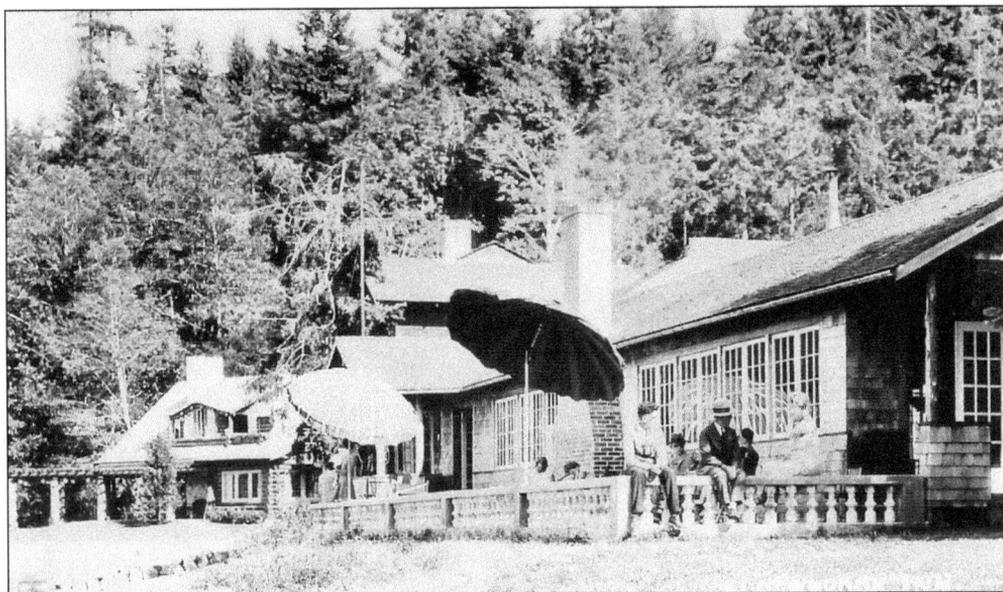

Since 1913, when Harold Stumer founded Alderbrook with tent cabins and attracted guests with the magnificent views and serene waters, the resort has grown in size and in elegance. Wes Johnson owned Alderbrook from the 1950s to 1970s and added a wing of rooms as well as a golf course and building lots. In 2004, Alderbrook expanded again when new owner Microsoft executive Jeff Raikes demolished the older rooms, remodeled the lodge, added an airplane-only docking area, and moved the state highway.

In this 1930s advertisement, Clara Eastwood and Eloise Flagg, owners from 1926 to after World War II, promoted Alderbrook as "the grandest vacation" and included not only swimming, boating, hiking, and fine dining, but also a visit to local "artist at the waterwheel" Waldo Chase as part of the canal vacation.

ALDERBROOK INN

DINING ROOM NOW OPEN

★

Serving Breakfasts
Luncheons     Dinners

★

RIGHT NOW is the time for you to resort to Alderbrook for the grandest vacation. Swimming, boating, hiking, fishing, putting on our popular green, or just relaxing and inhaling the salt air give you a keen appetite for Alderbrook's delicious cuisine! For dinner Reservations, telephone Union 231.

2 Miles North of Union     HOUSE KEEPING COTTAGES
                           HOTEL COTTAGE ROOMS

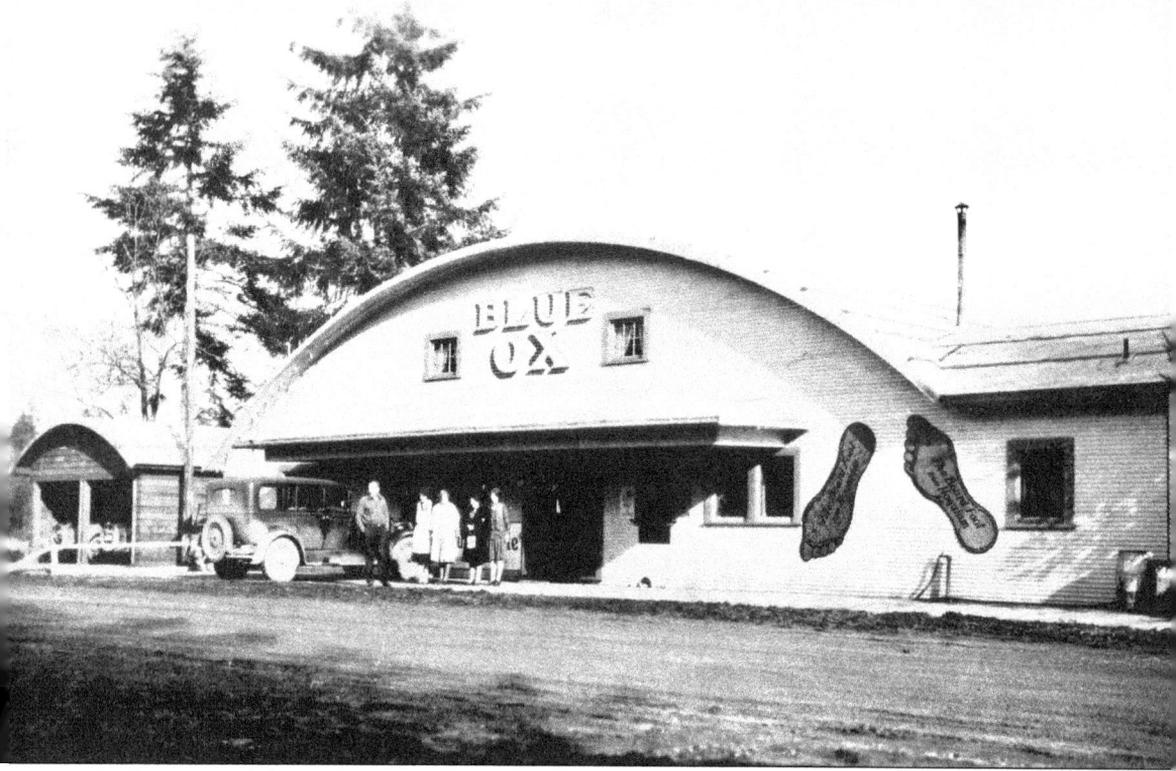

During Prohibition, the Blue Ox, named after Paul Bunyan's legendary companion, was opened north of Hoodsport by Edna Rae and Clarence "Dick" Shively, an ex–Seattle cop and bootlegger. The feet on the wall were two "Board Foot from Hoquiam." Shively's clients traveled the Olympic Highway from the nearby lumber towns to dance to bands like the Bremerton Flyers. Government agents regularly visited the roadhouse, but apparently few violations were discovered. The much-loved Shivelys entertained revelers every weekend, from Bremerton and Olympia boys to CCC workers, Phoenix Company loggers, and Shelton mill workers. And, of course, they all came to dance.

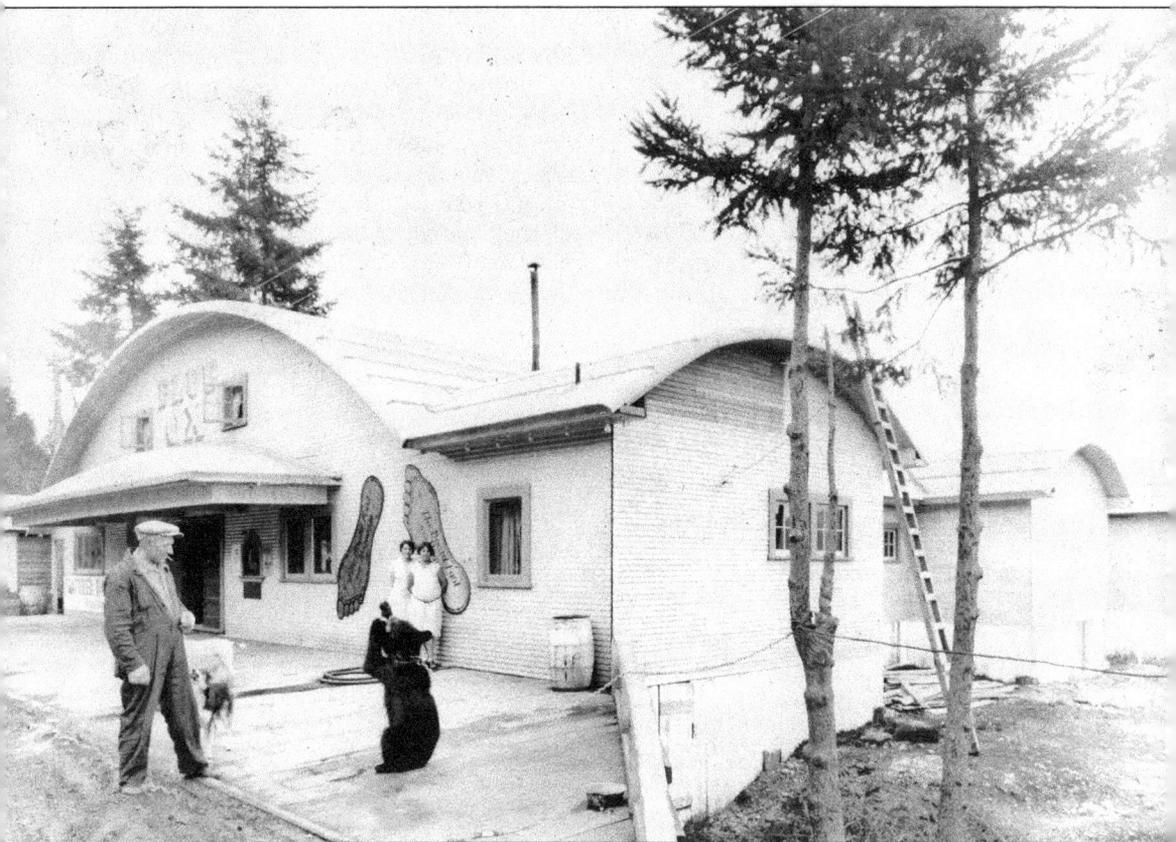

Dick Shively not only quenched his guests' thirst for drink and dance, but he also offered a pet bear, Jippo, as amusement. Other Hood Canal residents kept bears as pets. Apparently this bear is at the end of his chain, though the two women huddled against the building didn't exhibit Shively's and his dog Tuffy's careful courage.

Bootleggers and Blue Ox owners Edna Rae and Dick Shively are seen outfitted in their flapper and sartorial best. They led federal agents on merry chases by land and by sea—and by litigation. After selling the Blue Ox, the couple moved their business ventures to the Grand Coulee Dam project. However, although they no doubt serviced well their customers' desires, authorities soon broke up the joint. The couple eventually divorced, and Edna Rae returned to Mason County.

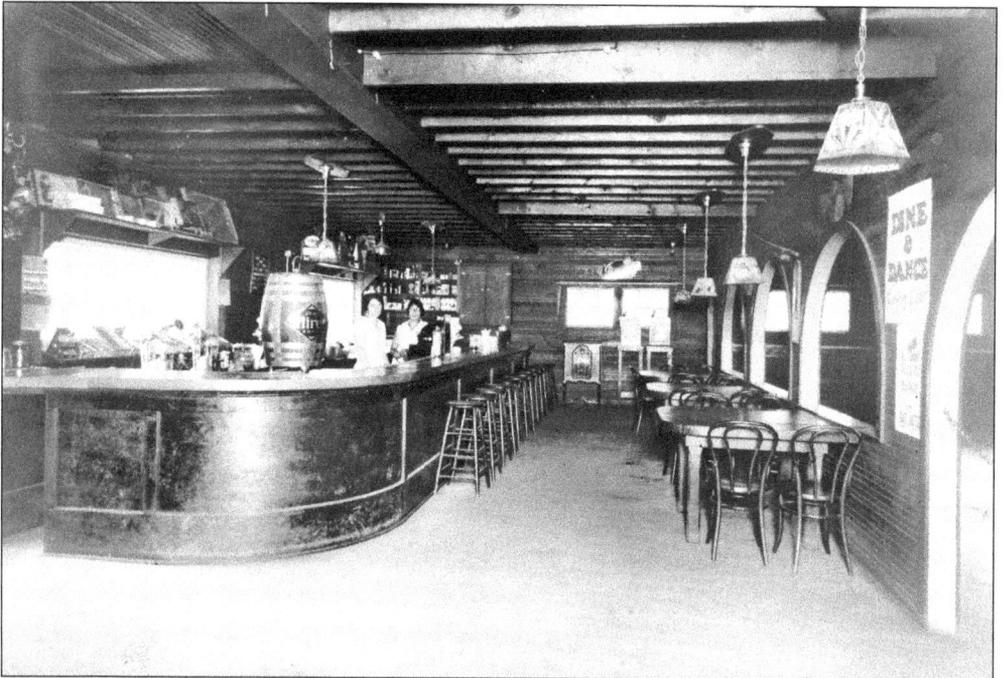

The Blue Ox interior was partitioned into a dance floor and a bar. Edna had a switch installed on her drink dispenser—to properly serve the patron, be it logger, lady, or liquor agent. The Blue Ox was considered by patrons not as a bottle club but as a bootleg club.

Blue Ox owner Edna Rae Shively lounged on a load of bootleg Canadian whiskey in the Victoria harbor. During the 1928 trip, the Shivelys motored through the San Juan Islands, trolling for bass before harboring at Smuggler's Cove. Rumors implied the bootleggers offloaded supplies along the canal passage, following the old mosquito fleet deliveries.

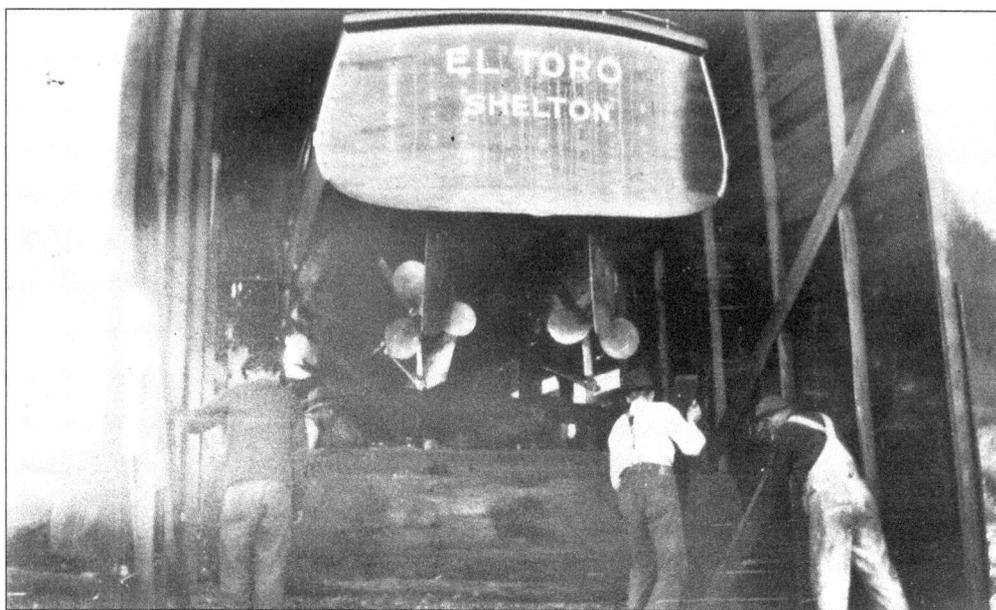

Dick Shively's dual-propeller *El Toro* was placed in storage; Edna's scrapbook scrawl read that Dick was "on vacation," likely for either bootlegging whiskey or bank robbery. The twin propellers greatly improved the *El Toro*'s power for hauling greater loads and also enhanced its speed and elusiveness.

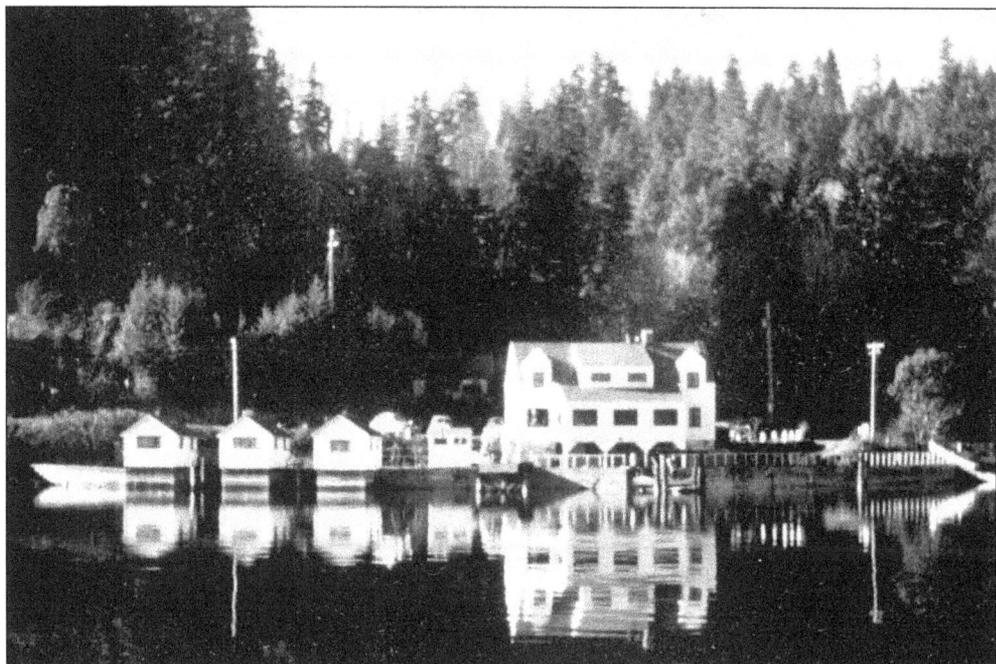

In 1937, Mel Bearden, an artist and land developer from Centralia, on Hill Creek, built a bulkhead, "a restaurant, several cabins and a dock," and, combining his wife's name and his, named it ClarMel Inn. He hung painted panels of Olympic Mountains scenes on the walls. In the early 1960s, pulp and paper company ITT Rayonier purchased it for a marine research laboratory. It has been unused in recent years. At Hill Creek, the Twana had a summer camp and harvested salmon.

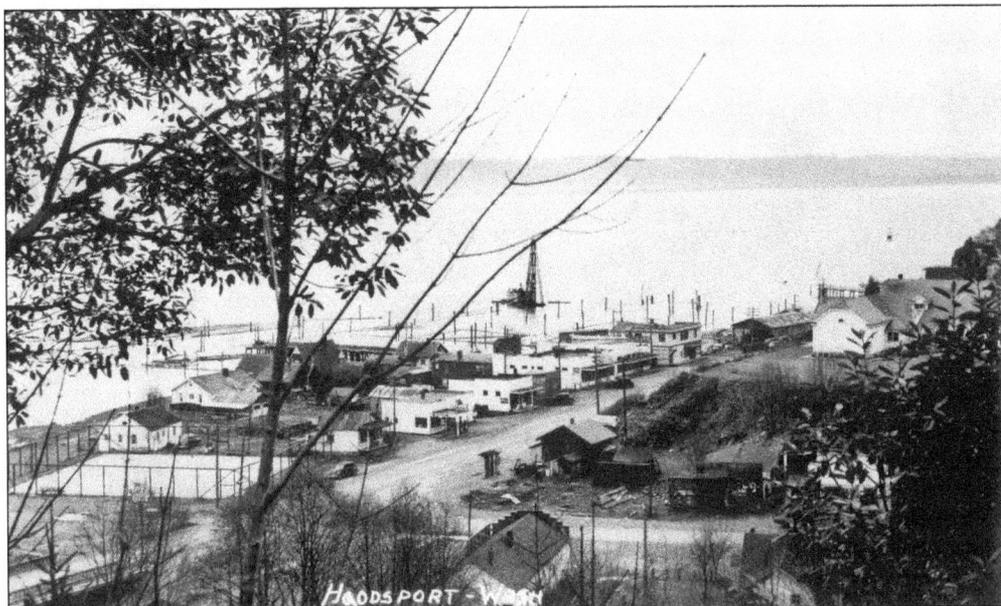

In the 1940s, Hoodsport bristled with a new school built by the WPA and with a pile driver in the tidewater. Although the Phoenix Logging Company had ceased operations, the CCC had been disbanded, and the Lake Cushman Dam crews had finished, Hoodsport was still vibrant with new logging in the U.S. National Forest. With the new tourist trade attracted by the Olympic National Park, it renewed its identity as the gateway to the Olympic Mountains.

In 1945, Bob and Jean Bearden purchased the old Morris Hotel and converted it into a restaurant. In the pre–World War II years, the building had housed a business of "ill repute," the Hoodsport Hotel, and a Pentecostal church. Later it served as the Hoodsport post office and the Lake Cushman sales office. After World War II, returning veterans flooded the canal, and many Hoodsport stores changed owners.

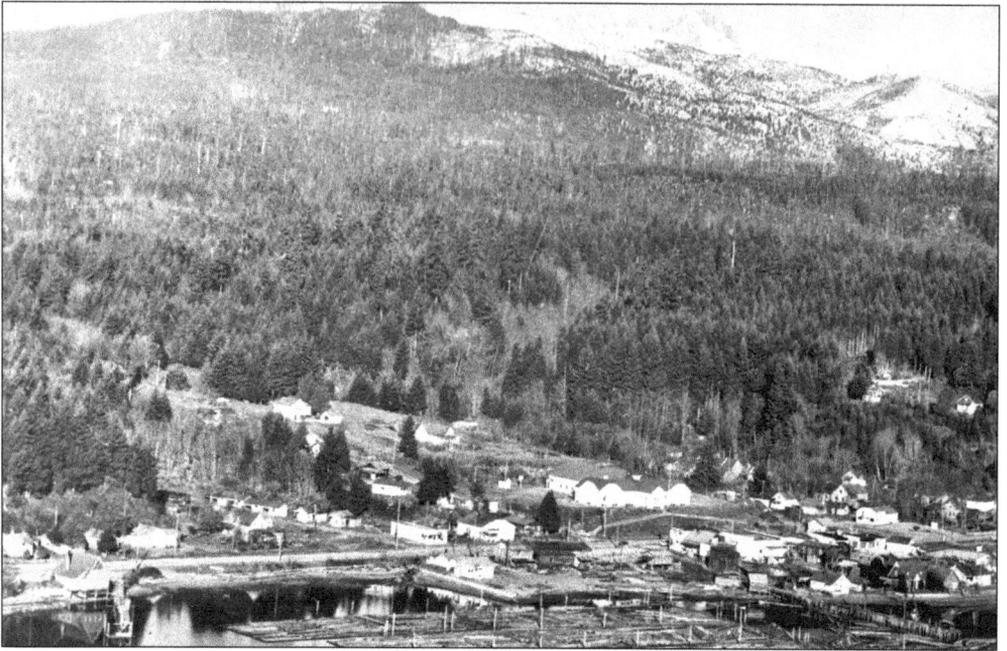

This 1950 Hoodsport photograph demonstrates that the new school was the center of the community and shows a large log boom where the pile driver had been in earlier years. On the left is the Hoodsport Auto Court. The commercial center on Highway 101 and the houses near the beach are clustered near Finch's original home site. Behind the tiny coastal town loom the Olympic Mountains.

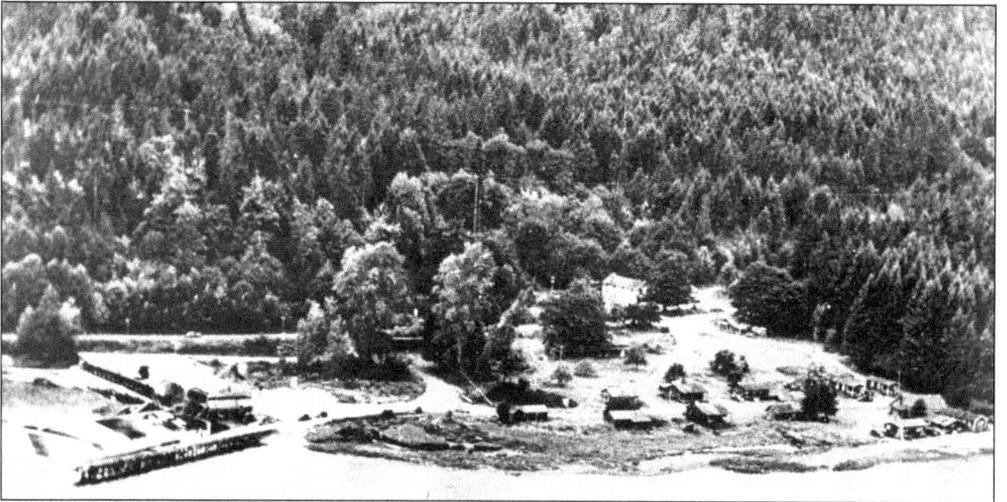

This c. 1950 photograph is of the wartime sawmill (left) of Inetai Lumber Company (locally properly spelled "Enetai"), which the state purchased in 1963 for Potlatch State Park. On the right is Fred Hanson's Minerva Resort and Mercantile, which consisted of cottages on the beach and a store, the large building on the road. Hanson would frequently give rock clams to his milk deliveryman, Max Latzel. In 1934, Hanson leased Minerva to landscape artist Mel Bearden, who painted an Olympic Mountains scene for an entrance gate and who also built a 200-foot railway to launch boats even in low tide. This made the cabins very popular, as did the "old Indian fishing hole," which was located right in front of them. Now the low dissolved oxygen threatens the fishing ground.

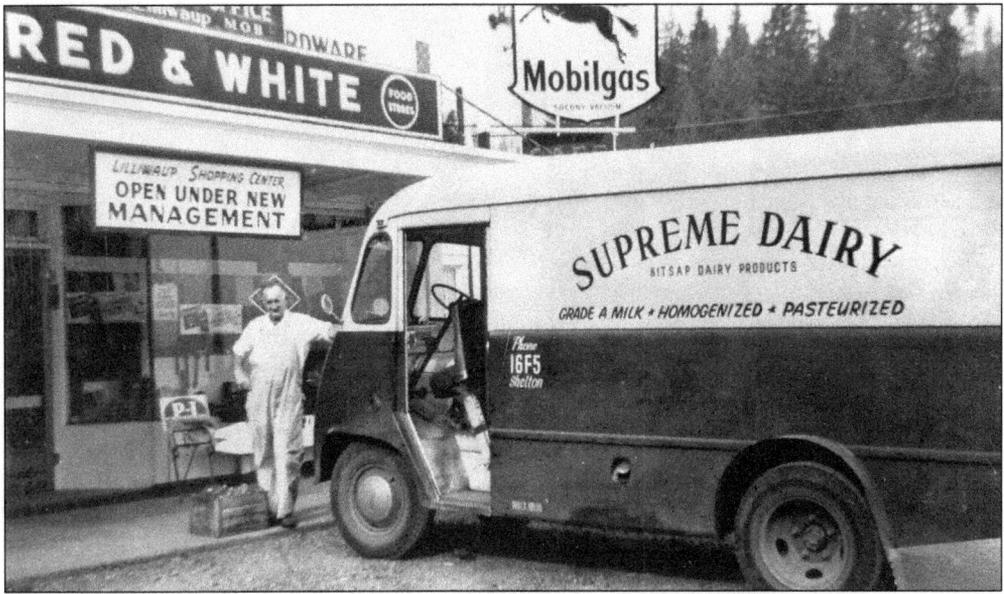

After World War II, many veterans formed new businesses prepared to cater to the returning veterans and their families. The Lilliwaup Shopping Center was one of the Red and White food store groceries. Max Latzel, owner of the Latzel Dairy, sold his milk to Kitsap Dairyman's Association, but he drove for Mason County Creamery, delivering to Hood Canal.

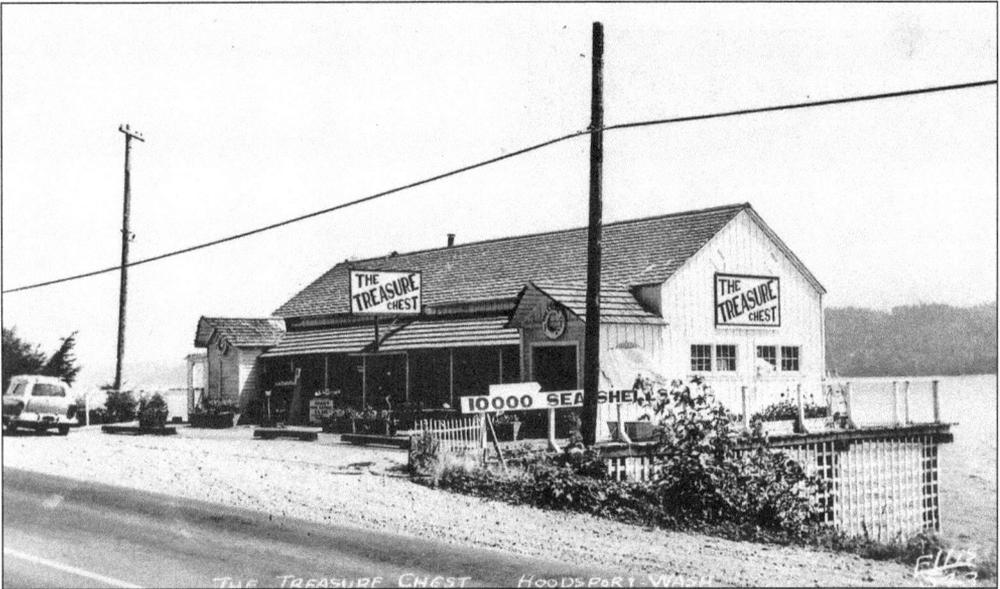

After World War II, businesses devoted to tourists flourished—the Treasure Chest gift shop included. Initially designed as Allard's Aquarium by Joe McKeil, who built Tacoma's Defiance Park Aquarium, it featured live marine life from the canal; his children built a unique popcorn stand next to it. However, the tourist trade remained as seasonal as the weather, and by the 1950s, the Dickinsons had converted it to a gift shop offering marine curios, such as conch shells from the Caribbean and giant oyster shells from the South Pacific. In the 1960s, Claire and Mel Bearden transformed it into a private residence, reflecting the change of use of the canal from a natural resource base to a tourism base to a more stable seasonal second-home market.

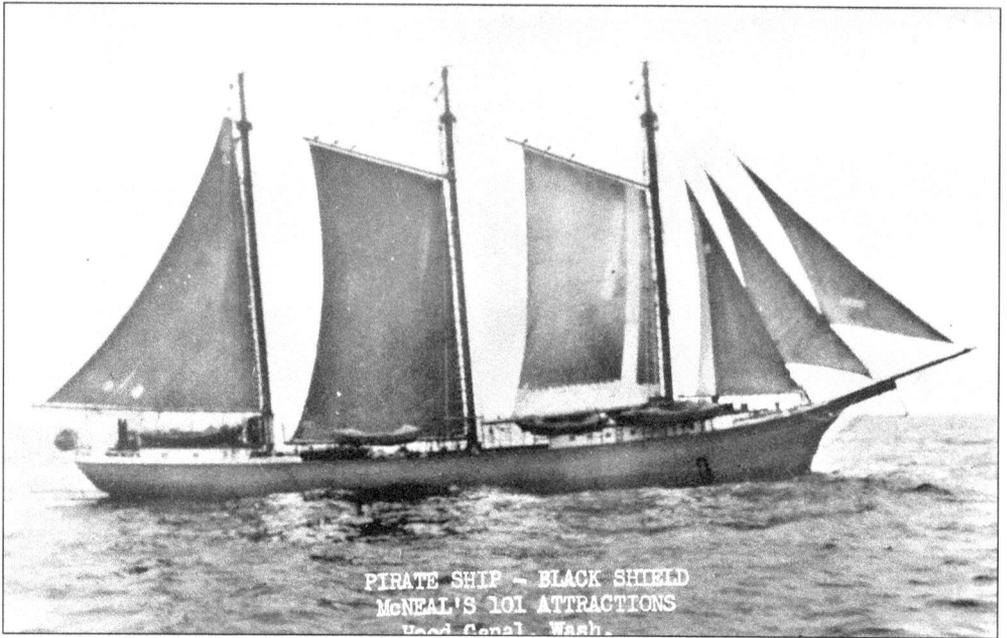

PIRATE SHIP – BLACK SHIELD
McNEAL'S 101 ATTRACTIONS
Hood Canal Wash.

During the postwar years, many veterans and their families toured the canal on the Olympic Loop Highway. Promoters offered tourist curios to amuse the children. In the 1950s, the pirate ship *Black Shield* was anchored in McDonald Cove, a few miles north of Hoodsport.

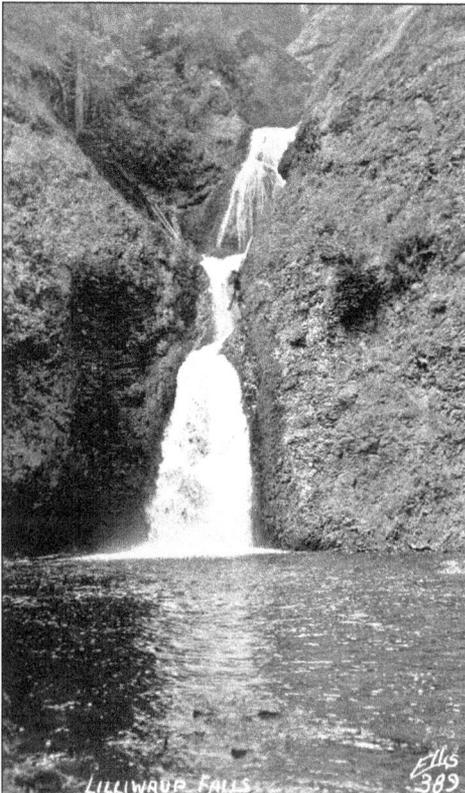

LILLIWAUP FALLS

Lilliwaup Falls has been the natural attraction for several development proposals. Before 1952, it was open to the public. But by 1952, eastern industrialist Elmer Beardsley had purchased the 150 acres and built an estate with a mansion and a waterfall he and his wife, Kathryne, named *Wailele*, or "leaping waters." Beardsley built a hydroelectric plant to power the estate and a 200-foot fountain, which rose higher than Old Faithful. In 1990, this "rustic fairyland" was offered for $185,000, advertised by a 10-page brochure.

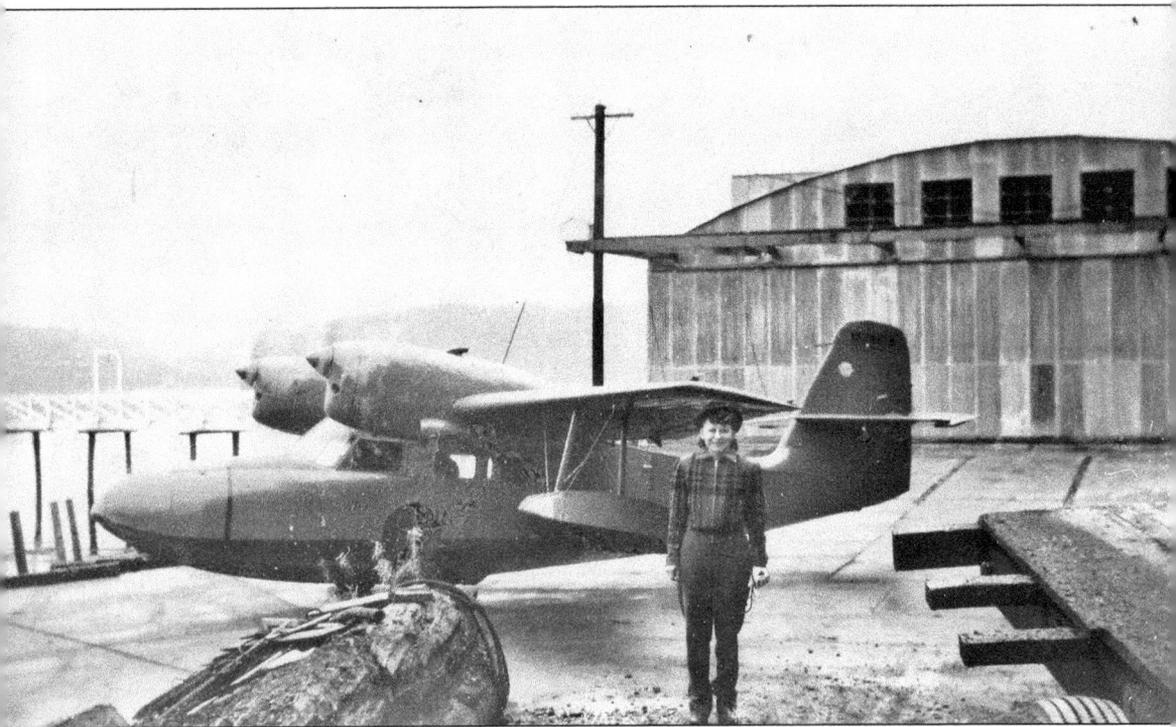

The Beardsleys also built a hangar at Lilliwaup for their five-passenger Grumman Widgeon seaplane. Kathryne "Honey" Beardsley poses as she prepares to board. The hangar was later used for Alaskan fishing boats. Today wealthy families still use seaplanes for commuting—a sort of mosquito fleet in the sky—and use the canal to land on.

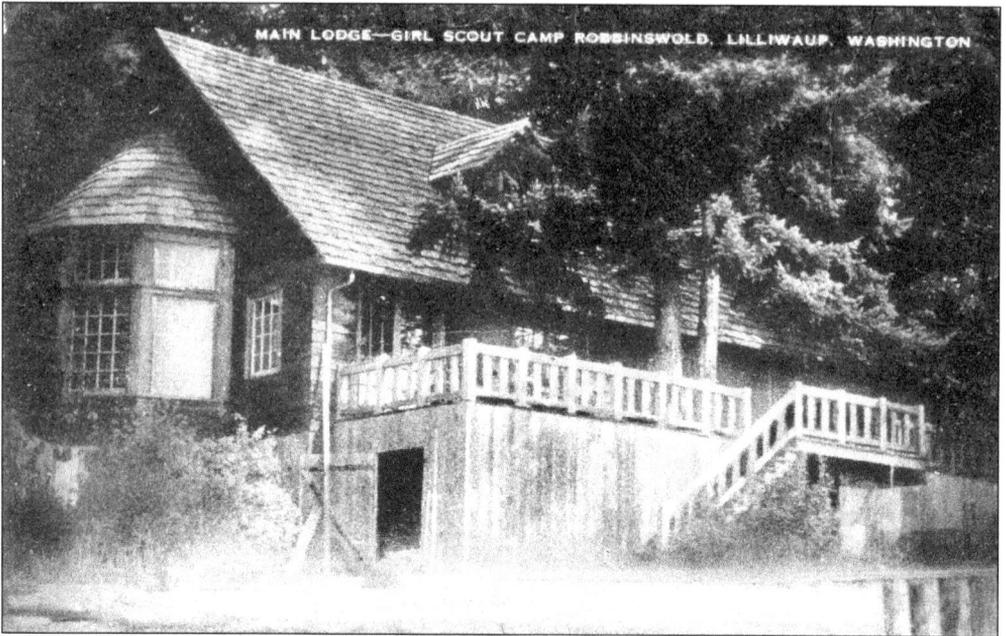

MAIN LODGE—GIRL SCOUT CAMP ROBBINSWOLD, LILLIWAUP, WASHINGTON

In the 1920s–1950s, the Scouting movement was active on Hood Canal. Robbinswold, the Girl Scout camp near Lilliwaup, entertained young girls with outdoor activities both in the Olympic Mountains and on canal waters, teaching self-reliance and confidence, as well as teamwork. Camp Parsons, near Brinnon, offered Boy Scouts an outdoor experience.

By 1970, the logging industry had lost its vigor, and the U.S. Forest Service had reduced its staff. Milo's had burned under suspicious circumstances and was fenced off and put up for sale. The loss of steady employment from logging crippled the town's local economy, and, as nothing could be done about the weather, the tourism trade remained seasonal.

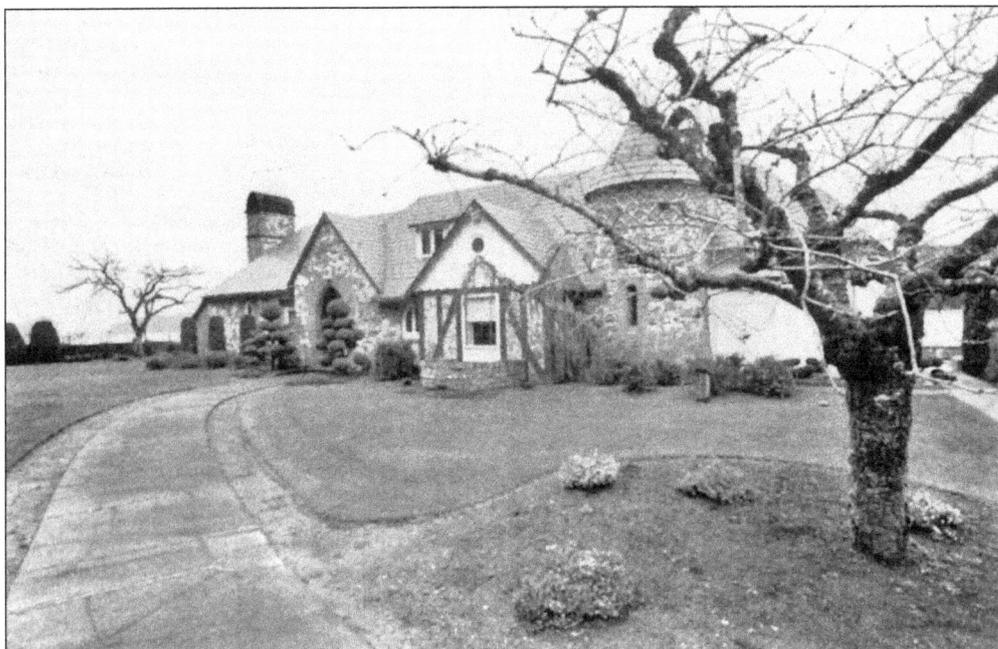

This summer home of Albert Schafer, wealthy Grays Harbor lumberman, won *Sunset* magazine's May 1936 House of the Month. The castle design, selected from a postcard, recalled the Swiss architecture from Schafer's youth. Although other family members built near Robin Hood, Albert selected the beach site because it receives the last lingering rays of the summer sun. Some refer to Hood Canal's south shore as the Gold Coast because of the number of large summer homes.

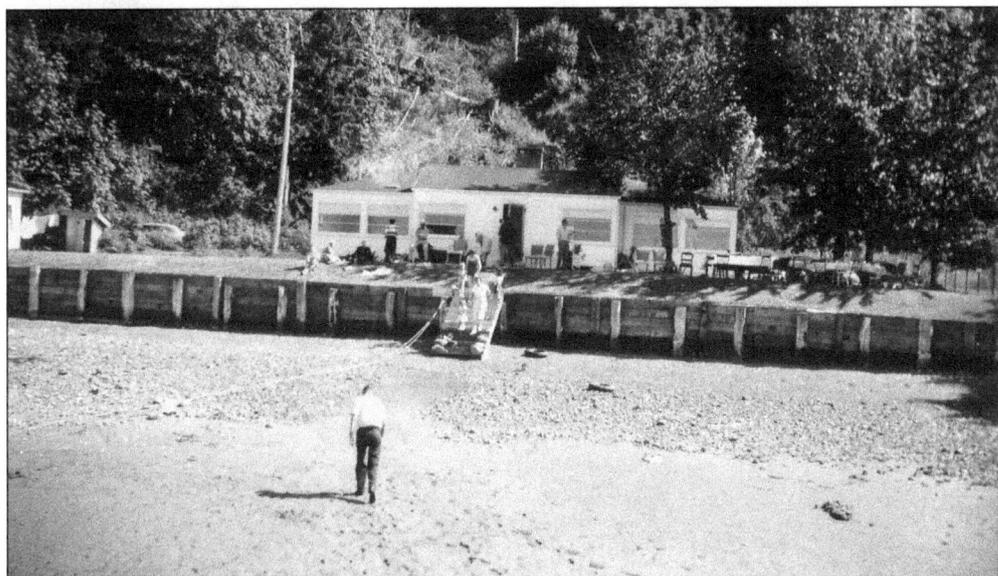

After the war and the building of the Navy Yard Highway, new developments began to fill in the canal shoreline. In Happy Hallow, Harold and Gert Potts built a summer home to entertain family and friends. In this July 1949 photograph, the tide is out, but the front yard is overfilled with chairs and children standing on the ramp, hoping the tide will return . . . soon.

After World War II, children of Grays Harbor families enjoyed the summers on Hood Canal. At Sunny Beach, near the Swedish Colony, Ned and Lillian Bishop built a log house next to Alderbrook and named it Bishopbrook. Son Neddy Bishop (center behind the wheel with jaunty cap) could give all the summer kids a boat ride on his 22-foot inboard.

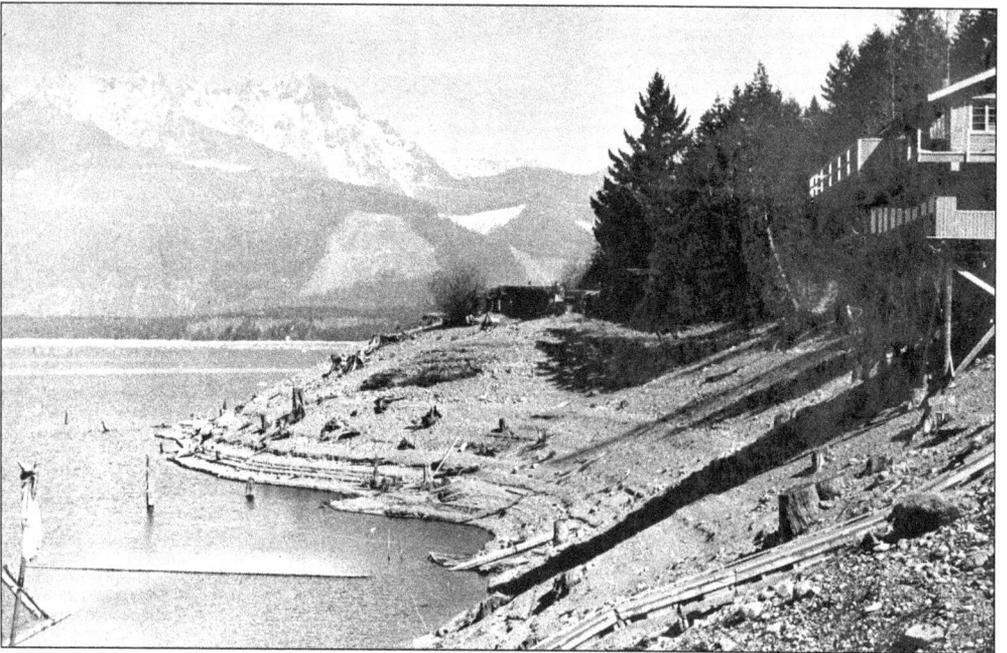

After the dam, Tacoma City Light built a golf course and developed hundreds of lots for summer homes on a 100-year lease. The Cushman Resort attracted visitors with its dock facilities, boat rentals, store, and cabins. During the 1954 drought, however, the low level of Lake Cushman hampered their access to the water.

## Six

# SKOKOMISH RESERVATION AND SKOKOMISH VALLEY

As this 1941 map displays, the Skokomish Reservation was divided into private parcels in 1886. It was originally reserved in 1860 for the S'Klallam; the Chemakum; three bands of Twana; the Skokomish; the Duhlelap from the head of the canal; and the Quilceeds, who lived around Quilceed Bay, the *Du-ka-boos* and the *Dos-wail-opsh* Rivers. Many tribal leaders felt the reservation was too small; in 1855, Twana chief S'Hau-at-Seha-uk declared, "I do not want to leave the mouth of the River . . . I am afraid I shall die if I do."

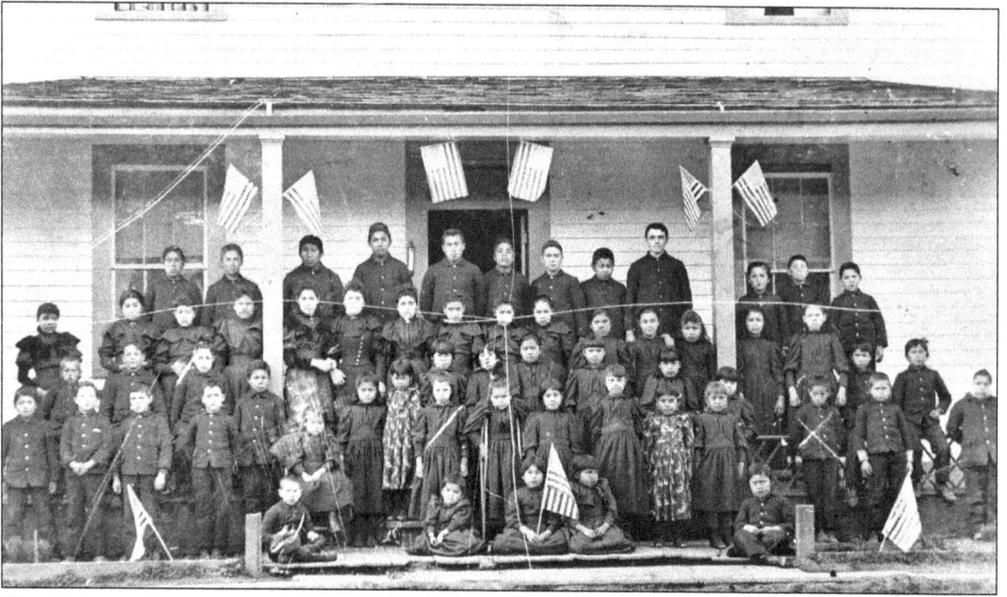

The Skokomish Reservation was established by the Treaty of Point No Point in 1855. Although tribal leaders balked, in 1859, Gov. Isaac Stevens established a reservation at the mouth of the Skokomish River, near a traditional settlement for the Skokomish people. A grammar school was built about 1870, and by 1882, the school began to board students from other tribes. In this c. 1882 photograph, the Native American children are uniformly dressed and festooned with flags. The agency school closed in 1896.

Congregational missionary Myron Eells served the Skokomish tribe from 1875 until his death in 1907, writing several books that detailed the life of the Twana tribe as it transitioned from an aboriginal to a Christianized society. His brother Edwin served as Indian agent. Both were child survivors of the 1847 Whitman Massacre. The well-meaning brothers implemented such reforms as land allotment, education, and Christian marriage. Myron Eells is buried in the Union cemetery, where Native American pallbearers helped carry his coffin.

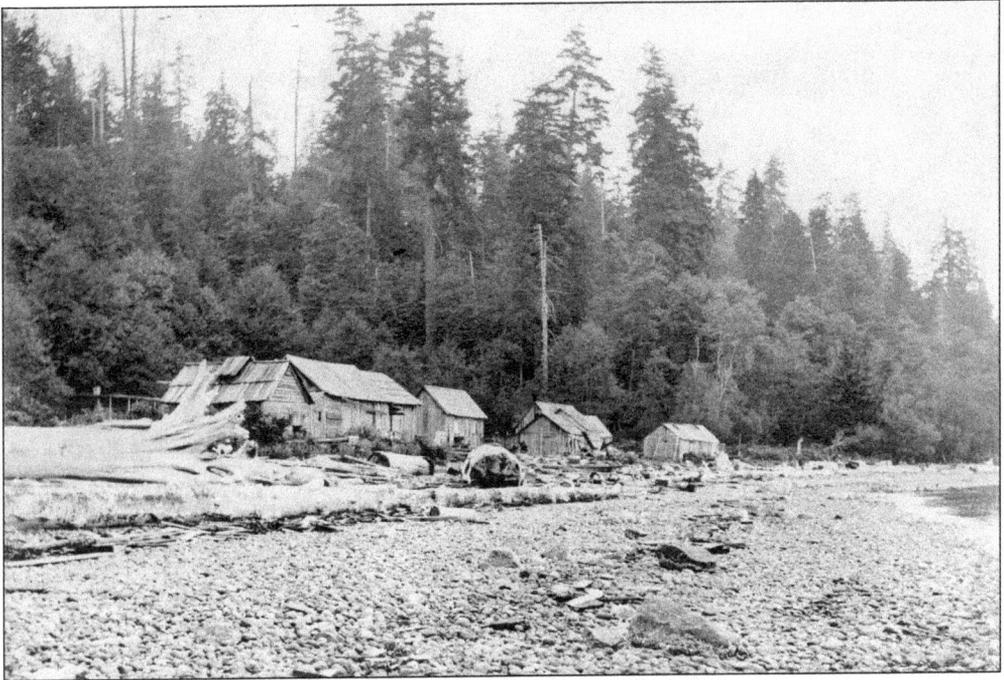

These Skokomish fishing cabins were located at Enetai, near the reservation. In the photograph, fish-drying racks lean up against many of the buildings, and drift logs barricade the beach.

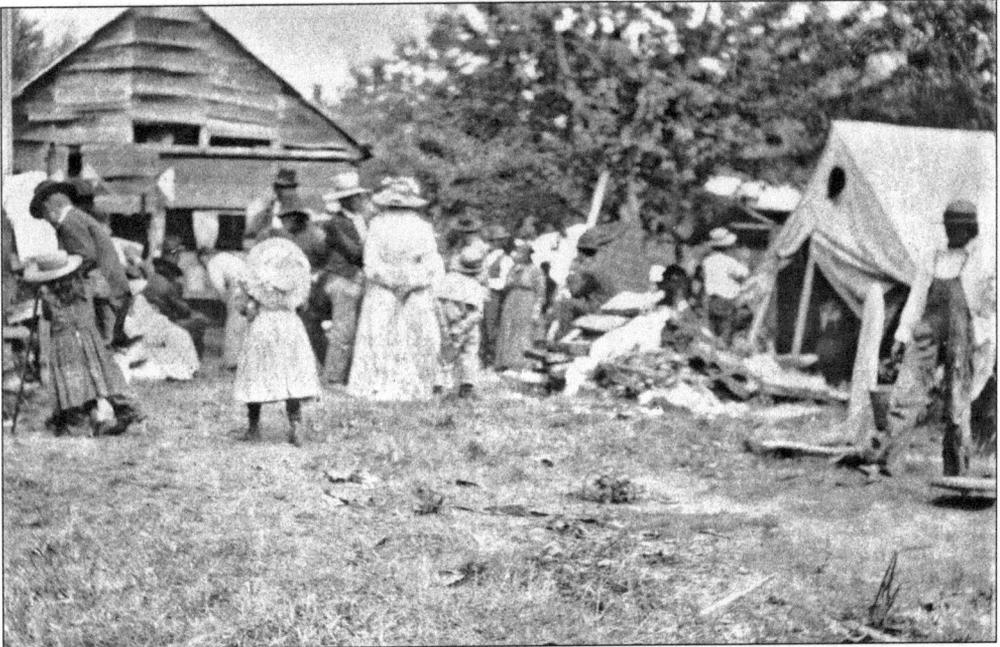

This c. 1900 photograph is of a Skokomish potlatch. Traditionally, distant families canoed to celebrate the potlatch of a great chief or event. By 1900, the Skokomish native dress of woven dog hair and conical hats had been replaced by calico dresses, suits, and brimmed hats. Missionaries discouraged potlatches because they believed this abundant gifting left the giver destitute. However, the potlatches distributed goods communally and in return gained the giver much respect.

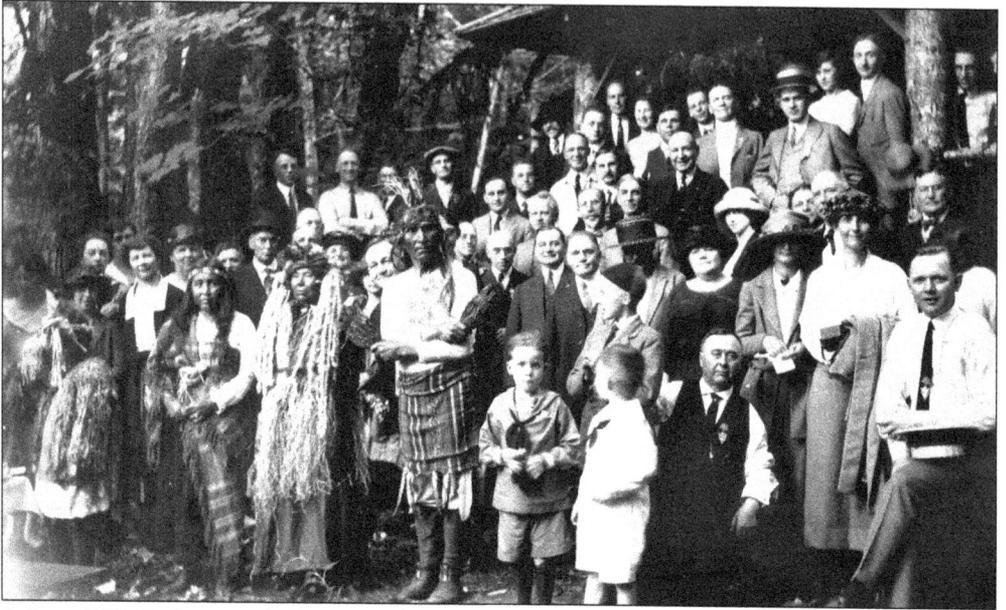

In June 1922, Shelton jeweler I. N. Wood entertained the state's convention of jewelers at Fernwood, his summer property near the mouth of the Skokomish River. They drank Eckert's grape juice, made in Mason County, and enjoyed clams steamed open by Chief Frank Allen. Then Chief Allen and his family staged an old-time war dance for their benefit. The costumed dancers are in the front center left. According to the *Mason County Journal*, conventioneers declared the event the "best ever."

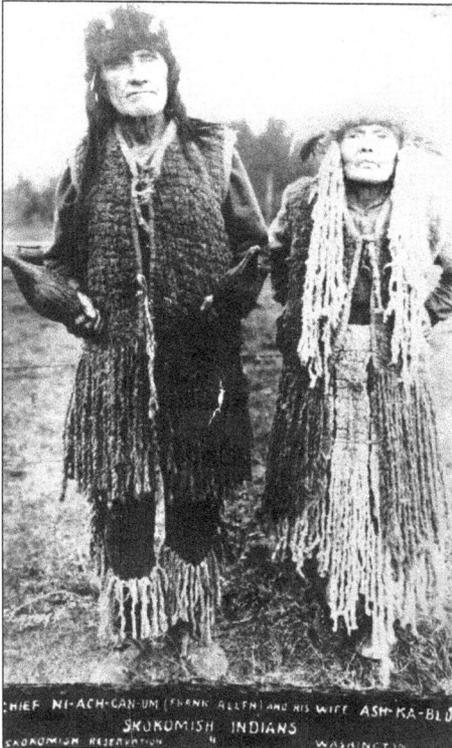

CHIEF NI-ACH-CAN-UM (FRANK ALLEN) AND HIS WIFE ASH-KA-BLU
SKOKOMISH INDIANS
SKOKOMISH RESERVATION                    WASHINGTON

In this photograph, Chief Ni-Ach-Can (Frank Allen) and his wife, Ash-Ka-Blu, are posed wearing traditional mountain-goat woolen garments with what appear to be bearskin caps. According to William Elmendorf, in 1928, Allen had his wife weave this ceremonial shirt with goat wool obtained from the Skagit tribe. He wore it at spirit dances on either the Lummi or Swinomish Reservation. Frank Allen (1860–1945) and his brother Henry (1865–1956) were the most helpful informants for anthropologists in the 1930s, including Elmendorf and University of Washington researchers Hermann Haeberlin and Erna Gunther. Frank may have been the last practitioner of Twana ways; Henry was more acculturated.

Henry Allen was a Twana elder and a principal informant, as was his brother Frank, for Prof. William Elmendorf's *Twana Culture*. Henry Allen could name all the Twana sites, remember traditional clam beds, and tell Twana stories. He was also known to the local whites as "Indian Henry" and built chimneys, including the Dalby fireplace and the large outdoor chimney at Alderbrook, well remembered by guests from the 1930s.

George Adams (1880–1954) descended from traditional tribal leaders. He attended Lower Skokomish School and was married in 1901 by Myron Eells. After serving as Mark Reed's legislative manager starting in 1923, he was elected as state representative in 1933. He served several terms until 1954 and advised on many state and federal Native American issues. He believed hatcheries would raise more salmon to return to the canal, enough for both whites and Native Americans to share. Each year, he held a canal-wide salmon bake, a sort of contemporary first feast.

State representative George Adams and Helen "Nell" McReavy Anderson (1882–1969) were longtime friends and genuine lovers of Hood Canal. Adams was a great admirer of what he called John McReavy's "red-whiskered . . . kindness." Nell Anderson, born in the Occidental Hotel, was a piano player, postmaster, insurance agent, PUD No. 1 secretary, and, in her gracious and sharing manner, almost the grand-aunt of Hood Canal. She and the Hood Canal Women's Club lobbied 20 years for Potlatch State Park. She liked to wear a Native American dress and beads for social occasions.

George "Sonny" Miller continued hosting grandfather George Adams's traditional salmon bake for Hood Canal residents, both Native American and white. Locals still like to celebrate the return of the salmon, both traditionally and with backyard barbecues. Here Helen "Nellie" McReavy Anderson shared the cooking duties at Twanoh State Park.

Louisa Pulsifer and Emily Miller were accomplished tribal basket makers. Baskets are woven from grasses and softened cedar bark gathered from the Hood Canal area and then colored with dyes from native plants. Although stitching was a traditional skill necessary to manufacture grass mats and clothing, women soon began making baskets as a trade item with whites. The patterns, such as the dog and the wolf, as well as dye colors, became symbols for the basket makers.

LOUISA PULSIFER

GEORGE CONTRERO    TOMMY PULSIFER

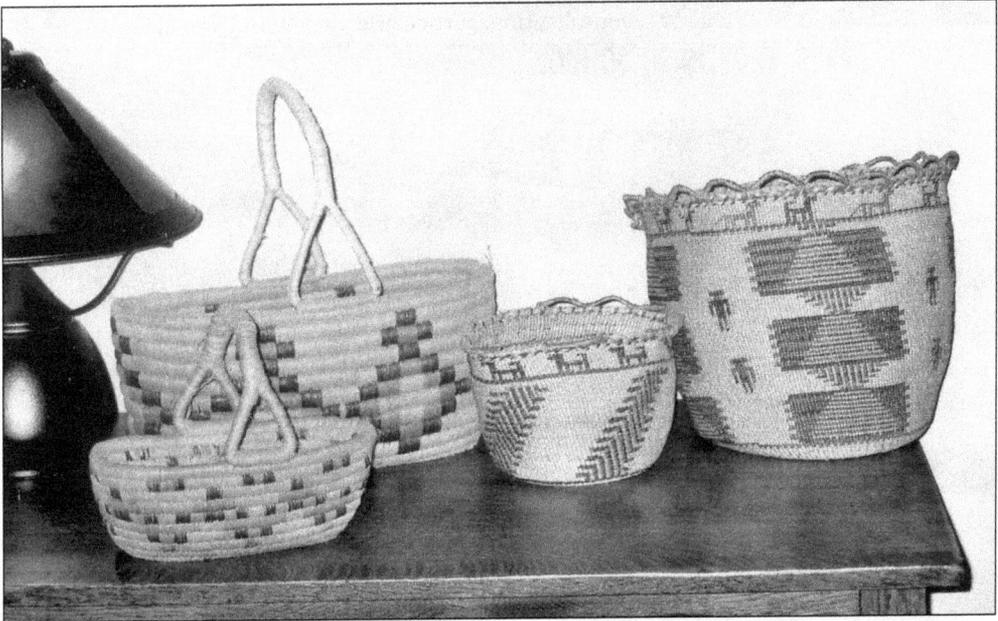

These baskets display different patterns and materials. On the right, the two grass baskets' rims are circled with dog (tail up) and wolf (tail down). The bear grass baskets with handles, on the left, are designed for gathering berries. Baskets have become collectible for their uniqueness, their patterns, and for their collective glance into ancient ways of tribal craftsmanship. To the Twana, a hard-coiled cedar basket was worth one slave.

Bruce Miller was a grandson of George Adams. As a teacher and artist, he revived interest and pride in almost-forgotten tribal skills and stories. After service in Vietnam, he gained national recognition as an artist and playwright in New York. Upon returning to the Skokomish tribe, he reintroduced plant and herbal gathering and weaving, collected tribal stories, and served as a mentor and role model for his tribe.

In 1906, the Upper Skokomish School was built deep in the valley and tucked next to the Olympics. In 1915, the school was moved and a second building added. The center of each community was the school building that served not only as a school, but also as a Sunday school and center for social events. As transportation improved, schools began consolidating, particularly after World War II.

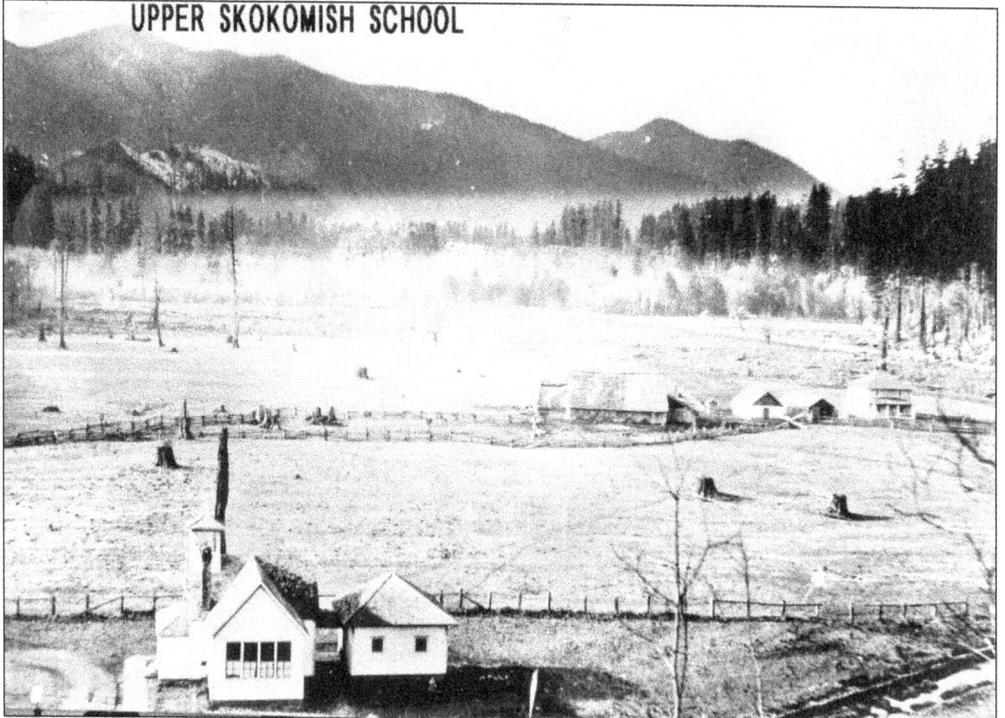

UPPER SKOKOMISH SCHOOL

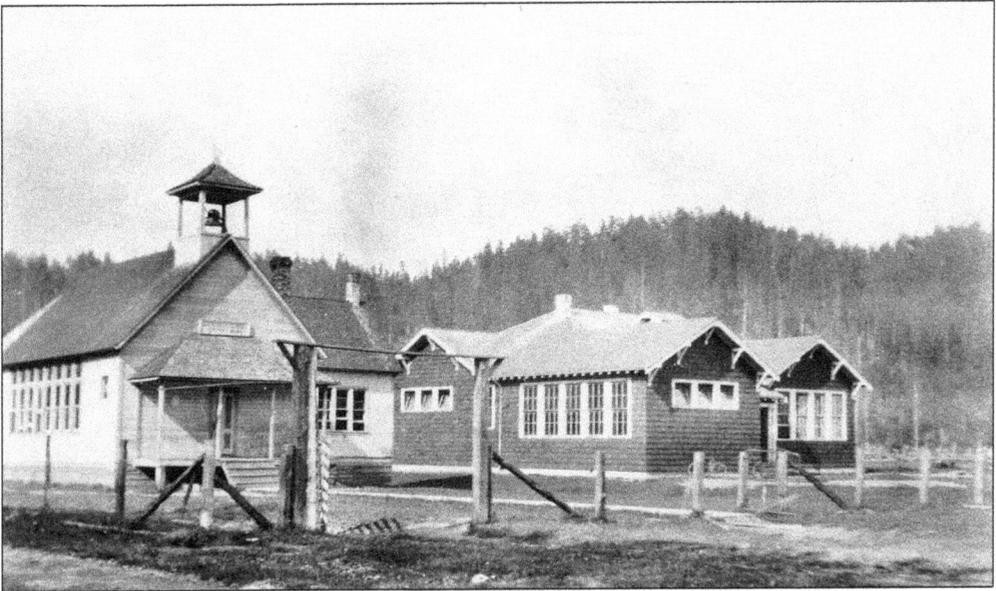

In 1923, the Middle Skokomish School replaced the earlier sites. Attendees included the Valleys, Richerts, Hunters, Johnsons, Jacobsons, and the Roses. Many families still remain on their farms in the Skokomish Valley. The baseball team would play games at Hoodsport, Lower Skokomish, or Simpson Logging Company's Camp No. 3. In 1957, the school consolidated into the Lower Skokomish Public School District No. 2.

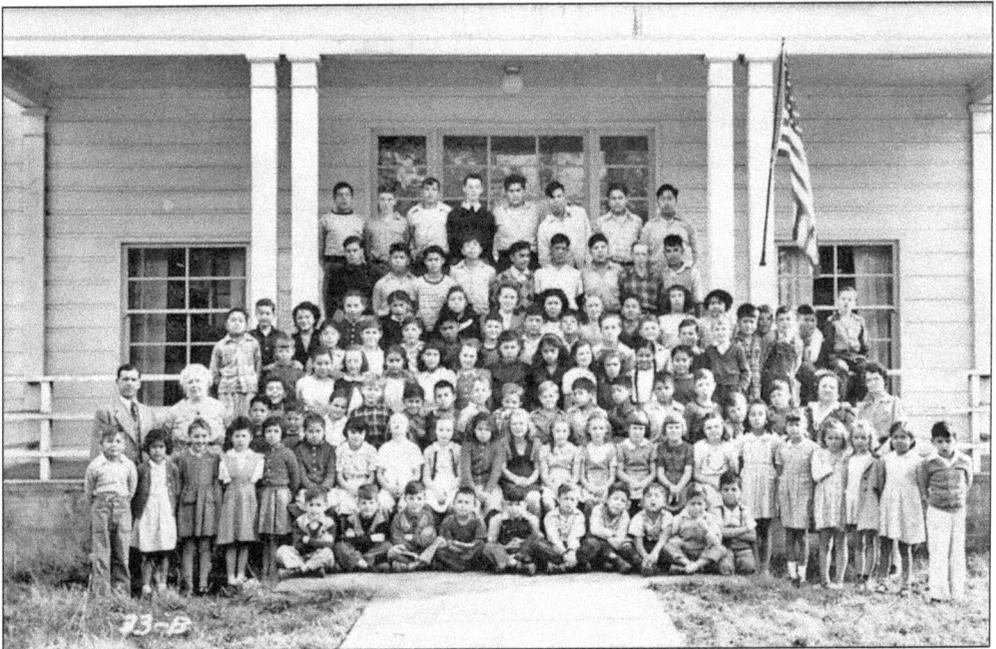

The Lower Skokomish School was founded in 1869 as a boarding school for Native Americans. In 1889, the school integrated white and Native American children, and many of the students formed lifelong friendships. The 1946 graduation song closed with the lyrics, "To the days we have spent with one another / There is no other Sko-ko-mish School." The building later was used as a tribal community center.

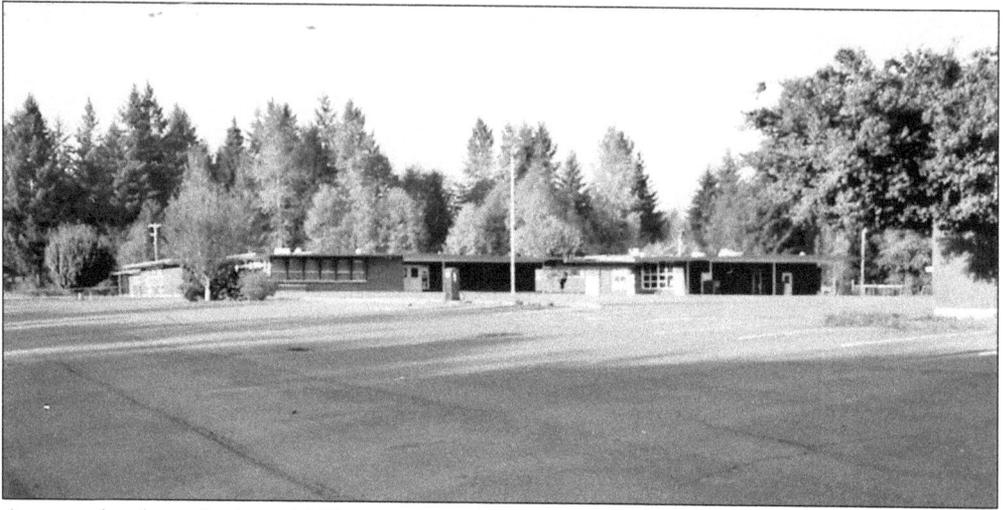

A new school was built in 1960 to serve as the Hood Canal District No. 404, which in 1957 consolidated Union, Hoodsport, and Skokomish schools for the elementary grades, with high school students being bused to Shelton. In 1988, an arson fire destroyed the school, and it was replaced with an identical floor plan.

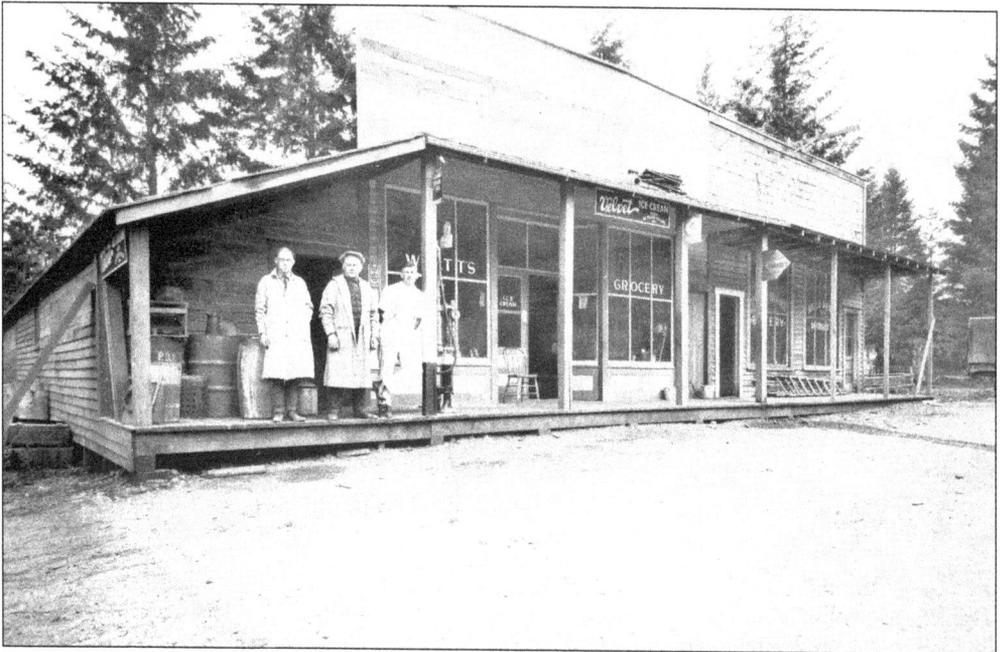

The Wyatt's Grocery trade was primarily with Skokomish Valley and Skokomish Reservation residents, as it was located four miles south of Hoodsport on U.S. 101. Later the Wyatt family moved their store to Union, and it served as an informal community center.

# Seven

# MARINE LIFE AND CONTEMPORARY TIMES

This *c.* 1900 photograph displays sturgeon and salmon caught in canal waters—sturgeon as large as sharks, and salmon bigger than a fish story. Thick eelgrass in the tidal shallows attracted herring to feed and reproduce. Herring are forage fish for the larger species. Mysteriously, the eelgrass beds disappeared in the 1950s and 1960s, as did the herring and the abundant salmon. Some speculate it could be the radioactivity from the navy dump after World War II, some say the siltation smothers the beds, and some say it is due to too many bulkheads and septic systems.

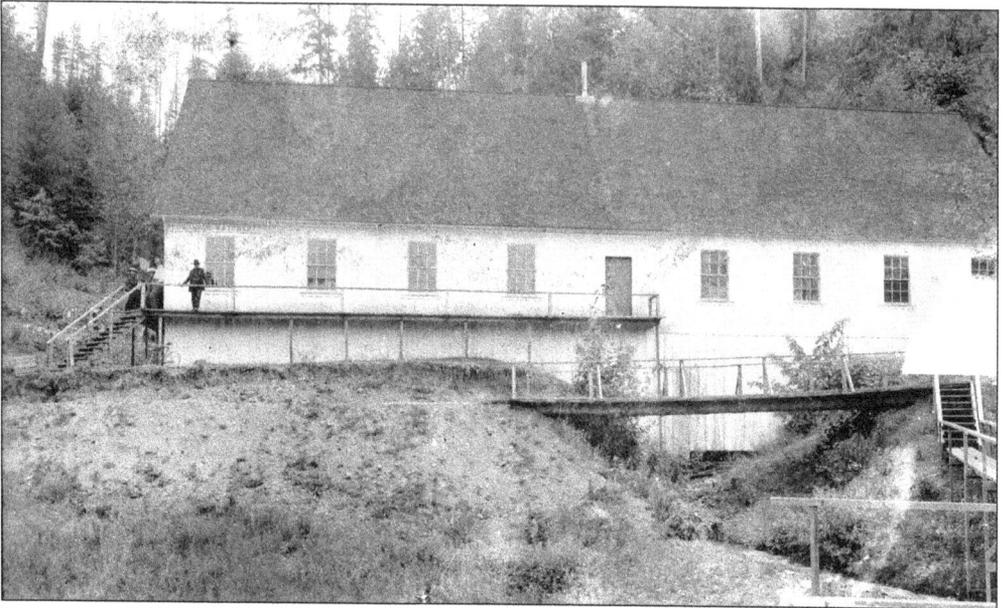

Many rivers feeding into the canal have hosted fishery programs. The Duckabush hatchery operated from 1927 to 1942. This photograph is of the Skokomish hatchery, located on Purdy Creek at the Fish House. The 100-by-40-foot structure, built in 1903 from lumber milled at Union City, was Washington's second hatchery. In 1896, with 45 camps of fishermen working the canal, many felt the canal fishery could be soon exhausted. Five employees raised steelhead in the spring and salmon in the fall. Ed Dalby was an early fisheries employee, and he supplemented his family's income by hunting seals for state bounty.

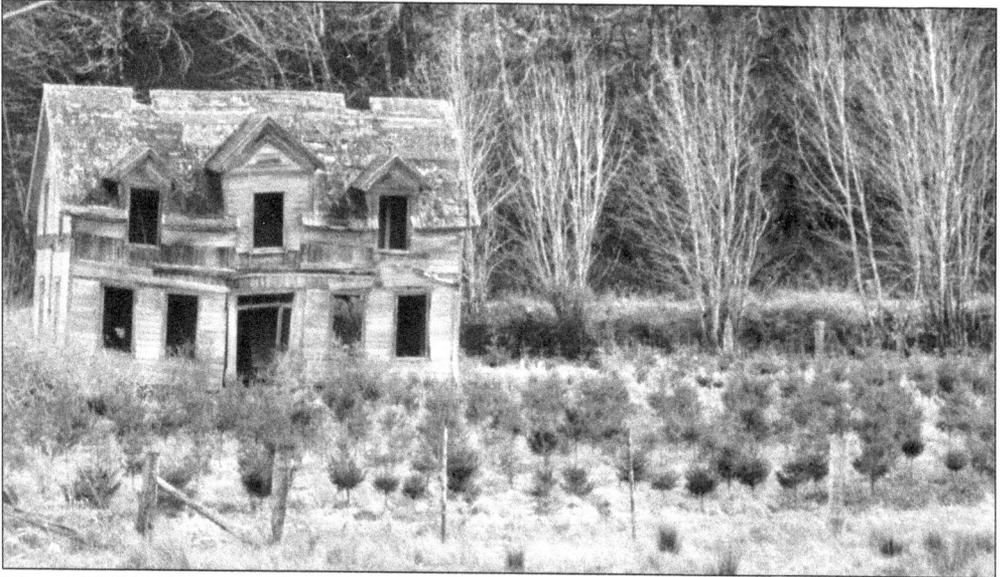

The old Webb house was built in 1872 by reservation carpenter Michael Fredson. It finally succumbed to gravity in the late 20th century; the site is now overgrown with Christmas trees. Its three dormers looked out at three mountains: Ellinor, Washington, and Constance. But it also saw many changes in the Skokomish River in its front yard, in the highway that runs by it, and in the canal that, because of the slow siltation, has returned a little farther out with each tide.

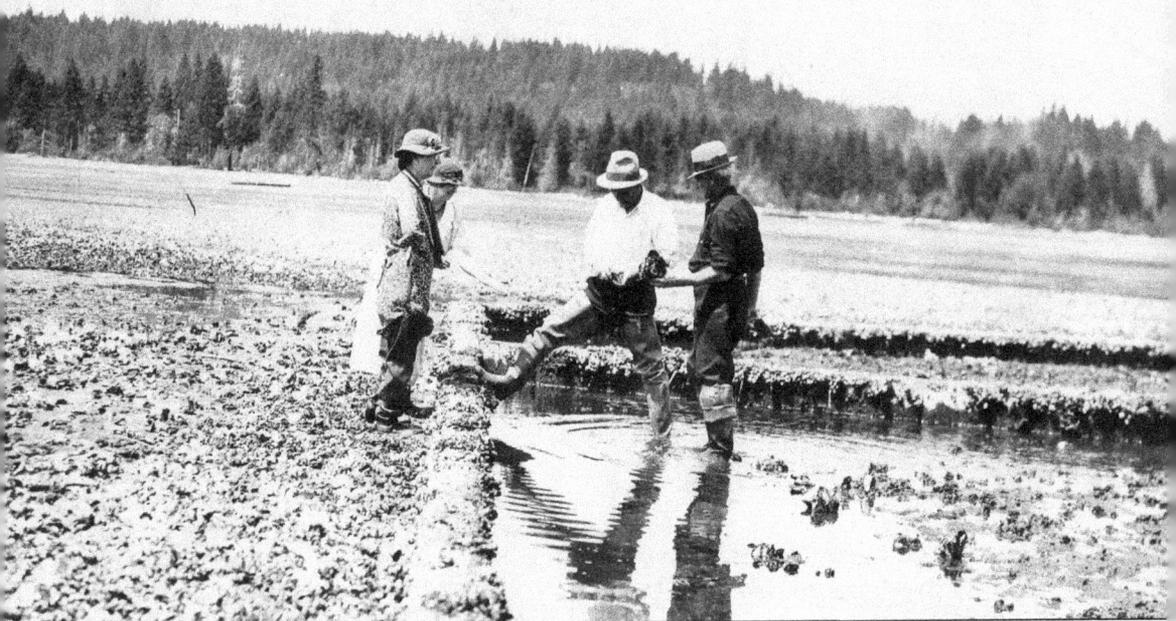

Much of Hood Canal tidal flats were diked to create oyster beds, typically the Pacific oyster imported from Japan in 1910–1920 after the tiny Olympia oyster had harvested out. Shelton pharmacist L. D. Hack owned these beds. His wife, Minnie, is the woman in front with friends Cora and Frank Rowley. Oyster bed superintendent Rice is on far right.

With the successful planting of Pacific oysters, many small oyster businesses developed along the west side. This cheerful crew is opening oysters at Lilliwaup. When the tide eddies into the narrow estuary, the slow tide and the rich marine waters make oyster growing profitable.

Hood Canal depths issued an aquarium full of fish rarely seen in any waters. In 1929, this fisherman hauled a 5-foot wolf eel out of those murky and mysterious waters near the Shivelys' Blue Ox. In 1936, a tourist claimed to have spotted a 20-foot sea monster with the face of a horse just north of the Blue Ox. That summer, many locals cruised Highway 101 looking for the sea monster.

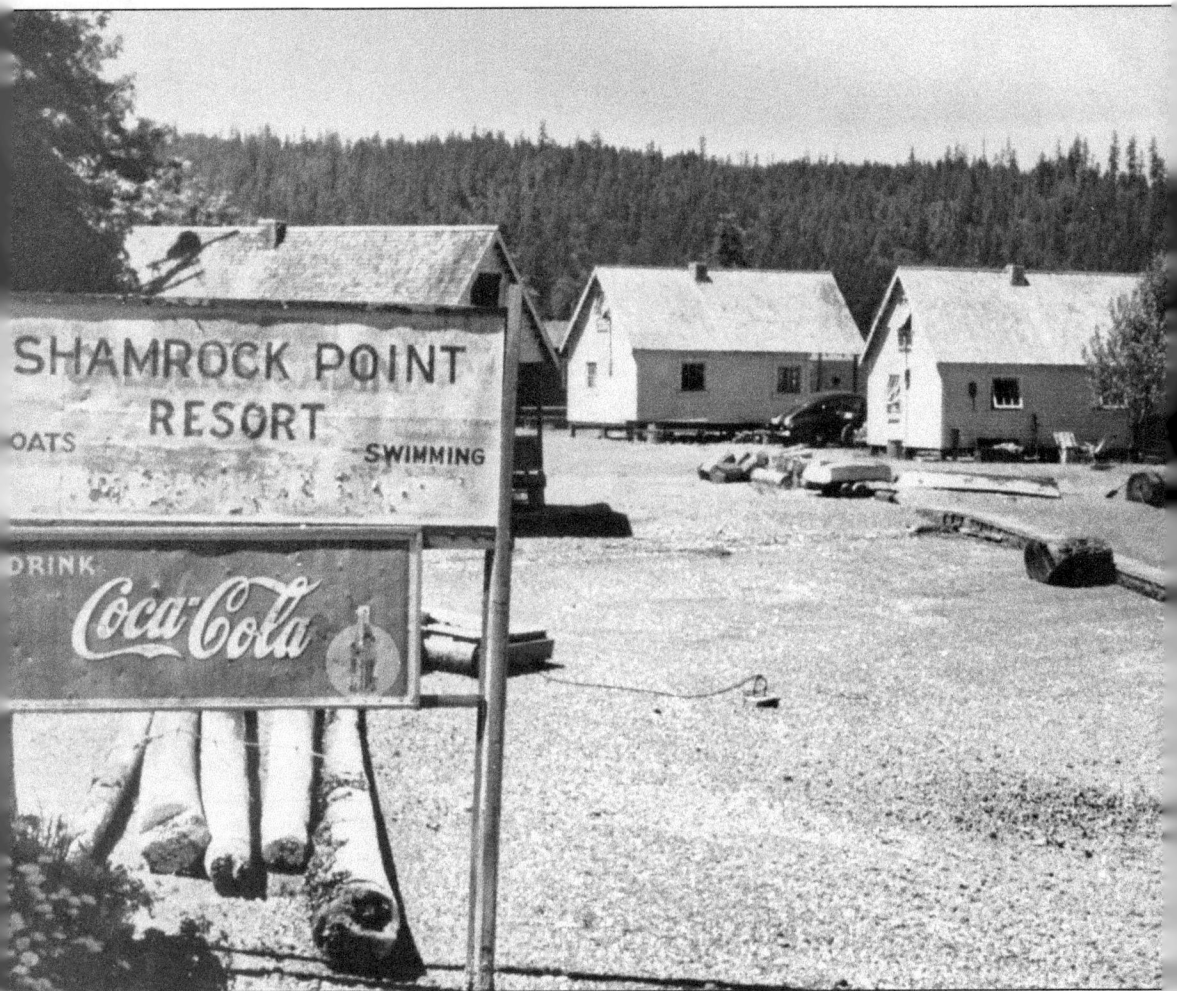

The Shamrock Point Resort was another boating and swimming resort on the Navy Yard Highway. Within a mile of Twanoh State Park, Shamrock Point was a favorite destination for Bremerton residents. Several cabins spread across the gravel beach, and the store sold the preeminently popular Coca-Cola. It closed in 1967.

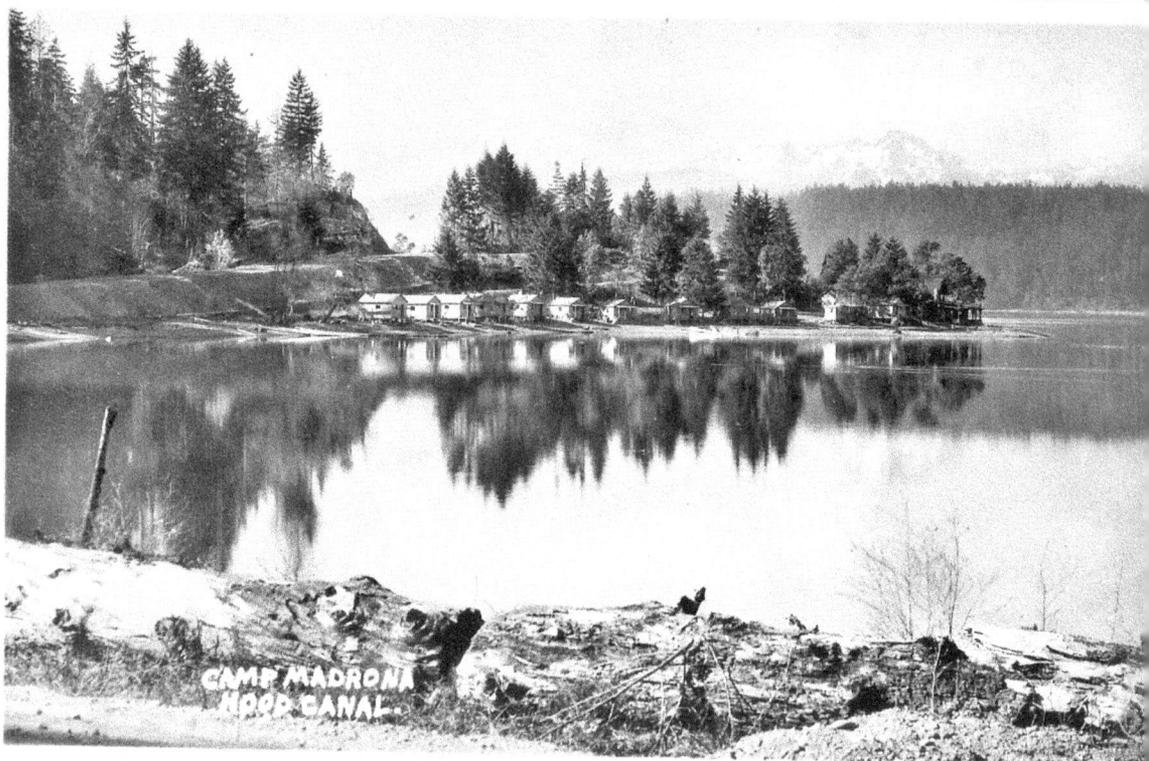

CAMP MADRONA
HOOD CANAL

About 1916, the original Camp Madrona was built of logs and little windows on Toe Jam Cove by Henry Pixley, who anticipated San Francisco tourists visiting for the perfect summers and grand scenery. Later Fryberg developed these cabins for summer vacationers. After World War II, the resort cabins were sold to private families. During the early 1960s, these children of summer would water-ski and hula-hoop during high tide. At low tide, the families would boat to the Skokomish tide flats to dig geoducks and gather crab and cockleshells. By the 1980s, most cabins had been replaced by more contemporary homes.

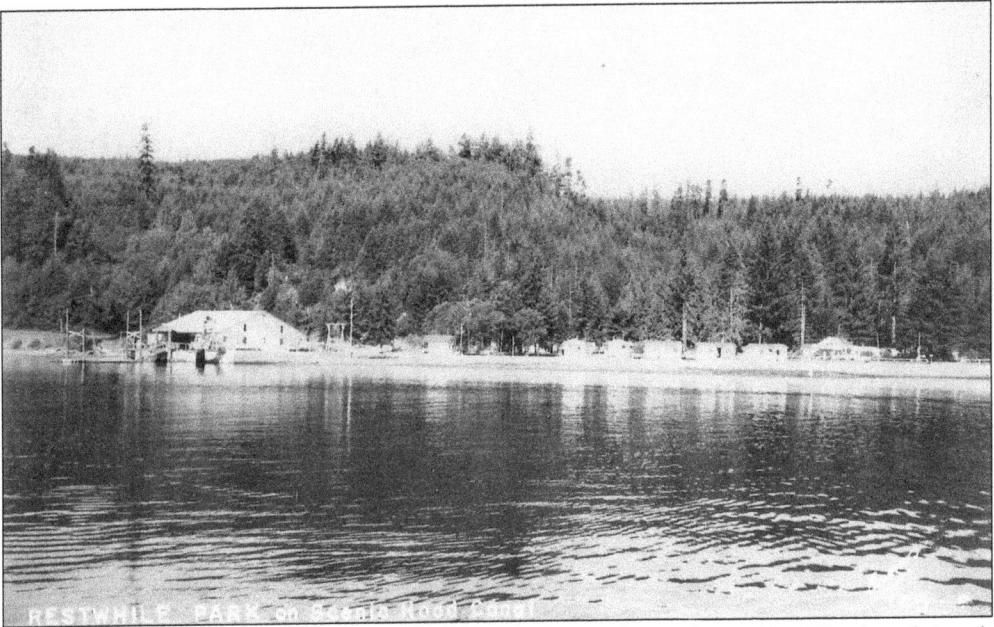

Rest-A-While park was another canal fishing resort. It was located near Sund Rock and Ayock Rock, a favorite place for king salmon to school and for fishermen to cast. By the 1950s, the canal offered nearly year-round fishing with five runs of salmon.

Rest-A-While resort, near Sund's Rock, offered a lift for boats and a camping ground for fishermen. On July 23, 1950, Henry Linger and Bill Kuhr caught this 23-pound-4-ounce salmon. Rest-A-While is one of the last resorts that today remains true to its fishing roots, with a boatlift, a ramp, a convenience store, and camping hookups still perched at the mid-waters of Hood Canal.

In August 1962, Bill Kuhr posed with this lingcod, so heavy he had to hold it up with two hands. Canal water supported an amazing diversity of marine life, from shellfish, shrimp, and crab, to herring and smelt, to octopus, sharks, jellyfish, and seals, topped with five species of salmon running up nearly every stream and nearly year-round.

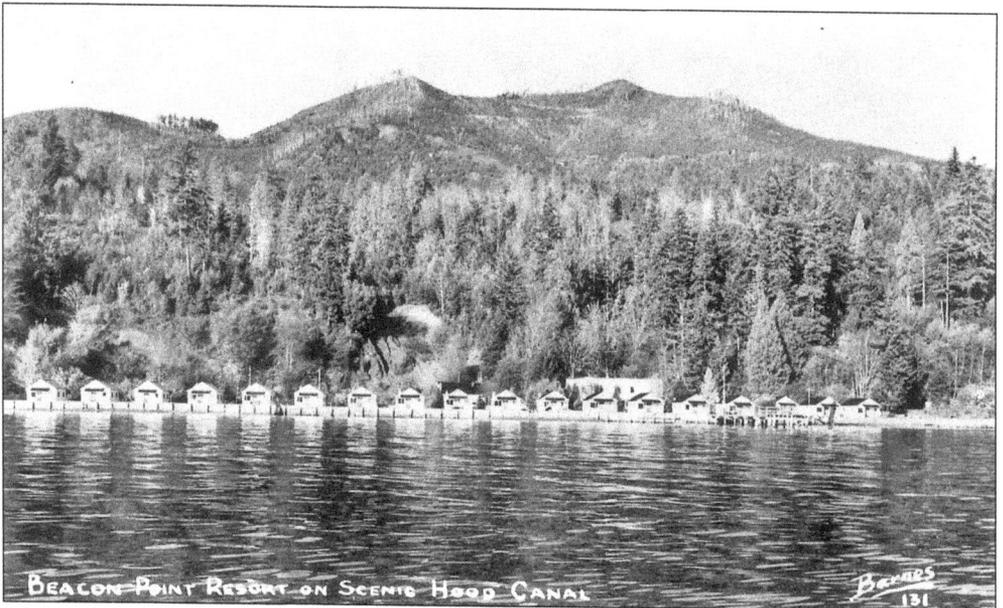

This 1956 photograph is of Beacon Point Resort, another cabin resort on Hood Canal. As the popularity of fishing resorts waned, the cabins were demolished and the uplands were developed into single-family lots for summer homes, such as Colony Surf and Olympic Tracts.

116

As Hood Canal became more accessible by automobile, the small resorts slowly gave way to private residences. Wealthy families built their own private complexes, and many remain in the family. Microsoft founder Bill Gates, who spent boyhood summers on Hood Canal, expanded his family's holdings by adding the building seen on the extreme right.

Hunter Farms has become a retail center for gardens in spring, vegetables in summer, and Christmas trees in winter, as well as host for such seasonal events as pumpkin patch rides and apple pressings. Originally homesteaded by Tom Webb, in 1945, the farm's 500 acres were purchased by Paul and Harold Hunter. The dairy farm sold milk on routes at Belfair and Bremerton. The Hunter family moved to the Skokomish Valley in 1892, and, through the generations, several Hunters have served as Mason County commissioners.

117

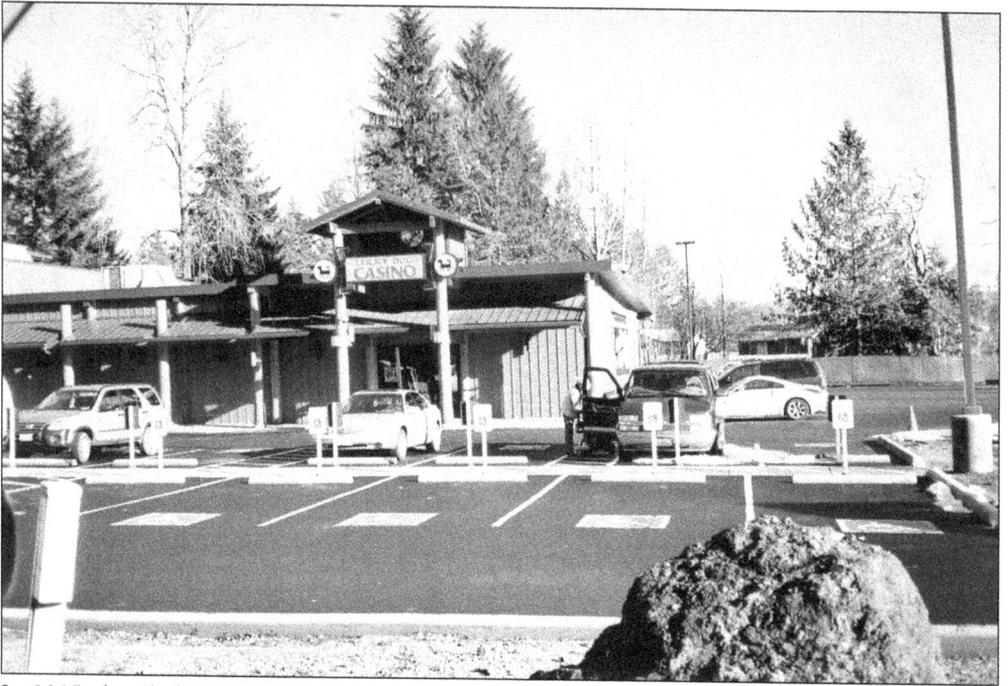

In 2005, the Skokomish tribe opened the Lucky Dog tribal casino on Highway 101. The casino provides employment for tribal members and is a prosperous tribal enterprise. In earlier times, at potlatches the Twana played many gambling games, including a bone game and a disk shuffling game. The casino connected two buildings: MacDonald's open-air fruit stand and a grocery store.

In 2007, the Hood Canal School District No. 404 built a new school, dwarfing the earlier school building in the far rear. This $8.4-million project will be attended by students bussed in from points up and down Hood Canal, from the Skokomish tribe, the Upper and Middle Skokomish Valley, Hoodsport, Lilliwaup, Eldon, and Union.

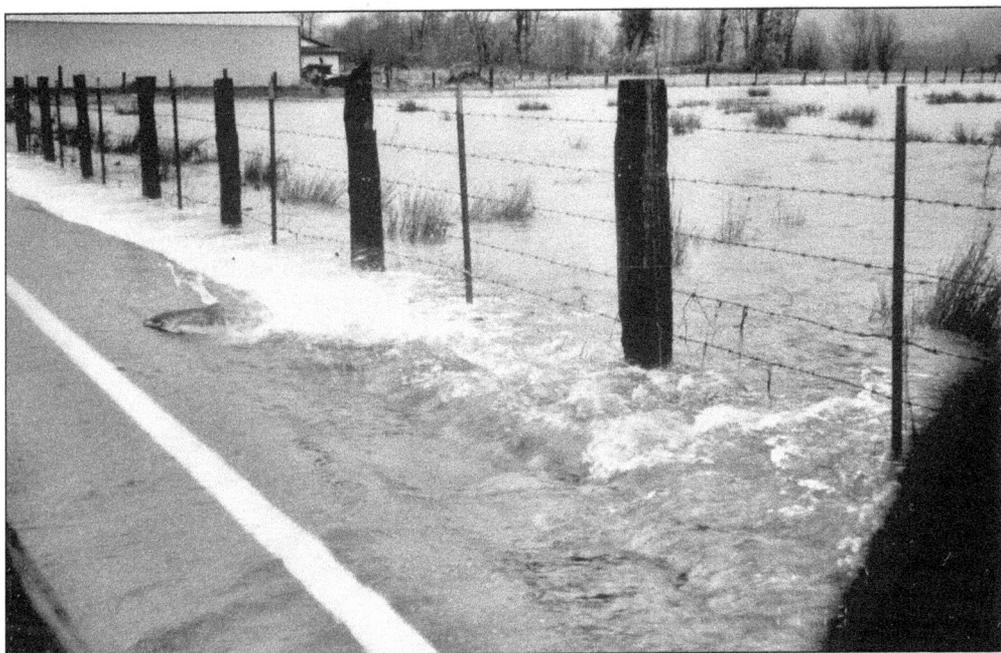

If the November rains and high tides coincide with the chum salmon run during the Skokomish Valley floods, the chum seem to walk across the road into the farming fields to spawn. They charge the ripples made by passing cars until they die, their carcasses becoming feed for the seagulls. (In a seemingly unrelated note, the valley is famous for its sweet corn.)

Although Ethel Dalby was born a city girl, she was bred a canal woman. In this 1930 photograph, Dalby, in waders, hoists two king salmon caught in the river. She, too, loved the canal and spent her last years in the family home feeding her domesticated flock of ducks, chickens, and seagulls.

In this 1952 photograph, Bob Bearden hoists his steelhead catch of the day. Fishing the Skokomish River is a rite of late summer and early fall. The George Adams hatchery releases millions of salmon fry annually, and when the kings begin to nose the river, so too do the fishermen.

The George Adams Hatchery was completed in June 1961 on Purdy Creek. It was originally required as a condition of the Cushman Dam, and it took more than 30 years for the City of Tacoma to fund the hatchery. The very popular fishery has spawned the term "combat fishing," and even youngsters like six-year-old Easton Waylett enjoy the thrill of "fish on!"

In 1953, the Hood Canal hatchery at Hoodsport was dedicated. Located on Finch Creek at the site of the old Gateway Inn, it reproduces king salmon and chum salmon. In fall, at the creek's mouth, first the anglers cast for kings, then, later, tribal fishermen harvest the returning chum for eggs to sell to Japan.

This cabin symbolizes the stages of change of Hood Canal. It was originally built in 1922 as a cookhouse for Chet Kneeland's logging operation, and a short railroad extended into the small cove. By the 1930s, a private owner had built a small resort, Shake Cabin Camp, and catered to fishermen with such services as gravity-fed water and an outhouse out back. After World War II, the resort was demolished, and the cabin was sold in 1957 to a family member and returning veteran. The family spent childhood summers playing on the beach in low tide and on the water at high tide. A fifth generation of that family currently enjoys canal summers at the cabin. Now a dock juts into the water, reaching almost to the broken pilings of the old railroad wharf.

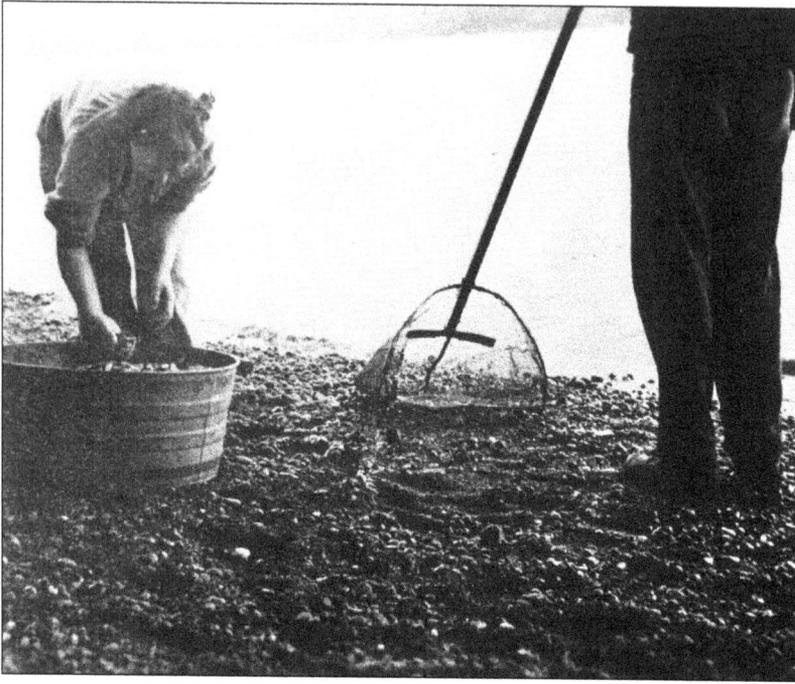

Smelt runs were prolific on canal shores, and cars would careen the canal road with smelt nets poking out the windows, hoping to spy the smelt boiling in the low tidewater. In the 1950s, summer homes and bulkheads began to wall off the beach, blocking the smelt from the beach rubble where the baitfish spawned.

Maria James (left) and Nell Anderson display geoducks dug on the Union tide flats. These giant mollusks bury themselves an arm's length in the mud and extend their necks to siphon in feed. A summer's secret delight of locals was to splash across the flats and the eelgrass at low tide, seeking horse clams, cockles, crab, and the squirting geoduck. Diggers would dike around the geoduck's neck and then shovel a hole large enough for someone to lay flat on the mud, reach his arm down, and scrape the sharp-edged, hard-shelled, long-necked succulent clam out of the wet mud. In recent years, professional scuba divers have greatly diminished the numbers of geoducks.

122

Hood Canal offers sport crabbing as well as a short season for shrimping. Other shellfish gathered from canal beaches include oysters, clams, mussels, and, on an extreme low tide, geoducks. In addition to their staple, salmon, the Twana ate a wider variety of marine food, including salmon eggs in seal oil, barnacles, and horse clams. They would canoe each season to the best beaches to camp and harvest each species.

The low dissolved oxygen level in the canal waters have resulted in more frequent fish kills and prompted political interest, although kills have been documented as a natural occurrence in at least 1926, 1935, and 1963. Here Hood Canal Salmon Enhancement Group volunteer Mya Keyzers monitors water quality while being observed by a University of Washington research vessel of politicians. Although aging septic systems, manure runoff, and slow tidal flush are frequently blamed for the fish kills, a recent National Public Radio broadcast cited a University of Washington study that suggested that, because of untreated effluent from international cities, up to 18 times the amount of nitrogen is carried into the canal than is produced from within the watershed. Some local divers say they have seen no evidence of low oxygen and that it is a conspiracy to require installation of a costly sewage system.

On occasion, orca whales hunt harbor seals in Hood Canal, typically when the seal population grows above the canal's estimated capacity of 1,000 seals. Linda Sund took this photograph near Hoodsport on February 8, 2003, of male orca T-74. These stirring, sleek, seal-eating mammals were called blackfish in earlier times.

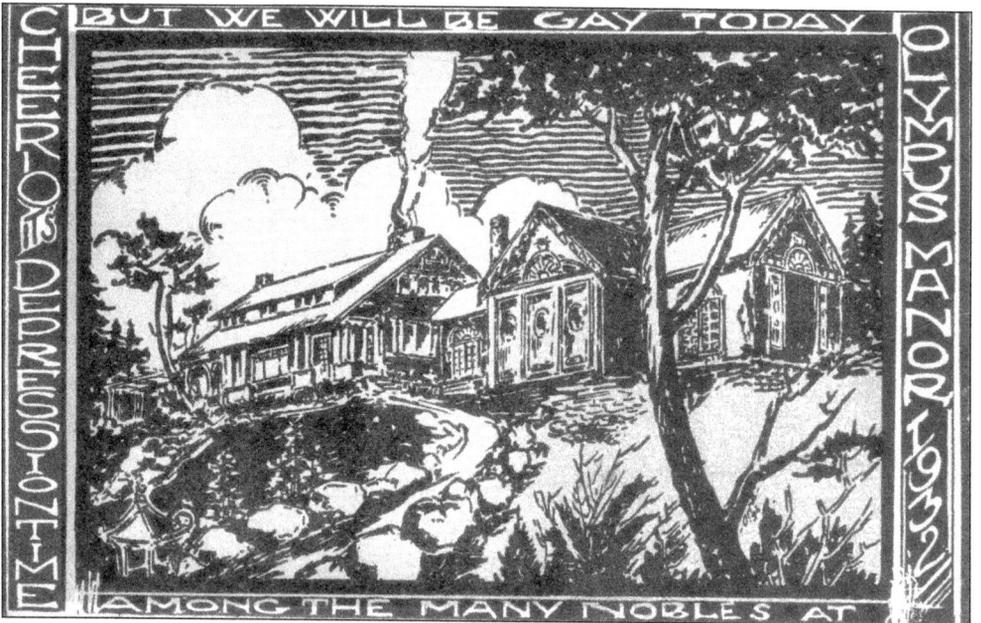

Orre Nobles and his family built Olympus Manor lodge in 1924, gradually adding other structures until it reflected the Nobles's vision of having Chinese art in every room. Olympus Manor guests could expect musical concerts, plays, and other events each summer and a lasting memory to take home. The lodge burned in 1952, though for years the artists' colony lingered. Now only a stone pillar remains of the magical years of Olympus Manor. (Courtesy Clinton White.)

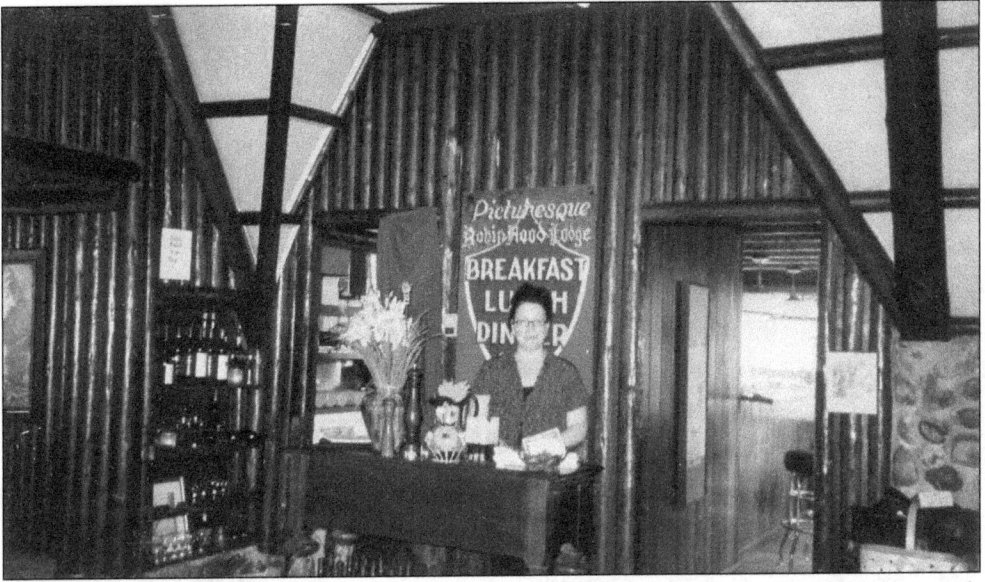

In 2002, managers Blake and Corrine Caldwell remodeled Robin Hood Restaurant, reviving much of the 1930s decor, including signage in the dining room, which features a stone fireplace and stained poles, the stones from the creek, and the poles from the little trees. In the back lounge, the removal of ceiling tile and sheetrock uncovered a 25-foot mural of Hood Canal. By 2005, local artists, musicians, and historians began a revival of the artists' colony on Hood Canal.

In this 1997 photograph of Hoodsport's Fourth of July, fireworks fill the sky like a giant jellyfish. After the decline of the logging industry, Hoodsport citizens, led by Mike Kirk, raised local funds to celebrate the Fourth of July to raise local spirits and to once again celebrate the summer on Hood Canal in grand fashion.

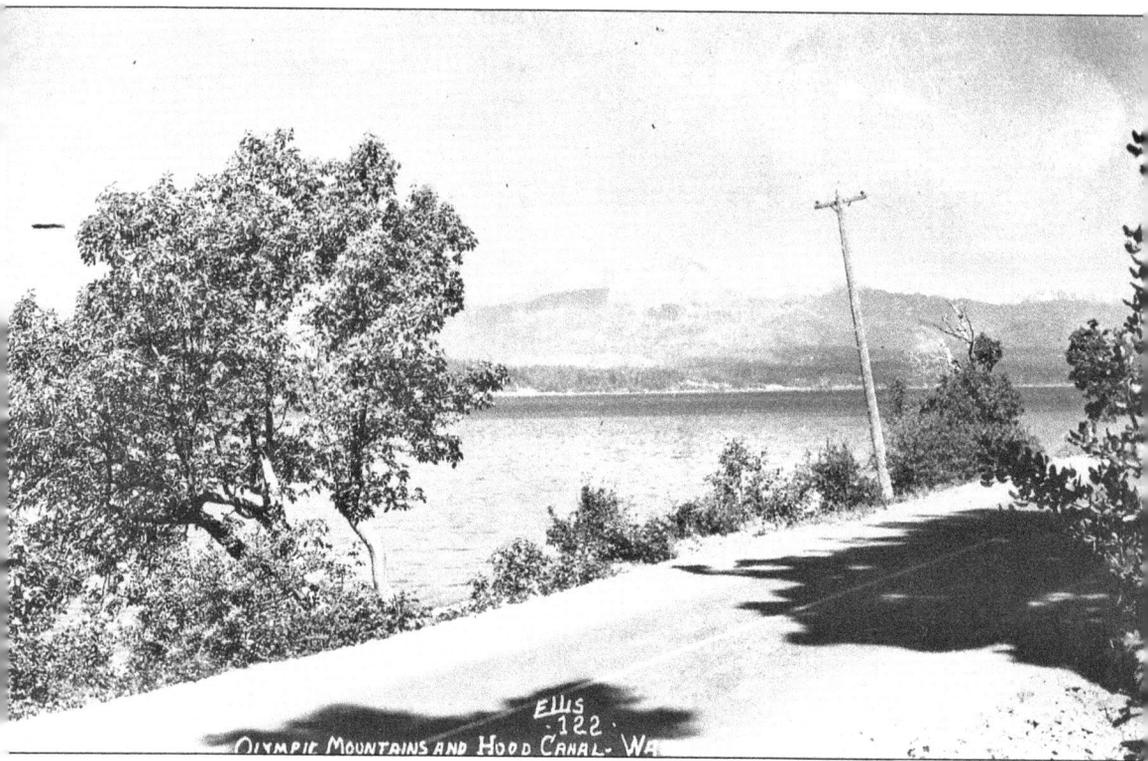

Ellis
·122·
Olympic Mountains and Hood Canal· Wa

It is as if the gods of the Olympics chiseled a profile of the father of our country so he could overlook the most scenic of all his lands, and he can only be seen in profile from Hood Canal. Mount Washington, ringed with green treed hills, rises majestically above the reflecting pool of Annas Bay. In this inlet, which even Captain Vancouver couldn't label correctly, all who touch these waters never really leave, perhaps almost hearing some Hood Canal blessing: "May the tide always be in, may the waters always be warm, and may the summer days refresh your body and spirit."

# BIBLIOGRAPHY

Anderson, Helen McReavy. *How When and Where On Hood Canal*. Everett, WA: Puget Press, Inc., 1960.

Bailey, Ida and Vern. *Brinnon: A Scrapbook of History*. Bremerton, WA: Perry Publishing, 1997.

Bearden, Jean L. *A History of Hoodsport, Gateway to the Olympics*. Washington: self-published, 1987.

Castile, George Pierre. *The Indians of Puget Sound: The Notebooks of Myron Eells*. Seattle and London: University of Washington Press, 1985.

Davis, Irene, B. *The History of Belfair and the Tahuya Peninsula (1880–1940)*. Shelton, WA: Mason County Historical Society, 2001.

Deegan, Dr. Harry W. *History of Mason County, Washington*. Shelton, WA: self-published, 1960.

Elmendorf, William W. and A. L. Kroeber. *The Structure of Twana Culture*. Pullman, WA: Washington State University Press, 1992.

Elmendorf, William W. *Twana Narratives*. Seattle and London: University of Washington Press, 1993.

Fredson, Michael. *Log Towns*. Shelton, WA: Mason County Historical Society, 1993.

———. "Orre Nobles and the artist colony on Hood Canal." *Shelton-Mason County Journal*. August 3, 2006.

———. *Shelton's Boom: The Classic Years (1910–1933)*. Shelton, WA: Mason County Historical Society, 1982, reprinted 1997.

Haeberlin, Hermann and Erna Gunther. *The Indians of Puget Sound*. Seattle and London: University of Washington Press, 1930.

Kruckeberg, Arthur R. *The Natural History of Puget Sound Country*. Seattle and London: University of Washington Press, 1991.

Lien, Carsten. *Exploring the Olympic Mountains. Accounts of the Earliest Expeditions 1878–1890*. Seattle, WA: The Mountaineers Books, 2001.

Mason County Historical Society Archives. Shelton, WA.

Meany, Edmond S. *Vancouver's Discovery of Puget Sound*. Portland, OR: Binsfords and Mort, Publishers, 1942.

Montgomery, David R. *King of Fish*. Cambridge, MA: Perseus Books Group, 2003.

Neal, Carolyn and Thomas K. Janus. *Puget Sound Ferries: From Canoe to Catamaran*. Sun Valley, CA: American Historical Press, 2001.

Nordstrom, Katharine Johanson. *My Father's Legacy*. Seattle, WA: Distributed by University of Washington Press, 2002.

Overland, Larry. *Early Settlement of Lake Cushman*. Belfair, WA: Mason County Historical Society, 1974.

Perry, Fredi. *Seabeck: Tide's Out, Table's Set*. Bremerton, WA: Perry Publishing, 1993.

Replinger, Pete. *Tall Timber Short Lines*. "Hama Hama Logging Company." pp11-30, Issue 77, Winter 2005.

Richert, Emma. *Long, Long Ago in Skokomish Valley*. Belfair, WA: Mason County Historical Society, reprint 1965, 1984.

Visit us at
arcadiapublishing.com